HANDCRAFTED
IN THE
BLUE RIDGE

DISCOVERING THE CRAFTS, ARTISANS, AND
STUDIOS OF WESTERN NORTH CAROLINA

IRV GREEN AND ANDREA GROSS

PEACHTREE
ATLANTA

Ꝓ
PUBLISHED BY
Peachtree Publishers, Ltd.
494 Armour Circle NE
Atlanta, Georgia 30324

Cover design by Loraine M. Balcsik

Book design by Loraine M. Balcsik and Terri Fox

Manufactured in the United States of America

10 9 8 7 6 5 4 3 2 1
First Edition

Library of Congress Cataloging-in-Publication Data

Green, Irv (Irving), 1937-
　　　　Handcrafted in the Blue Ridge: discovering the
　　　　crafts, artisans, and studios of Western North
　　　　Carolina / Irv Green and Andrea Gross. — 1st ed.
　　　　　　p. cm.
　　　　Includes index.
　　　　ISBN 1-56145-145-2 (tp)
　　　　1. Handicraft—North Carolina—Asheville Region—
　　　　Guidebooks. 2. Artisans—North Carolina—Asheville
　　　　Region—Directories. I. Gross, Andrea, 1940- . II.
　　　　Title.
　　　　TT25.A74G73 1996　　　　　　　　96-45228
　　　　745.5'09756—dc21　　　　　　　　　　CIP

CONTENTS

AREA 3: THE NORTHERN PEAKS

AREA 7: THE ROLLING FOOTHILLS

Introduction

We began this book on an early spring day, when the air was crisply fresh and wildflowers blazed on the hills. Since then we've traveled hundreds of narrow roads and graveled lanes—watching as the trees changed to countless shades of green before donning the dashing colors of autumn, listening as the streams tumbled over rocks and the rivers roared through narrow gorges.

During this time we visited nearly two hundred working craft studios. A few were in the alleys or lofts of Asheville's city center. Some were in shops along the main streets of small towns. But most were in basements, garages, or spare rooms of private homes, some high on the crest of a mountain with fifty-mile views, others tucked into valleys and surrounded by trees.

We spoke with longtime mountain men like David Boone, a wood-carver who traces his ancestry back seven generations to Daniel, the great frontiersman, and to newcomers like Pei Ling Becker, an assemblage artist who recently came to the mountains from Taiwan. We visited with graduates of some of the best art schools in the nation, with self-taught craftsmen, with young folks just beginning their careers, and with older ones who, after retiring to North Carolina, were finally getting a chance to do what they'd always wanted.

The crafts we saw were as diverse as their makers: the contemporary woven metal sculptures of Cori Saraceni and the sleek pottery of Steven Forbes-deSoule, the traditional work of broom maker Kim English and weaver Suellen Pigman, the folk art of B. J. Precourt and Robert Frito Seven. We saw works made of clay, glass, wood, iron, gold, fabric, yarn, reed, and recycled industrial machines. We learned about kiln temperatures, lost-wax casting, overshot weaving, and Norwegian embroidery.

More than 4,000 people in western North Carolina earn part or all of their living from crafts, an unusually high number for an area that, except for Asheville, is largely rural. But this is a region with a strong craft tradition. While settlers in many places built their own cabins, made their own furniture, wove their own blankets, and sewed their own quilts, in Southern Appalachia they did so longer. The people lived on isolated farms and in small villages, where manufactured goods were hard to come by. So they made do, and in many cases, they made beauty at the same time.

By the last part of the nineteenth century, missionaries, social workers, and local women of means—all appalled by the dismal poverty that stalked the mountains—began to realize that in crafts lay the road to economic salvation. In 1895, Frances L. Goodrich, a Yale-educated dynamo who had come to the mountains to teach in a small community just north of Asheville, was given a hand-woven "Double Bow Knot" coverlet, made nearly fifty years before. Charmed with the gift, inspired to preserve the dying craft, and eager to help the mountain women raise their standard of living, Goodrich founded Allanstand Cottage Industries. (Allanstand was named for an abandoned log structure, Allen's Old Stand, which was the source of the logs for the first weaving cottage.) The woven goods sold so well that a few years later Goodrich opened a larger shop in Asheville.

Other women found similar ways of making a difference. In 1901, Edith Vanderbilt, the wife of George Vanderbilt III, founded Biltmore Industries in Asheville. This was a school where young men and women could learn the traditional crafts, especially weaving and woodcarving. A few years later, in 1909, a

young doctor named Mary Martin Sloop reinvigorated the craft of hand-weaving in Crossnore, a long horseback ride north of Allanstand and Asheville. In 1923, Lucy Morgan founded Penland Weavers and Potters in the mountains between Allanstand and Crossnore, again with the intention of helping mountain women use old-time crafts to sustain themselves. Further south, near the North Carolina–Georgia border, Olive Dame Campbell and Marguerite Butler started John C. Campbell Folk School, named after Olive's deceased husband and inspired by the *folkehøjskole* (folk schools) of Denmark. While encouraging other craft activities, they paid local folks to whittle small animals which the school in turn sold to an ever-increasing number of customers.

Finally, in 1928, Lucy Morgan called a meeting at Penland. Olive Dame Campbell came, as did Mary Martin Sloop, a representative of Francis Goodrich, and seven other people. During a two-day retreat, these folks hammered out the principles for a guild (later named the Southern Highland Craft Guild) that would conserve and support mountain crafts. Today, the schools and institutions that these women started form the foundation for much of western North Carolina's craft revival. Frances Goodrich's Allanstand Craft Shop, now operated by the Southern Highland Craft Guild, is located in the Folk Art Center on the Blue Ridge Parkway, where it attracts more than 300,000 visitors a year. Mary Martin Sloop's Crossnore School uses weaving to support a respite home for youngsters from troubled families. Lucy Morgan's Penland has become an internationally known learning center for those interested in contemporary and experimental art. Olive Dame Campbell and Marguerite Butler's folk school offers courses in virtually all

Appalachian crafts, from basketry, bead work, and black-smithing to tatting, tinsmithing, and weaving. And the Southern Highland Craft Guild has become the premier organization for fine craftspeople, offering membership only to those who do well in a rigorous jurying process. Their craft shows, which are held every July and October in Asheville, draw craft aficionados from across the United States.

In 1972, John Cram, a young entrepreneur from Wisconsin, moved to Asheville and opened New Morning Gallery, a first-rate craft shop that enticed matrons from big cities like Charleston and Atlanta to consider tiny Asheville as a mecca for crafts. Cram has since opened three more galleries—Bellagio for wearable art, Blue Spiral 1 for fine art, and American Folk for antique and contemporary Americana—and continues to be a driving force behind the Carolina craft renaissance.

More recently, in 1993, Asheville won funding from the Pew Partnership for Civic Change to start HandMade in America, a nonprofit organization dedicated to supporting and promoting regional crafts. The result of all this activity? More and more craftspeople are moving to western North Carolina, drawn not only by the beauty of the mountains, but also by the welcoming support of an entire community.

Visiting these people—talking with them, learning from them, and yes, buying from them—is a real treat. We hope you enjoy it as much as we did.

Irv Green and Andrea Gross

THINGS TO CONSIDER

Arranging a time

It is *always* best to call ahead. Craftspeople usually run small, one-person operations. Even though they may intend to keep certain hours, plans may change or emergencies occur.

Try to call during normal working hours. Most of the phone numbers we've listed are home numbers, and craftspeople deserve the chance to have a phone-free night with their family.

Leave messages that state when you'll be available for a callback. Many craftspeople let their answering machines pick up the phone when they're in the middle of an involved procedure. They do their best to get back to you as soon as they can.

Plan your visits for midweek if at all possible. Many craftspeople are away at shows on weekends, especially during the summer and fall.

Getting there

Have a pencil and paper ready when you call for directions; they're likely to be long and detailed. Many mountain roads don't have posted names. You may be told, for example, to "turn on the first dirt road after the red brick church."

You'll often be on long gravel roads, far from a gas station. Keep your gas tanks full and a spare tire in the trunk. (This is "just-in-case" advice. We never needed our spare.)

If you get lost—and we certainly did—just stop at a country store and ask for help. That's half the fun.

When you're there

Ask lots of questions—about the crafts, the process, the people, the area. But be sure to respect the craftspeople's time. If you overstay your welcome, they won't be as willing to let future visitors into their studios.

Be careful when you're in the workshops and, if you have small children, hold their hands. Most craftspeople work with dangerous tools or chemicals, and many of their products are breakable.

Making a purchase

Prices of individual items vary due to many things, especially material (for example, cherry is more expensive than pine), size, and complexity. If a particular piece has won an award, it will be more expensive than other, somewhat similar items. The prices given in this book are only approximations.

Many craftspeople have seconds or experimental pieces at their studio that they sell at a reduced price. But, in order to be fair to local gallery owners, they usually charge full retail for first quality items.

While many craftspeople accept credit cards, they always prefer payment with cash or traveler's check. (Some even offer discounts to those who pay with cash.)

GREATER
ASHEVILLE

ASHEVILLE

THE NORTH CAROLINA MOUNTAINS WERE a fortress in the early days, a tall blue wall that separated the colonists who lived to the east from the Indians who lived to the west. Asheville, located at the juncture of several old Indian paths, began as a trade center and was incorporated by the state in 1797. But it wasn't until the 1880s, when the railroad came to the mountains, that it began to develop the aura of a small but cosmopolitan city.

With the mountains providing natural air conditioning, Asheville became a mecca for rich folks who wanted relief from muggy lowland summers. Between 1880 and 1930 the town boomed, quadrupling its population to nearly 10,000. Architectural treasures—especially from the heyday of the 1920s—line the streets of downtown, and many consider Asheville to have more examples of art deco than any other city in the southeast with the exception of Miami. Now, with a population of nearly 65,000, Asheville is becoming known as a leading center for American crafts.

Antique shoppers will find treasure-laden shops sprinkled throughout town, especially along Swannanoa River Road, Broadway, North Lexington Avenue, and Rankin Street. If you want to explore the sites on foot, the Asheville Urban Trail offers a self-guided walk through Asheville's past; call 704/251-9973 for information.

Don't miss Biltmore Estate, George Vanderbilt III's grand mansion that has 250 rooms, 50,000 objects of art (including paintings by Renoir and Whistler), and seventy-five acres of formal gardens. Biltmore Village neighbors the estate; these

houses, where the artisans and craftspeople lived while building the Vanderbilt mansion, are now home to charming shops and restaurants. Details about the Biltmore Estate and Village are available at 704/255-1700 or 800/543-2961.

The Thomas Wolfe Memorial State Historic Site is a must-see for all fans of *Look Homeward Angel;* this site was Wolfe's childhood home and served as the inspiration for the boarding-house in his famous novel. Call 704/253-8304 for information about visiting. And when you're ready to relax and enjoy some mountain food and music (including clogging!), stop by the Mountain Smoke House. Contact them at 704/253-4871.

METAL SCULPTURE
Stefan Bonitz

*Y*ou never know exactly what you'll find when you enter the Bonitz studio. Why? Because Stefan Bonitz never knows what materials he'll have to work with. He creates sculptures—some functional, all decorative—from industry discards and scrap throwaway.

"Ninety-nine percent of my material is recycled," he says, pointing toward a large coiled basket that stands about two feet high and is made from rebar, the steel rod used to reinforce

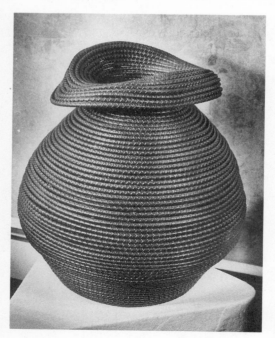

concrete. The wall sconces began as transmission rings, the bird houses as pipes, the giant spiderweb wall sculpture as an old industrial fan cover, while the table was created from lawn mower blades.

Although Stefan learned many of his techniques from blacksmiths, he doesn't use a forge.

Stefan Bonitz,
metal basket

Most of his work is cold-bent—cut with an acetylene torch and welded into place. Everything, for obvious reasons, is one-of-a-kind.

PRICES
Candleholders, $10+;
wall sconces, $45;
large outdoor creations, $3,500+

LOCATION
Shop studio

ADDRESS & PHONE
86 S. Lexington Ave., #4
Asheville, NC 28801
704/274-5492; 704/253-4610

WEB SITE
http:/www.circle.net/steebo

HOURS
Mon.–Fri., noon–5 P.M.,
or by appointment

PAYMENT
Personal checks

CUSTOM JEWELRY
Paula Dawkins, Jennifer Jenkins, John Zinni-Scott, and Dudley Culp

Paula Dawkins intended to be a psychologist and, in a way, she is. When someone asks her to make a ring for a loved one, she starts by asking questions. Her purpose, she explains, "is to find the person's inner core, the soul image." Unlike most artists, Paula doesn't want her work to be an expression of herself but rather an expression of the person who wears it. "I see myself as being a conduit for people," she says. "I'm not designing out of my ego but rather designing a piece that belongs to the wearer."

Paula also has standard pieces. Every year she designs the line that she and her partners present to galleries. For example, one immensely popular line, "Beauty Lies Within" was a series of rings that, in addition to diamonds on the outside, also featured four small diamonds on the inside. "That was to remind us that it's what's within that counts," says the psychologically attuned jeweler.

Prices
Sterling rings with gemstones, $90+; 18-karat gold-and-diamond rings, $9,000; custom orders quoted individually

Location
Shop studio

Address & Phone
63 Haywood St.
Asheville, NC 28801
704/254-5088

Catalog
Write for catalog

Hours
Mon.–Sat., 10 A.M.–6 P.M.

Payment
Visa, MasterCard, American Express, Discover, personal checks

Paula works with three other jewelers, all of whom have been at their craft for at least fifteen years. Although they work well together and occasionally team up for certain projects, each has his or her specialty. Paula's work is classic, Jennifer Jenkins prefers the contemporary, John Zinni-Scott likes the organic, and Dudley Culp enjoys working with fine gemstones.

Visitors to their studio can see the four at work in a viewing area. Most of their jewelry—rings, plus some earrings, pins, and pendants—is made by the lost wax method. A wax carving of the desired piece is embedded in a plaster mold with small entry and exit holes. When this is heated in a kiln, the wax vaporizes, making room for molten metal to be poured into the mold. Finally, the plaster is removed and the formed metal is trimmed and polished. A

slightly different technique is used for the group's gallery line; a rubber mold, which can be used time and time again, is made of the initial carving.

VESSELS OF THE SPIRIT
Susan Lightcap

*T*ake the small bone of a bird, some gilded paper, a piece of raw silk, and a poem neatly printed in calligraphy. Put all this in Susan Lightcap's creative hands and, with a combination of glue and heart, she'll create something totally unique: a "vessel of the spirit."

Susan's vessel might be a cloth-covered box filled with treasures. Seen through geometric windows, the beads, stones, bones, and charms take on a new life and communicate new ideas. The vessel also could be a book, filled with handmade paper, covered with a richly textured fabric, decorated with feathers or beads or papers, and hand-bound using a variation of ancient binding techniques. It sits waiting for the words that will make it whole.

"I create safe, safe, nurturing spaces where people can complete their journeys," says Susan. "I do half the work. The rest is up to the person." People relate to Susan's work in very individual ways.

PRICES
Books, $100+;
box sculptures, $250+;
commissions and
restorations accepted

LOCATION
Studio

PHONE
704/232-0202; 704/258-2534

HOURS
Call first

PAYMENT
Personal checks

When she's showing at craft fairs, she can tell when the "right owner" of a book comes along. "It jumps into her hands," she says. "The person can't put it down. It speaks to her." These people she says "are seekers. They are seeking to live consciously in the right relationship with themselves, with the earth, and with the spirit."

Cori Saraceni, metal weaving

WOVEN METAL SCULPTURES
Cori Saraceni

*Y*ou may have seen Cori Saraceni on television. Before she moved to Asheville in the late 1980s, she appeared in programs such as "Lou Grant" and "Hill Street Blues." Between acting stints she wove fabric and developed a high-style line of clothing. But she got as tired of fashion as she did of the Los Angeles freeways. When she moved to Asheville, she decided to try something else. Drawing on her background in weaving as well as the principles she learned as a child from her architect father, she developed sculptural weavings, combinations of fabric and metal that seem suspended in air.

In the embryonic stages of her new craft, Cori wove fabric and glued it to a rigid board. But that wasn't quite right; she wanted every rib to support itself. She began stringing her loom with thread and weaving strips of metal through it—thin aluminum rods, flat strips of copper, coiled piano wires, anything glittery and stiff. After her weaving was complete, she could bend the metal, capturing movement in midair. Sometimes she sculpted the metal before weaving, giving her yet another way of achieving her vision. Finally, she developed a way of framing her sculptures in a manner that frees them at the same time it supports them.

PRICES
Metal weavings, $800+

LOCATION
Shop studio

PHONE
704/254-1211

HOURS
Call first

PAYMENT
Personal checks

EAST ASHEVILLE......................

NORWEGIAN NEEDLEWORK
Cathryn Carlson

*T*ake a fabric that has been specially woven to have the same number of threads per inch horizontally as vertically. Embroider it with a geometric pattern of satin stitches, carefully counting the fabric threads so that each stitch is precisely the correct size and in the place desired. Selectively cut the fabric and remove some threads to create small holes that will enhance the design. Use small, tight stitches to pull certain threads to the side, thus opening the fabric and making a pattern of even smaller holes. This is Hardanger embroidery, a form of counted thread embroidery that was developed three centuries ago near the fjord-rich west coast of Norway.

Cathryn Carlson remembers watching as her grandma made the fine, lacy patterns on evenweave cotton and linen. She wanted to learn the technique, but her grandmother died before passing on her secrets. So Cathryn learned on her own, painstakingly studying old photographs and experimenting until she could reproduce the delicate designs.

Much of Cathryn's work is white-on-white, but some is made with colored fabrics and threads. "Both," says Cathryn, "are traditional ways of creating this folk art."

PRICES
Small 1 1/2" x 1 1/2" embroidery in frame, $32; large 22" x 22" embroidery in frame, $2,000

LOCATION
Home studio; 15 minutes east of Asheville

PHONE
704/299-7503

HOURS
Call first

PAYMENT
Personal checks

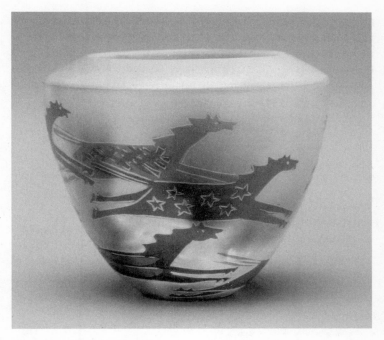

Chiwa, earthenware vessel

NATIVE AMERICAN EARTHENWARE
Chiwa

"The Ancient Ones believe that everything has a spirit," says Chiwa, a deeply spiritual woman whose Native American earthenware often features pictographs as symbols of forces such as power, energy, and illumination. Her work seems to spring from the earth. She shapes many of her pieces like shards, chipping the edges of the clay once it becomes leather-hard to

give an old, found effect. She adorns her work with figures that look like cave paintings, executed in Indian colors of turquoise and rust against an off-white background. Then she fires her creations in a pit filled with scraps of paper and native plants. As the fire smolders, the plant material burns off, leaving a reverse shadow, a white imprint surrounded by smoky ash. The earth and plant have, once again, become one.

Chiwa, also known as Chris Clark, assumed her new name during a dawn solstice celebration and later learned that it means "light that shines beneath the eyes." The name fits a woman whose goal is to "get my mind out of the way [so] the Spirit can speak through my hands."

• • • • • • • • • • • • • • •

PRICES
Earrings and pins, $20+;
single switch plates, $30;
clocks, $100+;
seconds sometimes available

LOCATION
Home studio; 10 minutes
east of downtown Asheville

PHONE:
704/298-0426

HOURS
Call first

PAYMENT
Personal checks

• • • • • • • • • • • • • • •

CONTEMPORARY QUILTS
Janice Maddox

"*I* take traditional patterns and do something innovative," says Janice Maddox, pointing to a quilt that began as a "Trip Around the World" pattern but, in Janice's hands, evolved into something quite different. By choosing flowered pastels and arranging them so that the colors flow from block to block, she allows the individual squares to become less prominent and the

pattern less pronounced. Instead the quilt seems like a painting, a soft watercolor of spring flowers.

Other times Janice uses triangles and squares to create pictures, as in "Tesselated Cats," a quilt that juxtaposes playful reds and pinks to create stylized animals. By using color in new and different ways, she can create contemporary quilts even while using age-old shapes and techniques.

Janice has been sewing since she was a child. She tried other needle arts—needlepoint, crewel, knitting—until she finally settled on quilting. Now, in addition to creating quilts both for herself and others, she teaches quilting at several locations near Asheville.

A photograph of Janice's work appears on the title page of this book.

PRICES
Decorative quilts, $550–$3,100

LOCATION
Home studio;
10 minutes east of Asheville

PHONE
704/254-9103

HOURS
Call first

PAYMENT
Personal checks

HAND-HAMMERED JEWELRY
Ralph D. Morris, Jr., Sibyl Vess, and others

Ralph Morris understands when someone calls his business and asks for "Stuart Nye." After all, the sign out front bears the name of the company's founder, although the man himself has been gone for many a year. The dogwood blossom jewelry that was his trademark is still made according to the same techniques and hammered with the same tools.

Nye didn't know anything about jewelry making when, after World War I, he came to Asheville for treatment of lung problems. In 1933, finally out of the hospital, he was running a popcorn stand when a friend offered him some silver and some tools. He hammered out a simple bangle bracelet, and an Asheville institution was born. Ralph Morris's father, who managed a large department store, was Nye's best customer and most valued advisor. In 1947 the two men became partners. Shortly after that, young Ralph joined the business.

PRICES
Sterling silver pins, $13+;
charm bracelets, $110
(at the Guild Shop)

LOCATION
Shop studio;
5 minutes east of Asheville

ADDRESS & PHONE
940 Tunnel Rd.
Asheville, NC 28805
704/298-7989

CATALOG
Write for catalog

HOURS
Mon.–Fri., 8 A.M.–11:30 A.M.
and 12:30 P.M.–4 P.M.

PAYMENT
Visa, MasterCard, Discover,
personal checks

While they make a multitude of patterns, floral designs—made into pins, earrings, bracelets, tie tacks, and Christmas ornaments in silver, brass, and copper—are still the bestsellers. Sibyl Vess, who's been working at the shop off and on since the mid-1940s, can't even begin to estimate how many dogwood petals she's hammered.

Sibyl and the other employees are used to having people watch them work. When the current shop was built in 1948, Nye decreed that visitors should be able to see craftsmen at work without feeling pressured to buy. "You can buy, but you'll have to go over there to do so," says Ralph, gesturing toward the Guild Crafts store next door. "When you visit here, it's just for education and entertainment."

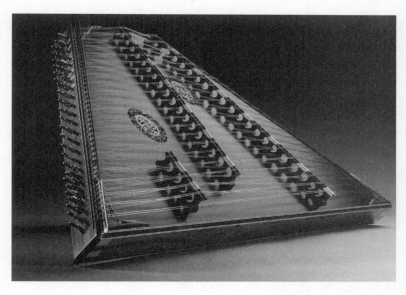

Jerry Read Smith, dulcimer

Hammered Dulcimers
Jerry Read Smith

*W*hen Jerry Read Smith moved to North Carolina in 1972 he'd never even seen a dulcimer. But once he did, he delved into building them with a passion. He began by sending for a free pamphlet put out by the Smithsonian. Following its rudimentary instructions, he constructed his first instrument, which he thoroughly expected to be his last. But then he realized that the dulcimer wasn't *that* hard to make. He built another that sounded just a little bit better, and then another and another. "Pretty soon," he says, "I was in business."

Although he calls himself "a blue-collar musician," instrument
making eventually became music making. In 1981 he made his
first album. He was interviewed by National Public Radio and
pretty soon he had quite a reputation both as a dulcimer builder
and as a performer. Orders for his dulcimers came pouring in; to
get a handmade Jerry Read Smith instrument meant an eight-
year wait.

PRICES
Dulcimers, $735+;
seconds occasionally available;
recordings: $10 tape,
$15 compact disc

LOCATION
Home studio;
10 minutes east of Asheville

PHONE
704/298-0167

E-MAIL
Songofwood@aol.com

HOURS
Call first

PAYMENT
Visa, MasterCard, personal checks

Now Jerry has made more than
650 dulcimers, each containing six
to eight woods. His wife Lisa, who
accompanies him on flute in many
of his recordings, strings the
instruments which come in three
sizes: three, three-and-a-half, and
four octaves. Assistants help him
produce pluck and bowed psalter-
ies. Jerry's dulcimers and record-
ings are also available at his shop,
Song of the Wood, in downtown
Black Mountain.

Marquetry
Clyde Badger

*L*ike all ancient crafts, marquetry (wood inlay) has been adapted to modern times. Many contemporary craftspeople cut multiple pieces at a time, in effect mass hand-producing their work, or use a laser to cut the small, very thin pieces. Not Clyde Badger. He works in the same way that the masters have done for centuries—individually knife-cutting each piece so that it fits precisely into place, without need of putty or wood-fill.

Clyde begins with a thin piece of veneer which he calls a waster. He traces his design onto the waster, then carefully cuts out the shape that represents the area furthest in the background. He then puts the waster over another piece of veneer and, using the hole in the waster as a pattern, traces the shape onto the new wood. After he cuts this out, he edge-glues it into place in the waster and proceeds to the next area. One by one he traces, cuts, traces, and cuts—knifing each piece at least twice so that it meets its neighbors perfectly, like a delicate jigsaw puzzle. By the time he's finished assembling the piece, the waster has been entirely cut away.

Prices
John Kennedy portraits with 15 pieces, $55; Curiosity Shop pictures with 500 pieces, $600

Location
Home studio; 10 minutes north of Asheville

Phone
704/252-1373

Hours
Call first

Payment
Personal checks

The final step, sanding, is the only process that Clyde performs with a power tool, and even then the bulk of the work is done

by hand. If he sands too much and goes through the paper-thin veneer, the piece is ruined. "Very often it can't be repaired, and I must begin again," he says.

CONTEMPORARY JEWELRY
James Charneski

*J*ames Charneski's jewelry is filled with contrasts. Clusters of gold strips, almost like a miniature set of pick-up sticks, form a bed for a brilliant stone. Metals and stones are juxtaposed, and matte finishes contrast with areas of high polish.

In order to achieve the crisp edges that form the tossed-stick patterns on his signature pieces, Jim uses a charcoal casting technique. The desired shape is carved into a block of charcoal, forming a negative image of the finished piece. As the molten metal is poured in, it fills the empty spaces, hardening to form the desired image.

Jim—who makes everything from earrings, rings, and bracelets to pins, pendants, and belt buckles—works with a variety of metals (gold, silver, pewter, platinum, aluminum) and a great many stones, although the opal is a personal favorite because of its iridescent quality.

PRICES
Earrings, $50+;
pendants with gemstones, $300+;
custom orders accepted

LOCATION
Home studio; 3 minutes
north of Asheville

PHONE
704/255-8629

HOURS
Call first

PAYMENT
Personal checks

DECORATIVE PORCELAIN
Don Davis and Marian Davis

*W*hen *The Last of the Mohicans* was filmed in Asheville, Don Davis was commissioned to create the movie's pottery. He made four large storage vessels (each three feet tall) and twenty-six Iroquois cooking pots. The rustic pottery was a bit different from Don's usual style, but he likes challenges.

Because his wife Marian, a former decorative painter, casts midrange vases from his wheel-thrown originals, Don is free to make one-of-a-kind decorative pieces—primarily vases, teapots, and platters. Most of his shapes are classically simple, often with

Don Davis in his studio

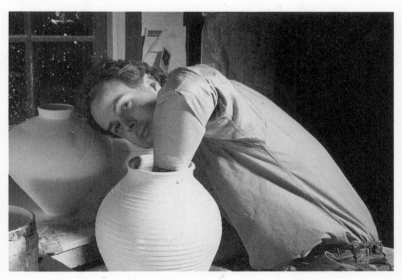

a narrow neck leading to a gracefully swelled belly. Many of them are fairly large, eighteen to twenty-four inches tall. Some of them, like the Mohican vessels, are truly giants.

To make his mammoth pots, which often weigh more than one hundred pounds when the clay is wet, Don uses a combination of wheel and coil pottery techniques. He begins by throwing a large bowl-shaped base. After this has dried enough to bear the weight of additional clay, he adds several rows of massive coils. He repeats this until the vessel is the proper height, realizing that it will shrink considerably as it is fired.

Don generally prefers a light glaze, letting it enhance rather than cover the clay beneath. He often uses one or two slashes of bright color—sometimes charcoal gray, frequently copper red—to accent a soft undercoat.

PRICES
Cast vases, $20–$55; hand-thrown vases, $50–$650; teapots, $125–$750; seconds sometimes available

LOCATION
Home studio; 10 minutes north of Asheville

ADDRESS & PHONE
67 Rice Branch Rd.
Asheville, NC 28804
704/251-1425

HOURS
Fri.–Sat., noon–6 P.M.; other days, call first

PAYMENT
Personal checks

FIBER ART
Suzanne Gernandt

S uzanne Gernandt likes to experiment. She weaves squares of dark fabric and then "discharges" the color, leaving small patches of dark surrounded by larger areas of white. The process, she explains, is like a reverse tie-dye. In tie-dye you add color to the areas that are not blocked off; in discharging you take color out. Then she dyes the cloth again—repeatedly bleaching and dying until she's pleased with the shapes and patterns.

When she uses different types of threads in her weaving, some threads accept the dye and bleach more readily than others, adding even more variation to her work. Often she adds areas of paint or creates interest with lines of machine stitching.

The result is abstract, often symbolic. "I like to create feeling and mood," she says, "and I want to convey a feeling of communication." She sets a mood by her choice of colors—often soft greens, blues, lavenders, and oranges set against off-white or black. She gives a sense of communication by incorporating letter-like symbols— sometimes historic, often invented—into her work.

PRICES
Framed fiber art, $375–$525

LOCATION
Studio; 2 minutes
north of Asheville

PHONE
704/253-7013

HOURS
Call first

PAYMENT
Visa, MasterCard,
personal checks

Functional Pottery
George Handy

"*I* love doodling," says George Handy. "Doesn't everyone?" But not everyone doodles in quite the same way George does. Instead of on paper, he draws on mugs, bowls, plates, vases, and tiles that he's made himself (or with the help of an apprentice). Instead of chewed-down pencil stubs, he uses a variety of brushes and a palette of specially formulated glazes that give him vivid blues, reds, golds, and purples.

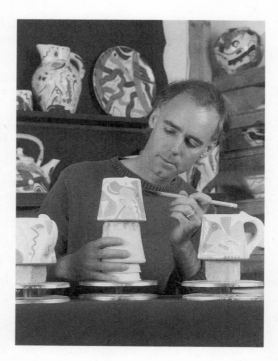

George Handy
in his studio

Each piece is completely unique, but George has developed several different patterns so people can buy coordinated sets. His "Sketch-book" line, which is part of the permanent collection of the Smithsonian, has delicate lines and curls. "Theater" is much bolder and more dramatic, while "Palette" has even spots of color circling the edge.

Although mugs and other dinner-ware are his mainstay, George was recently commissioned to do a sixteen-foot-wide by eight-foot-high tile mural for the gymnasium of the University of North Carolina at Asheville.

PRICES
Tiles, $22+; mugs, $22–$24; plates, $32–$42; vases, $42–$55

LOCATION
Shop studio; north Asheville

ADDRESS & PHONE
2 Webb Cove Rd.
Asheville, NC 28804
704/254-4691; 800/948-2790

HOURS
Mon.–Fri., 9 A.M.–6 P.M.,
or by appointment

PAYMENT
Visa, MasterCard,
personal checks

CONTEMPORARY JEWELRY
Paul K. Harter

Paul Harter wanted to give his daughter something special when she graduated college. "A pair of opal earrings with a matching pendant would be nice," he thought. Being handy with tools, he decided to make them himself. That was back in 1972, and Paul's been making jewelry ever since.

First he became hooked on cutting stones—lapis, azurite, mala-chite, opal, gold lace agate, and snowflake obsidian. Then, he says,

"I had to get into metalwork to make use of the stones I was cutting." He works mostly with sterling silver and gold fill, shaping the metals into pendants, earrings, and pins with a strong contemporary flair.

Finally, in the early 1990s he went one step further, fashioning intricately woven chains. He begins by wrapping a long strand of silver wire around a mandrel (a steel rod) to form a dense spiral. He then saws through the row of circles to form individual rings that open just enough to be linked together. As he weaves his chain he must open, attach, and close each ring, forming distinct and complex patterns. Some chains, like his popular twenty-seven-inch "square A" necklace, have more than six hundred rings.

PRICES
Silver chain bracelets, $11+; small silver pins, $40+; 14-karat gold pendants with gemstones, $700+; commissions accepted

LOCATION
Home studio; 20 minutes north of Asheville

PHONE
704/645-5567

HOURS
Call first

PAYMENT
Personal checks

PORCELAIN POTTERY
Tyrone Larson and Julie Larson

In eight magical minutes during a recent Christmas season, Tyrone and Julie Larson sold 886 porcelain bells trimmed in gold. During the next half hour they sold another 114—and then had to turn customers away. Their first experience with the QVC cable shopping network was a grand success. The Larsons

are still making bells, but after preparing a thousand for their television debut, they're happier working on other items: large "dream portholes" (wall bowls adorned with seascapes), coil baskets, slab-built canister sets, and hurricane and oil lamps, among others.

Most of their pieces are functional, but design and ornamentation are integral. They prefer geometric forms, from perfect circles to hard-edged rectangles, pyramids, hexagons, and octagons. Sometimes they decorate for elegance, applying a series of simple gold bands on a solid background. Other times they soften the stark geometry of their pieces with painted flowers.

Potters since 1966, Tyrone and Julie are proficient in most ceramic techniques. Since 1986 they have turned to slip-casting for most of their pieces, which allows them to get the sharp lines that define their work. However, Ty recently has started to make more hand-thrown items, while Julie is making more coiled items.

PRICES
Small bowls, $12–$18;
bells, $14–$35;
hurricane and oil lamps, $18–$35;
large wall pieces, $250–$500;
seconds sometimes available;
selected items on sale most
summer weekends

LOCATION
Shop studio; north Asheville

ADDRESS & PHONE
Larson Porcelain
and Design Studios
440 Weaverville Hwy.
Asheville, NC 28804
704/645-4777

HOURS
Wed.–Sun., 10 A.M.–5 P.M.,
or by appointment

PAYMENT
Visa, MasterCard, personal checks

TILE WORKS
Madison MacLaren

*I*f you think a tile is simply a flat square of clay for a shower
stall or countertop, Madison MacLaren will make you think
again. In her capable hands tiles can be rectangular, round, or
free-form, and flat, curved, or sculptural. They can be hung on
walls singly or in groups, inset in counters or tabletops, used to
outline fireplaces, or curved to form shallow bowls.

Madison's studio is filled with a variety of clay-making tools.
Sometimes she uses an extruder, which pushes clay through a
shaped die much like toothpaste is squeezed through the round
tube opening. She then cuts the
roll into thin slices, thereby
forming multiple tiles of the same
shape. She also sometimes uses a
slab roller which, like a giant
mechanical rolling pin, flattens a
slab of clay into a large sheet. Then
she cuts out tiles, either with a
knife or an oversized cookie-cutter.
Occasionally, in order to make
sculptural tiles like the one
featuring a man in the sun with
crinkly eyes and protruding nose,
she uses molds that she makes

PRICES
Flat bun warmers, $16;
custom murals, $300 per sq. ft.

LOCATION
Home studio; 10 minutes
north of Asheville

PHONE
704/258-9707

HOURS
Call first

PAYMENT
Personal checks

herself. "My idea comes first; then I figure out the technique.
Otherwise I'd be letting my method of making something limit
my ideas," Madison explains.

Madison also does commissions. She created a set of elegant

cabbage rose tiles to match a client's kitchen curtains, and some rough-hewn terra-cotta tiles for another person's bathroom. "I simply like variety," she explains. "The more unusual, the better."

A photograph of Madison's work appears on the back cover of this book.

CARVED FURNITURE
Kurt Nielsen

*H*eather and Lou are quite tall—for chairs, that is. The dashing young gent in a collared shirt and the ponytailed, well-endowed lass stand five feet tall. Whether they're welcoming folks in your entrance hall or serving as chairs around your dining table, one thing is certain: they'll make folks smile. "My furniture's meant to remind you to lighten up," says Kurt Nielsen.

When Kurt was in college he made straight, design-oriented work, but then he realized that he didn't have to be so serious. He learned that he could do quality work and still have fun. He made Dilbert, a duck who's harnessed to a bench upholstered in red silk. Then, because Dilbert needed a buddy, he made Mario, a mirror image. He expected the benches to sell to

PRICES
Small ladder-back chairs, $400+;
duck or penguin benches, $1,200;
set of 2 folk chairs, $3,000;
commissions accepted

LOCATION
Shop studio; 10 minutes
north of Asheville

ADDRESS & PHONE
111 Grovewood Rd., Studio 12
Asheville, NC 28804
704/251-1760

CATALOG
Send self-addressed, business-size
envelope with $.32 postage

HOURS
Call first

PAYMENT
Personal checks

upscale parents for their children's bedrooms, but instead they attracted decorators who placed the pieces in tony law offices and design firms.

Now Kurt makes a whole series of cartooned furniture which he paints in bright, vivid colors. He also makes antiqued creatures, such as his mythological horses that hold a glass tabletop. Some of his work, like the cabinet adorned with pelicans, is more serious.

MARBLED PAPER AND FABRIC
Laura Sims

H istorically, marbled paper featured controlled patterns with evenly distributed color and designs that were consistent from one end of the page to the other. This made the decorative paper a favorite of bookbinders. But, says Laura Sims, the marbling technique is very versatile. She was taught the traditional ways back in the early 1980s, and she still uses them on occasion. But now free-flowing, asymmetrical forms appeal to

PRICES
Mats for photos, $5+;
note cards and envelopes, $8;
silk scarves, $32+;
men's ties, $45; vests, $140+;
seconds sometimes available

LOCATION
Home studio; 3 minutes
north of Asheville

PHONE
704/255-8629

HOURS
Call first

PAYMENT
Personal checks

her more. She's inspired by the concentric forms of nature—a rippling pool, an aged tree trunk, a piece of stone.

Laura turns her marbled paper and fabric into a variety of items, from household decoratives like mats and frames to wearable art like vests and ties. In addition, she's written two books about marbling.

CANDLE LAMP POTTERY
Bob Wagar

*B*ob Wagar's studio is filled with light. Tiny flames are held by small angels—Uriel, whose name means "Fire of God," Raphael, called the "Healing Angel," and Israfel, known in Arabic folklore as "The Burning One." Fire also sparkles from candle lamps made in the shape of Indian chiefs, turtles, fish, and teapots, as well as from more standard globes, cubes, and pyramids. Bob is also planning to design a fire-spewing dragon lamp.

Of course, candle lamps aren't the only things he makes. A professional potter since the mid-1970s, he's also known for his biscuit basket (a creatively formed bowl-on-legs) and a variety of miniature

PRICES
Miniatures, $3;
standard candle lamps, $20–$30;
angel candle lamps, $30–$100;
seconds sometimes available

LOCATION
Home studio; north Asheville

ADDRESS & PHONE
82 Spooks Branch Rd.
Asheville, NC 28804
704/253-5515

CATALOG
Send self-addressed business-size
envelope with $.32 postage

HOURS
Mon.–Sat., 10 A.M.–4 P.M.

PAYMENT
Visa, MasterCard, personal checks

vases and jugs that are the correct size for American Girl dolls. His hand-cast porcelain pieces have a distinctive glaze, thanks to one of his "rock hound" friends, who finds mineral deposits up in the mountains. The friend has a machine that crushes the rocks into small particles which Bob mixes into his glazes; this causes his work to twinkle with iridescent flecks.

Each spring, Bob organizes a studio tour to benefit Eliada Home, an Asheville family shelter. "My motto," says Bob, "is that it's better to light one candle than to rage against the darkness."

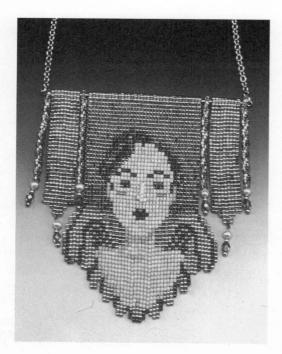

Carol Wilcox Wells,
beadwork purse

CONTEMPORARY BEADWORK

Carol Wilcox Wells

*W*hen beads took over Carol Wilcox Wells's life, she quit her job as a graphic artist and devoted herself full time to bead weaving. As she got busier and busier, husband Bob also quit his job. They then moved to North Carolina and set up shop in their home, but it didn't take long for the beads to take over the house. Now they have a studio/office that gives them space to run an all-purpose bead business.

Carol does as much off-loom bead weaving as she can, making elegant amulet purses, evening bags, barrettes, pendants, and brooches. She also creates bead baskets and vases which are woven so tightly and precisely that they stand on their own. Most are woven with 285 beads to the square inch.

Carol never repeats a design. "I've never wanted to be a production worker," she says, "and I never do two things alike. I don't even like to make earrings, because they come in pairs!" Carol has authored a book on bead weaving, teaches classes across the country, and sells kits that provide beads and easy-to-follow instructions. She and Bob also import beads from Japan and sell them to crafters across the country.

PRICES
Amulet purse kits, $40+;
brooches, $250; necklaces, $600;
large evening purses, $3,000

LOCATION
Studio; 2 minutes
north of Asheville

ADDRESS & PHONE
340 Merrimon Ave., Ste. B
Asheville, NC 28801
704/252-0274

CATALOG
Write to P.O. Box 8492,
Asheville, NC 28814 for catalog

HOURS
Call first

PAYMENT
Visa, MasterCard, personal checks

FOLK POTTERY

Rodney H. Leftwich

Rodney Leftwich is an expert on North Carolina pottery; he's been studying it and collecting it for more than twenty years. Now a folk potter in his own right, he's proud to carry on the tradition. He spends Wednesdays and Thursdays at Pisgah Forest Pottery, where he's reviving the cameo designs and crystalline glazes of W. B. Stephans, who opened the pottery in 1926. "Pisgah Forest is like a working museum," says Rodney. "Most of the buildings and equipment have been there for more than sixty years."

The rest of the week he's at his own studio, drawing on scenes from his mountain childhood to create his own style of pottery. Rodney first throws the vessel. Then, when it is partially dry, he sketches with an inkless pen and cuts out some of the negative spaces so that candlelight will be able to flicker through. After a bisque firing, he applies slip (liquid clay) prepared from local materials into the recessed lines. The result is a dark line drawing against a clay-colored jug.

PRICES
Cameo mugs, $25; cameo vases, $75–$200; candle lanterns, $75–$200; folk figures, $400–$900

LOCATION
Home studio: 10 minutes south of Asheville
Pisgah Forest Pottery: 20 minutes south of Asheville

ADDRESS & PHONE
Home studio: 720 Reed St., Asheville, NC 28803
704/274-4102
Pisgah Forest Pottery: Hwy. 191, Asheville, NC 28803
704/684-6663

HOURS
Home: call first
Pisgah Forest Pottery: May–Oct.: Mon.–Sat., 9 A.M.–5 P.M.

PAYMENT
Personal checks

Decorative Tiles
Diana Gillispie and Anne Alexander

*T*he logo of Asheville Tileworks, Diana Gillispie and Anne Alexander's studio, is a floating oak leaf. "This," says Diana, "symbolizes strength and resilience and the joy of life." Diana, who paints the tiles that Anne rolls and cuts, has a delightful loopy style. Her paintings are cheerful splashes of color casually outlined in black.

Diana begins by covering earthenware clay with an opaque white glaze. This provides a white surface that acts as a canvas for the bright decoration. Today this process is a full-fledged art form called Majolica, but it began as a way to make imitation porcelain. In the tenth century, people in the Middle East became intrigued by Chinese ceramics, but without white clay of their own, they were unable to duplicate it. They eventually came upon the idea of coating their earthenware with white. Over the years the technique spread throughout the Mediterranean. "It is from this European folk tradition that I derive inspiration for my work," says Diana.

PRICES
Flat decorated tiles, $15+; relief tiles, $22+; wrought iron tables with tile tops, $300; seconds sometimes available; custom work, $70+ per sq. ft.

LOCATION
Studio; 5 minutes west of Asheville

ADDRESS & PHONE
Asheville Tileworks
119 Roberts St.
Asheville, NC 28801
704/259-9050; 800/340-4591

BROCHURE
Write for flyer

HOURS
Call first

PAYMENT
Visa, MasterCard, personal checks

She and Anne focus on four- and six-inch square tiles, but they can make clay slabs in just about any shape imaginable. In addition to the decorative paint work, they also make relief tiles with three-dimensional patterns such as spirals, shells, and leaves. These are frequently used as borders in bathrooms, backsplashes in kitchens, or fireplace surrounds in living rooms and dens.

GEOMETRIC QUILTS
Lynne Harrill

Sometimes Lynne Harrill preplans her quilts, so she will know exactly how they will come out. She plugs different quilt squares into her computer and rotates the blocks until she finds exactly the right arrangement. But often she improvises as she goes. She sews a bit, hangs the squares on her design wall and, if she doesn't like what she sees, rearranges, adds other squares or colors, or experiments with different borders.

PRICES
Decorative quilts,
$100–$140 per sq. ft.

LOCATION
Home studio; 10 minutes
west of Asheville

PHONE
704/252-3775

HOURS
Call first

PAYMENT
Personal checks

That's how she came up with "Seasons of the Heart," a king-size quilt that's meant for the wall, not the bed. She began with small squares of color that represented the seasons. The quilt, she says, looked all right but it didn't "move" her; it wasn't exciting. So she began adding borders to each square, using the surrounding color as a metaphor for age. To the

Lynne Harrill, quilt

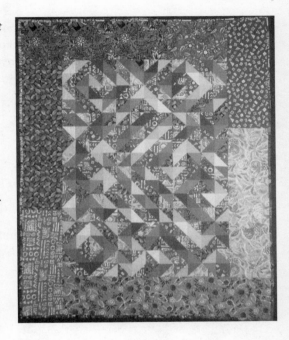

left, around the spring blocks, she added black borders to represent the turbulence and energy of youth. Moving two rows to the right she surrounded summer squares with gray and, further on, autumn blocks with a lighter gray. Then on the far right she boxed winter squares with pearly white borders to signify the serenity of age. She surrounded the entire quilt with another border, this one moving in opposition to the interior. The white rim on the left side gradually darkens as it moves to the right.

Some of her favorite quilts, the "Tacky Quilt" series, began as a way to use an assortment of "cheap, gaudy fabrics" that she'd collected. She decided that if she put them together—creating a bright, crazy assortment of color—that it just might work out. It did. Every one of her tacky quilts has won at least one award; some have won several.

By tweaking the traditional forms—varying the widths of her strips, setting interiors off-center, using color in inventive ways, adding metallic lace for accents—Lynne creates quilts that are surprising variations of an ancient art.

FUNCTIONAL PORCELAIN
Leah Leitson

*C*elebrations have always been important to Leah Leitson. As a child she loved to sit around the large dining room table, reveling in the tasteful serving pieces that were used on special occasions. Today, after years of training at ceramic schools across the country, Leah designs clay serving pieces to help others make their holidays special.

Working with porcelain clay which she throws, alters, and

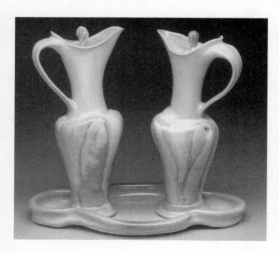

assembles, she produces items reminiscent of eighteenth- and nineteenth-century tableware. Her cruet set consists of two narrow pitchers resting on a rimmed tray shaped into scalloped lobes,

Leah Leitson,
cruet set with tray

while her creamers and sugar bowls are round and gently fluted.

Although she makes a wide variety of pieces, Leah is best known for her epergnes, derived from eighteenth-century centerpieces that consisted of a large central basket flanked by smaller vessels. Epergnes were traditionally used to hold fruit, but Leah prefers to make them into elaborate vases. Building from a globular base, she adds multiple smaller forms to create a shape that, like the flowers it is designed to hold, grows and branches in a way that is both organic and controlled.

PRICES
Mugs, $16+; cream pitcher and sugar bowl sets, $80+; cruet sets with tray, $125+; epergnes, $250+

LOCATION
Studio; 10 minutes west of Asheville

ADDRESS & PHONE
P.O. Box 6034
Asheville, NC 28816
704/252-2277

HOURS
Call first

PAYMENT
Personal checks

FORK AND SPOON ART
Robert Frito Seven

It's almost impossible to imagine Robert Frito Seven dressing up in a suit and marching off to work at a computer company. But that's exactly what he did in his former life. Then he was laid off—an event for which he fervently thanks God—and these days you're likely to find him at a craft fair, happily dressed in a Renaissance costume wearing a crown of forks (that holds a loaf of French bread and a banana) atop his head.

Robert is now a folk artist, drawing inspiration from outsiders like Howard Finster and St. EOM. He's rapidly becoming famous (he would say notorious), and counts Jimmy Buffett as one of his biggest fans.

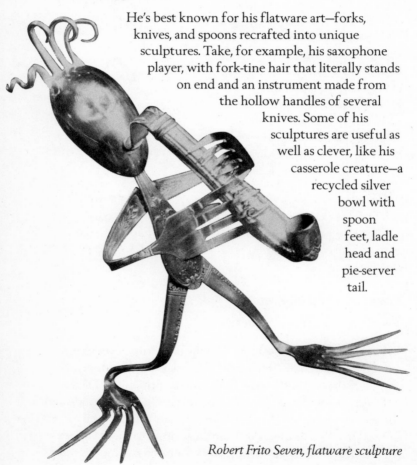

He's best known for his flatware art—forks, knives, and spoons recrafted into unique sculptures. Take, for example, his saxophone player, with fork-tine hair that literally stands on end and an instrument made from the hollow handles of several knives. Some of his sculptures are useful as well as clever, like his casserole creature—a recycled silver bowl with spoon feet, ladle head and pie-server tail.

Robert Frito Seven, flatware sculpture

While sizes vary according to available materials, this particular creature was nearly three-feet from ladle nose to server tail.

As a self-described "minister of creativity," Robert has also developed a line of "funky musical instruments with minimal learning curves." These include his "gourdjos" (string banjos made from gourds with flatware bridges), "thrums" (fun drums made from PVC pipe and featuring spoon cymbals, played with thumbs or chopsticks), "bobophones" (horns similar to Australian didjerdoos, made with PVC pipe and wash buckets), and cheesy dulcimers (made from a round cheese box with flatware ornamentation). While Robert intends to continue working with the flatware that has become his trademark, he's branching out into "flow works," a broad category which includes everything from paintings to clothing, from poetry to plays.

PRICES
Spoons, $15+; bobophones, $50+; thrums, $50+; gourdjos, $75+; musical characters, $90+; cheesy dulcimers, $100+; casserole creatures, $175+

LOCATION
Studio; 15 minutes west of Asheville

PHONE
704/667-1599

HOURS
Call first

PAYMENT
Personal checks

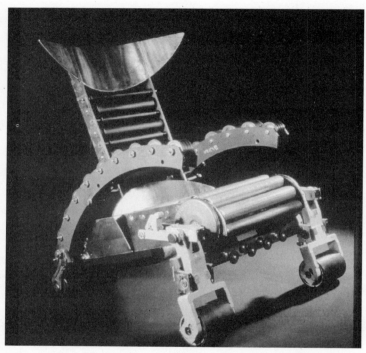

Cynthia Wynn and Noll Van Voorhis, industrial art chair

INDUSTRIAL ART FURNITURE
Cynthia Wynn and Noll Van Voorhis

Cynthia Wynn took her first metal class because she
wanted to make a kiln. She hated working with metal—it
wasn't at all creative, she thought—and finally ordered a ready-
made kiln so she could get on with her pottery. But first, just as a
joke, she decided to make a scrap-metal chair for her friend,

woodworker Noll Van Voorhis. But then Cynthia became obsessed with making more huge chairs. One day when she was working on her fifth one, she felt a strong gust of wind. "It was this incredible feeling," she says. "I just knew these chairs were going someplace and that if I just hung onto them, I'd go too."

The chairs did go someplace: they won her first place in a student art show; they were snatched up for exhibition at the Blue Spiral 1, one of Asheville's most prestigious galleries; and they were accepted into the Smithsonian's exhibition of crafts from the Southeast.

PRICES
Planters and lanterns, $50–$150;
small tables, $150–$450;
chairs, $750–$3,600;
lamps, $1200–$2,400

LOCATION
Studio; 5 minutes
southwest of Asheville

ADDRESS & PHONE
P.O. Box 1375
Asheville, NC 28802-1375
704/232-1090

HOURS
Call first

PAYMENT
Visa, MasterCard, personal checks

Noll found she also preferred making metal chairs to wooden ones, and the two women began scouring junkyards from Virginia to Florida, looking for unusual discards to recycle into furniture. A chair may have printing press rollers or scraper plates from an earth-moving machine for a back, conveyor belt rollers or safety flooring for a seat, hydraulic cylinders or large sprockets for legs, and plow parts for arms. Each piece is degreased, smoothed, altered, fabricated (welded, torch cut, ground), and lacquered until it becomes part of a new whole—a completely one-of-a-kind piece of industrial art furniture.

People are amazed, says Cynthia, that the chairs are so comfortable. Her dad and brother are both physical therapists, so she's learned to incorporate ergonomics into every design.

GALLERIES ·······························

DOWNTOWN ASHEVILLE
American Folk

From functional wood-fired pottery to folk carvings, this gallery
celebrates both contemporary and antique art and furniture.
- **Address:** 64 Biltmore Ave., Asheville, NC 28801
- **Phone:** 704/251-1904
- **Hours:** Mon.–Sat., 10 A.M.–6 P.M.; ,Sun., noon–5 P.M.

DOWNTOWN ASHEVILLE
Appalachian Craft Center

Traditional mountain crafts are the focus here, with a special
emphasis on pottery. One hundred artisans, 90 percent of whom
are from North Carolina, are represented.
- **Address:** 10 North Spruce St., Asheville, NC 28801
- **Phone:** 704/253-8499
- **Hours:** Mon.–Sat., 10 A.M.–5 P.M.

DOWNTOWN ASHEVILLE
Blue Spiral 1

This regional gallery features fine art, crafts, and folk art from
300 artisans, most of whom live in the Southeast, with special
exhibits every six to eight weeks.
- **Address:** 38 Biltmore Ave., Asheville, NC 28801
- **Phone:** 704/251-0202
- **Hours:** Mon.–Sat., 10 A.M.–5 P.M.
 May-Oct.: also open Sun., noon–5 P.M.

EAST ASHEVILLE
Allanstand / Folk Art Center

A wide variety of crafts, both traditional and contemporary, by members of the prestigious Southern Highland Craft Guild are shown here; members to the Guild are admitted from nine Appalachian states only after passing stringent jurying.

- **Location:** 15 minutes east of Asheville at Milepost 382 of Blue Ridge Pkwy.
- **Address:** Riceville Rd., Asheville, NC 28805
- **Phone:** 704/298-7928
- **Hours:** *Jan.–March:* daily, 9 A.M.–5 P.M.
 April–Dec.: daily, 9 A.M.–6 P.M.

EAST ASHEVILLE
Guild Crafts

This is an outlet for members of the Southern Highland Craft Guild, who live in the nine states that include the Appalachian range; a mix of contemporary and traditional work is shown.

- **Location:** 10 minutes east of downtown Asheville
- **Address:** 930 Tunnel Rd., Asheville, NC 28805
- **Phone:** 704/298-7903
- **Hours:** *Jan.–March:* Mon.–Sat., 10 A.M.–5 P.M.
 April–Dec.: Mon.–Sat., 9:30 A.M.–5:30 P.M.
 July-Dec.: also open Sun., noon–5 P.M.

NORTH ASHEVILLE
Gallery of the Mountains

A mix of contemporary and traditional crafts are shown; more than 200 artisans are featured, 50 percent of whom are from Southern Appalachia.

- **Location:** 10 minutes north of downtown Asheville in the Grove Park Inn
- **Address:** 290 Macon Ave., Asheville, NC 28804
- **Phone:** 704/254-2068
- **Hours:** Sun.–Tues., 9 A.M.–6 P.M.; Wed.–Sat., 9 A.M.–9 P.M.

NORTH ASHEVILLE
Grovewood Gallery

Contemporary pottery and jewelry take up the first floor of this gallery, while the second floor displays furniture. Seventy-five percent of the 300 crafters are from the mountain region.

- **Location:** 10 minutes north of downtown Asheville next door to the Grove Park Inn
- **Address:** 111 Grovewood Rd., Asheville, NC 28804
- **Phone:** 704/253-7651
- **Hours:** *Jan.–March:* Mon.–Sat., 10 A.M.–5 P.M. *April–Dec.:* Mon.–Sat., 10 A.M.–6 P.M.; Sun., 1 P.M.–5 P.M.

SOUTH ASHEVILLE
Bellagio

Features handmade wearable art, ranging from clothing to jewelry. The work of more than 250 artists, 10 percent of whom are from the mountain region, is represented.

- **Location:** 5 minutes south of downtown Asheville in Biltmore Village
- **Address:** 5 Biltmore Plaza, Asheville, NC 28803
- **Phone:** 704/277-8100
- **Hours:** Mon.–Sat., 10 A.M.–6 P.M.; Sun., noon–5 P.M.

SOUTH ASHEVILLE

New Morning Gallery

The more than 800 crafters featured here make functional "art for living"; a special room is devoted to North Carolina artisans.
- **Location:** 5 minutes south of downtown Asheville in Biltmore Village
- **Address:** 7 Boston Way, Asheville, NC 28803
- **Phone:** 704/274-2831
- **Hours:** Mon.–Sat., 10 A.M.–6 P.M.; Sun., noon–5 P.M.

SOUTH ASHEVILLE

Vitrium

A wide range of studio glass, from jewelry to large-scale sculptural pieces can be found here; more than half of the seventy artisans shown are from North Carolina.
- **Location:** 5 minutes south of downtown Asheville in Biltmore Village
- **Address:** 10 Lodge St., Asheville, NC 28803
- **Phone:** 704/274-9900
- **Hours:** Mon.–Sat., 10 A.M.–6 P.M.
 Thanksgiving–New Year's Day: daily, 1 P.M.–6 P.M.

Lodgings

The Grove Park Inn

Despite its size (510 rooms, five restaurants, four lounges or nightclubs, three boutiques, two swimming pools, nine tennis courts, an eighteen-hole golf course, and a fully equipped sports center), the Grove Park Inn has the feel of a warm, inviting lodge, which is exactly what Edwin Wiley Grove intended. On July 12, 1913, at a lavish dinner to mark the opening of the hotel, Grove made the following statement:

Rates
Mid-April–Dec.: $175–$225, double occupancy; *Jan.–mid-April:* $125–$155; some discounts and special packages available; open year-round

Location
5 minutes north of downtown Asheville

Address & Phone
290 Macon Ave.
Asheville, NC 28804
800/438-5800; 704/252-2711
Fax: 704/253-7053

Payment
Visa, MasterCard, Discover, American Express, personal checks

After a long mountain walk one evening, at the sunset hour, scarcely more than a year ago, I sat down here to rest, and while almost entranced by the panorama of these encircling mountains and a restful outlook upon green fields, the dream of an old-time inn came to me—an inn whose exterior, and interior as well, should present a homelike and wholesome simplicity, whose hospitable doors should ever be open wide, inviting the traveler to rest awhile, shut in from the busy world outside.

Grove was a pharmacist, inventor, and businessman; to make his dream come true, he enlisted the help of his son-in-law, Fred Seely, a newspaper editor turned architect. In just a little more than twelve months, the inn was

handbuilt of native granite boulders—hauled to the site first by mule and wagon, then by an "automobile train" (a Grove invention whereby a Packard truck pulled wagons laden with massive rocks). He outfitted his lodge with Roycroft fixtures and mission oak furniture, and the Grove Park Inn today has one of the largest collections of Arts and Crafts pieces.

Now on the National Register of Historic Places, the Grove Park Inn has hosted such notables as the Rockefellers, Henry Ford, Thomas Edison, F. Scott Fitzgerald, and eight American presidents.

The 142 rooms in the historic main inn are filled with original furniture, while the 202 rooms in the Sammons wing (opened in 1984) and the 166 rooms in the Vanderbilt wing (built in 1988) have top-notch reproductions. All have phones and televisions.

SOUTH ASHEVILLE
Cedar Crest Bed and Breakfast

In 1891, William E. Breese, a Confederate veteran and Charleston banker, built a nine-bedroom Queen Anne mansion graced with turrets and verandas on the outside and dark, ornate carvings around windows, doors, and fireplaces on the inside. The Breese home changed hands over the years, but fortunately no one ever painted over the moldings or surrounds. In 1984, Barbara and John McEwan purchased the home, removed thirteen layers of wallpaper, refinished the floors, and outfitted the rooms with quality antique pieces and window air conditioners. Then they opened the doors to paying guests.

One bedroom is located on the first floor, five on the second, and three on the third. A nearby cottage holds two suites, one with one bedroom, the other with two. Decor ranges from formal Victorian on the first two floors to country turn-of-the-century on the third floor to Arts and Crafts style in the cottage suites. All rooms have telephones; some also have televisions and VCRs. A full breakfast complete with homemade breads and rolls is served every morning; light refreshments are offered midafternoon and evening.

RATES
$115–$195, double occupancy;
includes full breakfast;
open year-round

LOCATION
2 minutes south of
downtown Asheville

ADDRESS & PHONE
674 Biltmore Ave.
Asheville, NC 28803
704/252-1389

PAYMENT
Visa, MasterCard, Diners Club,
Discover, American Express,
personal checks

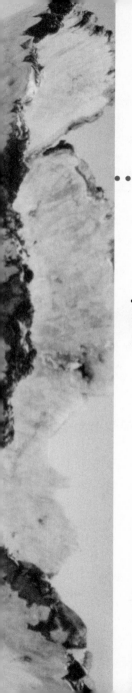

THE EASTERN HIGHLANDS

THE EASTERN HIGHLANDS

THE BLUE RIDGE PARKWAY CUTS through western North Carolina, starting at the Virginia-North Carolina border and ending at the edge of Great Smoky Mountains National Park. It forms the northern border of the Eastern Highlands, skirting past Reverend Billy Graham's hometown of Black Mountain as it heads toward Asheville. Black Mountain, which is just a mile from the Eastern Continental Divide, it a mecca for those who like antiques as well as crafts; Cherry Street and Sutton Avenue are especially good places to hunt for finds.

If you're in the mood for hiking, try Chimney Rock Park. The views are spectacular—keep an eye out for Hickory Nut Falls, which served as the backdrop for the climactic fight in the film *The Last of the Mohicans*. As the name suggests, this private park is located in Chimney Rock; call 704/625-9611 for details.

If wonderful views sound good but you're not in the mood for hiking, enjoy a leisurely boat ride on Lake Lure. Lake Lure Tours (704/625-0077) will introduce you to the lake that *National Geographic* called one of the most spectacular man-made lakes in the world.

BLACK MOUNTAIN

MIXED-MEDIA ART
Pei-Ling Becker and Rod Becker

*A*ccording to Chinese symbolism, a group of goldfish or cranes represents a happy family, two fish or cranes facing each other mean eternal love, and a Chinese coin stands for prosperity. By combining these images in her art, Pei-Ling Becker blesses her customers not only with a delightful piece of decorative art but also with a host of good wishes.

Pei-Ling has been in the United States since 1988, but she travels back to visit family in Taiwan every two or three years. She returns laden with materials: natural rice paper, antique Chinese buttons and coins, pieces of Chinese jade, thin sheets of cork, and olive pits carved to look like faces. She combines these materials to make exotic wall pieces, some featuring origami figures mounted atop a torn-paper collage of hand-dyed rice paper; other pieces contain a wider variety of materials. Her large temples often contain rice paper, bamboo, gold wire, coins, and Buddhist scripts, all of which are symbols of happiness, good fortune, and longevity.

Rod Becker, who met Pei-Ling in Taiwan while studying Chinese history, is her partner in both life and work. He mats and frames Pei-Ling's assemblages—no easy task, since many of them require frames that are several inches thick.

PRICES
Origami and Chinese knot jewelry, $20–$45; wall pieces, $100–$2,000

LOCATION
Studio; downtown Black Mountain

PHONE
704/669-9573

HOURS
Call first

PAYMENT
Visa, MasterCard

TURNED-WOOD VESSELS
Eddie Hollifield and Marshall Hollifield

A large mural on the side of the building says it all: two men—one elderly, the other much younger—are absorbed in their work, turning large pieces of wood on a lathe. The mural is bright and inviting; it makes you want to approach and learn more. That's just what Eddie and Marshall Hollifield want you to do. Their workshop has an oversized garage door which is almost always open. Several benches sit in the front of the workshop, where visitors can view the lathe and the wood vessels in various stages of completion.

PRICES
Small bowls, $15;
large designer vessels, $3,000;
individual or small group
instruction, $125 per day

LOCATION
Shop studio; downtown
Black Mountain

ADDRESS & PHONE
112 Cherry St.
Black Mountain, NC 28711
704/669-2450

HOURS
Mon.–Sat., 10 A.M.–5 P.M.;
Sun., 1 P.M.–5 P.M.

PAYMENT
Visa, MasterCard,
Discover, personal checks

Eddie and his father Marshall generally work with maple burls, which are native to the area. (A burl, explains Eddie, is a growth on the outside of the tree, caused by fungus or injury. Because of its growth pattern, it is more visually interesting and less likely to crack than an ordinary piece of wood.) Marshall likes to combine large, flat areas with rounded bowls, often ending up with pieces that resemble stylized cowboy hats turned upside-down. Eddie specializes in smooth, rounded pieces, sometimes making "two-story" affairs, where the bottom of one bowl opens to become the top of another.

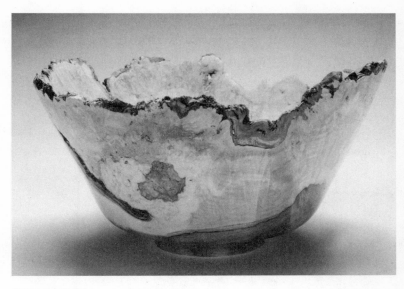

Eddie Hollifield, turned-wood vessel

Although they've sold their work in galleries across the United States, they're happier just supplying their own shop, which is adjacent to their workshop. "When you sell though other galleries, it's a cold feeling," says Eddie. "Here we get to meet the people, and that makes all the difference."

STONEWARE POTTERY AND ART DOLLS
Floyd Kemp and Lori Kemp

*S*ince moving to North Carolina from Michigan in 1991, Floyd Kemp has become a full-time potter, a welcome change from previous years when his craft had to take a back seat to his job as a college art instructor. His work, which encompasses nearly fifty items ranging from small spoon rests to large lamp bases, is distinguished by its surface decoration. Floyd

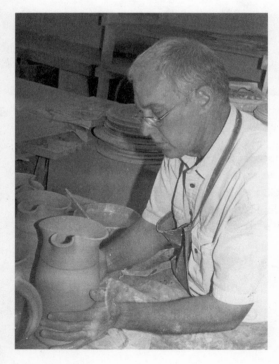

*Floyd Kemp
in his studio*

specializes in abstract designs that often combine shades of five or more colors. He decorates over the glaze, brushing accent colors where his first glazes meet, sometimes adding stamped decorations as well. Floyd sells his work at galleries throughout the Southeast, but especially at his wife's shop, Vern & Idy's, which is adjacent to their home.

Also available at Vern & Idy's are Lori Kemp's clay and fiber dolls; in fact, Lori creates most of her dolls in the studio at the back of the shop. Lori began sewing when she was a child. "I made clothes for dolls, but I never played with dolls," she says. "They were just mannequins for me." Her first "serious" dolls were made entirely from fabric, but then she discovered polymer clay and her doll faces became even more expressive, more individual. Now each doll is an original, never-to-be-duplicated little person like "Violet," who wears a navy dress with white polka dots, a fur coat, a red handbag, seamed hose, and red sandals.

PRICES
Floyd: Mugs, $14; lidded casseroles, $48; large vases, $70–$140
Lori: Most dolls, $270+;
4'-tall handwoven doll, $1,200

LOCATION
Floyd: Home studio
Lori: Shop studio; both 2 minutes west of Black Mountain

ADDRESS & PHONE
Floyd: 418 W. State St.
Black Mountain, NC 28711
704/669-6094
Lori: Vern & Idy's, 414 W. State St.
Black Mountain, NC 28711
704/669-2370

HOURS
Floyd: Call first
Vern & Idy's: Tues.–Sat., noon–5 P.M.

PAYMENT
Visa, MasterCard,
Discover, personal checks

COPPER SCULPTURE
Walter Massey

Walter Massey always knew he wanted to be an artist. As a youngster, when others were reading about Superman and Batman, he was reading about Leonardo da Vinci and Michaelangelo. Today, the sculpture that pleases him most is his nine-foot replica of David.

But most of the time Walter, who finally selected copper as his preferred medium, creates pieces he's designed himself. "The way I work is a lot like dressmaking," he says. He begins each design by drawing a paper pattern. Then, using this as a guide, he cuts shapes from flat pieces of copper, making strategic slits that allow him to bend the metal. He welds numerous small forms together to make a finished piece.

His fountains are graceful arrangements of flowers—usually hibiscus, bamboo, or dogwood—with water cascading over the blossoms and leaves. His weather vanes—eagles, pelicans, gulls, and ospreys—are made to stand in the ground or perch on a roof. And his multipronged chandeliers come in a variety of designs. "Each piece is one of a kind," he says. "The pattern is just a jumping-off place."

PRICES
Hummingbird ornaments, $25; fountains and chandeliers, $280+; weather vanes, $500+; large sculptures, $1,200+; commissions accepted

LOCATION
Home studio; 2 minutes north of Black Mountain

ADDRESS & PHONE
108 W. Cotton Ave.
Black Mountain, NC 28711
704/669-2162

HOURS
Call first

PAYMENT
Personal checks

NATURE CRAFTS
Jan Morris

*J*an Morris opens her scrapbook and points to a newspaper photo of Bill and Hillary Clinton. They're sitting in front of the White House Christmas tree—and directly above the president's right shoulder is one of Jan's cornhusk angels.

Jan works with pinecones, seeds, nuts, cornhusks, wheat—almost anything natural. She began in 1972 when the pinecones she'd gathered on hikes with her family threatened to overtake her garage. She learned to slice the cone in half and snip off the outer scales until she revealed the blossom shape hidden in the core. "Mother Nature puts it there for you to find," she says. "All you have to do is peek in there and say, 'Ah!'" Now she works with all kinds of cones, seeds and nuts, whittling them into shape, adding leaves and stems, arranging them into spirals and clusters and wreaths.

Jan's cornhusk dolls are made in the time-honored Appalachian way, without wire and using twisted cornhusks to stiffen the arms. Wheat weaving, the latest addition to her repertoire of nature crafts, results in a variety of delicate ornaments and decorations, many based on designs from other countries.

PRICES
Small pinecone corsages, $5; cornhusk dolls, $21–$48; large wheat-woven wall decorations, $60; large pinecone wreaths, $125

LOCATION
Home studio; 5 minutes northwest of Black Mountain

PHONE
704/669-6320

HOURS
Call first

PAYMENT
Personal checks

ETCHINGS AND ENGRAVINGS
Jay Pfeil

*J*ay Pfeil makes a highly complex process look simple. She begins by spreading a thin layer of "ground" (a special compound with a wax-and-tar consistency) over a zinc plate, then covering it with a piece of paper. Then, using a hard lead pencil and pressing firmly, she draws an image—perhaps a forest of aspens—on the paper. As she draws, the ground adheres to the underside of the paper in the places where the pencil has pressed. When she removes the paper, the picture appears on the plate as clean, "ground-less" lines amidst the surrounding compound.

Next, she bathes the plate with an acid which eats away the uncovered areas, leaving her design reproduced on the plate in recessed lines. She repeats this process two or three times, making slightly different plates, one for each color that she wants to include in the final print. Later, she inks the plate and wipes away the excess, leaving ink in the recessed areas. During the printing process the image is transferred to a fresh sheet of paper. As she rolls the paper through the press time after time, the plates with their different inks in different spots create a variety of colors, blending in areas where two inked plates print in the same place.

PRICES
Small single-plate prints with mats, $30+; midsize multiple-plate prints with mats, $120+; large multiple-plate prints with mats, $235+; seconds sometimes available

LOCATION
Home studio; 3 minutes south of Black Mountain

PHONE
704/669-5050

HOURS
Call first

PAYMENT
Personal checks

Most of Jay's prints are inspired by nature and include a variety of plants and flowers native to North Carolina; others are fantasy scenes complete with nymphs and sprites. She usually makes a maximum of ninety-five individually printed copies of each design, signing and numbering each one. Several of her prints were included in the Smithsonian display of Southern artists at the 1996 Olympics.

Jay Pfeil, engraving

COLUMBUS ••••••••••••••••••••••••••••

PORCELAIN POTTERY AND JEWELRY
Doug Dacey and Karen Dacey

*B*ack in the early 1970s, Doug Dacey was studying marine biology and working part-time in construction. Then a forklift ran over his foot. "Maybe this will give you something to do while you're laid up," said his wife Karen, handing him some clay from a class she was taking.

Doug has been playing with clay ever since, first earning a bachelor's degree in fine arts, then a master's degree. "I got caught up in the energy of it," he says. "And it was easy for me. Somehow the very first pot I threw turned out right."

For a while he worked with stoneware, but a few years ago he switched to porcelain. "That gives me a whiter surface, lets me use a more vibrant palette," he explains. He favors vivid blues—occasionally mixed with softer greens and pinks—for his dinnerware, vases, and lamps.

Karen's work is as delicate as Doug's is bold. Although she occasionally works with her husband on some of his functional pieces, her forte is jewelry. She makes a wide variety of pins and earrings, some beaded, some in the shapes of animals or angels.

•••••••••••••••••••
PRICES
Karen: jewelry $12–$35
Doug: mugs, $20+;
sculptured bowls, $250+;
seconds sometimes available

LOCATION
Home studio; 15 minutes
south of Columbus

PHONE
704/863-4466

HOURS
Call first; closed Jan.–Feb.

PAYMENT
Personal checks
••••••••••••••••••

WOOD BIRD CARVINGS
Lee M. Fairchild

*T*he tables in Lee Fairchild's home are covered with birds: songbirds, game birds, water birds, birds of prey—all sorts of birds. They look so lifelike that you want to touch their feathers—even though you know they're made of wood.

Lee Fairchild took up carving in 1979 because he knew retirement was fast approaching and he wanted a hobby to keep him busy. He took to it like a duck takes to water. By the time he actually retired and moved from Michigan to North Carolina, he was already a proficient and prolific carver.

But not all of his time is spent with knife in hand. He's a dedicated researcher, studying birds in the woods around his home, at a nearby nature center, and in books and photos. Most, though not all, of his carvings are of birds that live in or pass through North Carolina.

His work, painstakingly painted with acrylic and carefully mounted amid branches and leaves, is so good that it regularly captures awards at carving competitions and has been featured in both birding and carving magazines.

PRICES
$350–$1,500

LOCATION
Home studio; 5 minutes
south of Columbus

PHONE
704/894-3895

HOURS
Call first; no Sunday appointments

PAYMENT
Zoning restrictions prohibit Lee
from selling from his home.
He will talk with prospective
buyers, show them his studio, and
direct them to the nearby galleries
that handle his work.

FOLK POTTERY
Claude Graves and Elaine Graves

"*I* want to capture North Carolina in clay and glaze," says Claude Graves. He does exactly that by turning out utilitarian stoneware and salt-fired pieces that feature the horses, rabbits, leaves, and flowers that he can see from his window.

Claude and his wife Elaine, who specializes in sculptural figures, traveled around the world for a year in the 1960s. They studied folk pottery wherever they went, then, at year's end, settled on a piece of land just a few miles from the North Carolina–South Carolina border. In a wonderfully weathered gray shed that dates back to Gold Rush days, they set up a combination studio and shop called Little Mountain Pottery.

PRICES
Small bowls, $7;
large sculptural figurines, $150

LOCATION
Shop studio; 10 minutes
southeast of Columbus

ADDRESS & PHONE
Little Mountain Pottery
Peniel Rd., Rt. 2, Box 60
Tryon, NC 28782
704/894-8091

HOURS
Mon.–Sat., 10 A.M.–4 P.M.;
at other times, call first

PAYMENT
Visa, MasterCard, personal checks

Every year on the second full weekend in October they hold a kiln-opening party where they invite other area artists to show their work. Claude's functional pieces are featured on Saturday, Elaine's whimsical figurines on Sunday.

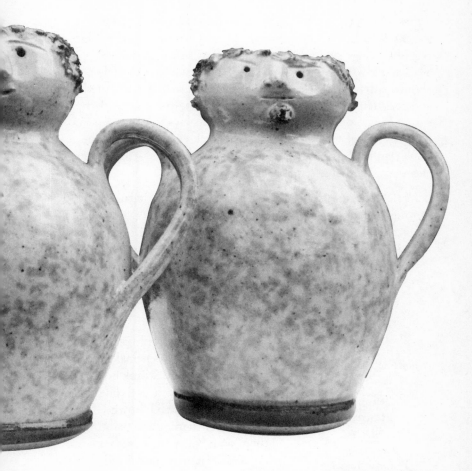

Elaine Graves, folk pottery

WOOD FOLK CARVINGS
B. J. Precourt

B. J. Precourt is a storyteller as well as a folk artist. "I'd like to tell you about my fish-man," he says, pointing to one of his recent carvings, a salmon-and-blue-colored fish with movable arms and legs. His eyes sparkle as he launches into a long tale about a fish who leaves his river home because it's too polluted and goes to live among the world of people. Ultimately the fish convinces a retired gentleman—a man who, says B. J., "just happens to look exactly like me, with thick white hair and blue jeans, flannel shirt, vest, and bandanna neckerchief"—to help him clean up all the rivers and streams and oceans.

B. J.'s rich imagination leads to other unique and fanciful carvings. There's a whimsical wall hanging of a fish with a cat's head called a Southern catfish. A five-foot-tall bay laurel branch has been turned into a lanky Uncle Sam. There are carvings of cows-on-wheels with farm boys perched on top, of turtles and skunks with hidden drawers, and of moonshine-makin' mountain men.

PRICES
$35–$500

LOCATION
Home studio; 15 minutes
north of Columbus

PHONE
704/894-3910

HOURS
Call first

PAYMENT
Personal checks

B. J. cares about each of his figures; they're almost like personal friends. "I don't dare think how much time I put into each one," he says. He's developed his own method for staining and painting them, an involved process that gives each figure a special, old-fashioned patina.

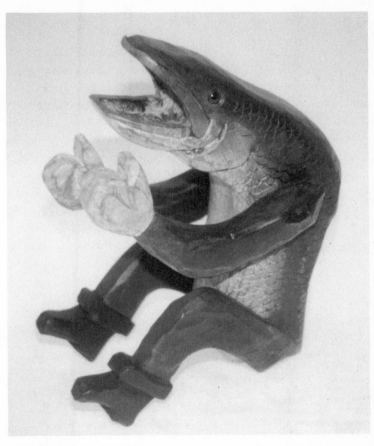

B. J. Precourt, wood carving

FAIRVIEW

FIGURATIVE POTTERY
Nels Arnold

A t first Nels Arnold thought of devoting herself to dance and theater, but four children changed all that. "I couldn't leave home a lot," she says, "so I turned to pottery, which I could do right there." It was a happy change, as evidenced by the joyful drawings that decorate many of her vases and wall platters.

After throwing a tall, swelled vase, Nels lets the clay dry until it's leather hard. Then she covers it with cobalt slip (liquid clay) and begins drawing children—eight youngsters playing follow-the-leader on one pot, ten tots climbing on a jungle gym on another. She carves away the background, leaving a merry picture in blue against a background of white, a folk-art rendition of simpler times.

Of course, not all of her work is blue-on-white, and not all of it involves children. She's also fascinated with cats, cows, wood nymphs, "gar-gals" (female gargoyles), and masks. These images—often drawn or carved into the clay but sometimes rendered in a more sculptured form—adorn her work. But years of parenting coupled with teaching art and drama in the schools have left their imprint on Nels: even her gargoyles and masks have a child-friendly flair.

PRICES
Plant holders, $24+;
figurative vases, $85+;
wall platters, $125;
seconds sometimes available

LOCATION
Home studio; 10 minutes
south of Fairview

PHONE
704/628-1622

HOURS
Call first

PAYMENT
Personal checks

SCULPTURED POTTERY AND PAINTING

Veryle Lynn Cox

*V*eryle Lynn Cox was chair of a high school art department; her husband, Blaine, was a stressed-out executive. One day, Blaine asked, "What would you like in a house?" "Peace," said Veryle. "I want peace." Within a year, both had quit their jobs and moved from Chicago to a cliffside home above Lake Lure, selected by *National Geographic* as one of the ten most spectacular man-made lakes in the world. Now Veryle, who was trained as a painter and studied at the Royal Academy of Fine Arts in Belgium, has time "to take my art as far as it can go."

Her work is rich with classically inspired human sculpture, especially serene female faces surrounded by flowing hair. She uses these headpieces to decorate her vessels, letting them serve as handles, knobs, rims, and feet.

Sometimes Veryle combines painting and sculpture in a single arrangement—a wall painting echoed by sculpted figures that sit on a shelf near the picture's bottom edge. One such arrangement features a sculpted family group standing on a black shelf. The picture behind it depicts a mirror with the reflected image of both the family and the room beyond. It's a complex construction, filled with shifting layers of meaning.

PRICES
Bowls, $30+;
classic head vases, $125+; sculptures
with background paintings, $2,000

LOCATION
Home studio; 30 minutes
south of Fairview or
5 minutes east of Lake Lure

PHONE
704/625-1256

HOURS
Call first

PAYMENT
Personal checks

CONTEMPORARY TURNED-WOOD VESSELS
Norman W. Earle

Norman Earle loves to travel. Armed with sketchbook and camera, he peruses the museums, galleries, and fairs of other countries, often coming home with new ideas which he incorporates into his own turned-wood vessels. When he was in New Zealand, for example, he saw a piece of pottery that was held upright by a sculptured tripod. Later, after much

Norman W. Earle, turned-wood vase with stand

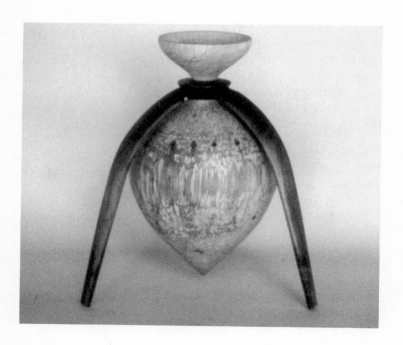

experimentation, he developed his signature piece in which a vase is held aloft by a three-legged stand made from wood of contrasting color.

Despite the influence of other cultures, Norm's work is uniquely his own. Using local woods—often gathered from his own property that overlooks Hickory Nut Gorge—he "formalizes" his designs, using wood from the interior of the tree and avoiding the rough bark that gives uneven edges. He frequently combines woods of different colors, as in one bowl of dark wood adorned with a series of inlaid circles of light-toned wood.

PRICES
Coin dishes, $20+;
small narrow-necked vases, $35+;
midsize vases, $150+;
large pieces with stands, $600+

LOCATION
Home studio; 15 minutes
southeast of central Fairview

PHONE
704/628-1236

HOURS
Call first

PAYMENT
Personal checks

RANDOM WEAVE BASKETS
Carla Filippelli and Greg Filippelli

*C*arla and Greg Filippelli used to make traditional Appalachian baskets. Then their palette exploded and their designs became less constrained. Now their work—often asymmetrical, always colorful and contemporary—has evolved into something totally original and highly sophisticated.

Carla and Greg weave their baskets from two types of rattan, both milled in Indonesia. First they dye the rattan, then, using wet, round reeds, they form a rim of predetermined size and,

improvising as they go, circle the reed round and round, over and under until they've formed the general shape of the basket. The reeds dry within a half hour, providing a stable form for the rest of the weaving. Next, choosing their colors carefully, they take flat reeds and fill in the spaces, weaving random patterns of verticals, horizontals, and diagonals that in lesser hands would look tangled, but in the Filippellis's hands become art. Finally, again using the round reed, they fill in the smaller spaces, sometimes adding accents of metal or leather.

Although each piece is completely original, Carla and Greg have nine basic shapes—some that sit on the floor ("a catchall for newspapers or shawls, a home for the cat," says Carla), some that sit on tables, others that hang on the wall. They use four basic color schemes: jewel tones of jade, sapphire, amethyst, and ruby; pastels of peach, aqua, lavender, and periwinkle; beach tones of sand, blue, and teal; earth tones of rust, tan, and green. The Filippelli baskets are featured at Pennsylvania House furniture galleries and owned by celebrity collectors including film director Peter Bogdanovich.

PRICES
Small bowls, $35; medium vessels, $130; extra large platters, $350; custom orders accepted

LOCATION
Home studio; 5 minutes west of Fairview

PHONE
704/628-2177

HOURS
Call first

PAYMENT
Personal checks

MINIATURE WOOD VESSELS
Jim McPhail

*J*im McPhail works small. His largest wooden vessel is less than four inches tall; his tiniest, a mere half-inch tall. Yet these vessels are every bit as complex as items many times their size. Jim spends almost as much time designing his tiny vessels as he does making them, using a palette of sixty woods to get the colors exactly right.

He begins by stacking his woods in the proper order. A midsize bowl (about two inches high) usually requires eight to twelve pieces of wood. One palm-sized dish, for example, had nine: a half-inch thick piece of sienna mesquite on the bottom, topped by a thin veneer of white holly, a slightly

*Jim McPhail
in his studio*

thicker piece of dark kingwood, a veneer of ochre yew, a defining midstrip of purple heart, and a reverse pattern of yew, kingwood, holly, and mesquite. Jim carefully glues these together and then turns his vessel on the lathe. He figures that the actually turning takes less than a third of his time; the designing, gluing, and finishing takes the rest.

Jim and his wife Pat, who helps finish the layered wood barrettes and crosses which Jim makes as a sideline, live atop a cliff that's as tall as his vessels are small. Most—but not all—of the road is paved, and Jim advises folks without a four-wheel drive to park at the top of the driveway and walk the short distance to the house.

PRICES
Layered barrettes
and crosses, $15–$18;
miniature vessels, $15–$65

LOCATION
Home studio; 10 minutes
north of Fairview

E-MAIL
McWood@aol.com

PHONE
704/628-0031

HOURS
Call first

PAYMENT
Personal checks

PAINTINGS ON CLAY AND PAPYRUS
Scott Rayl

*S*ome of Scott Rayl's paintings are done on clay tablets, others on papyrus or bark cloth. Why? Because surfaces that date back to antiquity seem right for paintings that combine anthropology and faith, biblical stories and Meso-American myths, Egyptian art and Chinese lettering.

Scott is well versed in both his subject matter and technique. As a student he studied ancient cultures as well as painting and ceramics, and as a Christian he knows biblical history and text. "I mentally place myself in the age and location of a particular ancient culture and then explore how I would express my faith and understanding of scripture using that culture's artistic imagery," explains Scott.

One of his paintings, for example, uses the colors, styles, clothing, and games of Mayan culture to tell the story of David and Goliath. While David still aims his slingshot, the confrontation takes place in a Mayan ball court, where ancient Indians used to play life-and-death games of kickball. Other paintings are more straight-forward, as when he uses Egyptian styles to recount the story of the Exodus.

Although Scott occasionally makes pictorial bowls, most of his work is done on slabs of clay painted with slips and underglazes, or on papyrus painted with gouache.

PRICES
Paintings on papyrus or bark cloth, $125–$500; paintings on clay shards, $125–$1,000

LOCATION
Home studio; 10 minutes north of Fairview

ADDRESS & PHONE
117 Chinquapin Tr.
Fairview, NC 28730
704/628-2946

BROCHURE
Send self-addressed business-size envelope with $.55 postage

HOURS
Call first

PAYMENT
Personal checks

MARION .

CUSTOM WOOD FURNITURE
Harry J. Burnette

arry Burnette is a craftsman's craftsman. Chairmakers Arval and Max Woody (both profiled in this book) regularly tell their customers to go to Harry if they want one of the best tables in the mountains. After all, Harry's been making tables since about 1964. He long ago lost count of just how many he's made.

Harry used to be a carpenter. One day when he was out of work, he began "piddlin' around" in his grandfather's cabinet shop. He made a piece or two that sold immediately, and started getting orders for more. He began studying how better furniture was put together, moved into a shop next door to Max Woody, and started putting his finished pieces out on the road. People stopped, bought, and passed his name on to their friends. Now Harry, who has moved his shop to an outbuilding on his own property, does only custom work and is usually backlogged six to nine months. "But people who've seen my work are usually willing to wait to get what they want," he says. "Then they'll be happy living with it for the rest of their life."

Harry makes all sorts of furniture—corner cabinets, hutches, gun cabinets, beds—but tables are his mainstay. Customers choose

.
PRICES
48" round pedestal tables, $600+;
42" x 76" gateleg tables, $900+

LOCATION
Home studio; 10 minutes
north of Marion

PHONE
704/756-4389

HOURS
Call first

PAYMENT
Personal checks
.

their wood (walnut, cherry, oak, maple, mahogany, ash, wormy chestnut, butternut, or white pine), size, and style. Harry has several basic legs—from Shaker-plain to Queen Anne-fancy—and also makes pedestal, gateleg, and trestle tables. Many of his tops are solid, others are extension or dropleaf, and some have drawers. "I can make pretty much whatever people want," he says.

A photograph of Harry in his studio appears on the back cover of this book.

PAINTED GEMSTONE JEWELRY
Bonnie Childers

*B*onnie Childers's work is unusual, charming, and extremely delicate. She paints miniature pictures on gemstones, banding them with twelve-karat gold or sterling silver so they can be worn as earrings, pins, or pendants. A hummingbird hovers by a branch of flowers on an oval stone smaller than your smallest fingernail, while a field of sunflowers is depicted in meticulous detail on another. On slightly

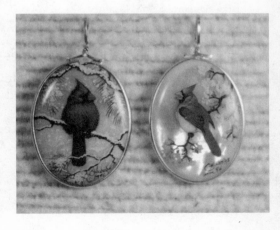

Bonnie Childers, painted gemstone earrings

larger pieces—about one inch wide by one-and-a-half inches long—she paints tigers, wolves, or maybe horses grazing in a white-fenced field, all stunningly realistic.

In the early 1980s, Bonnie, who graduated college with a degree in fine arts, was painting more traditionally sized pictures to hang on walls. Each picture was so filled with detail that it took her two or three months to complete a single one. Then she and her husband went to a gem festival where Bonnie saw a small stone with a picture printed on it, and an idea began forming. Why not paint directly on the stone, making each piece a hand-painted original?

It took three years of experimentation to perfect her technique. She quickly learned to reformulate her watercolors so they would stick to the surface of the stone and when to use acrylics. But she had trouble finding a coating that would protect the paint yet not be so brittle and hard that it would crack. She now has a "secret formula" that makes each piece both durable and bright.

Most of Bonnie's paintings— flowers, birds, wildlife, and occasionally humans—are done on mother-of-pearl, onyx, quartz, agate, lapis, or amethyst.

• • • • • • • • • • • • • • • • •

PRICES
Small pendants, $15–25;
medium pendants, $20–$74;
earrings, $30–$50;
large pendants, $35–$145

LOCATION
Home studio; 20 minutes
north of Marion

PHONE
704/756-4412

HOURS
Call first

PAYMENT
Personal checks

• • • • • • • • • • • • • • • •

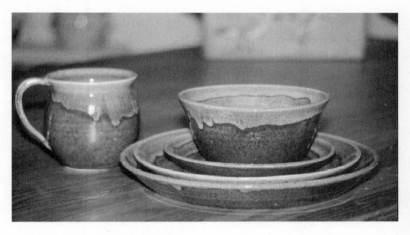

John Garrou, pottery place setting

FOLK POTTERY
John Garrou, Becky Garrou, and Derrick Garrou

On Monday and Wednesday mornings, John Garrou sits down at the wheel and begins throwing pots. "Other people hate Mondays," says John, "but it's my favorite day of the week."

John didn't much enjoy Mondays back in the early 1970s when he was a county tax assessor. After visiting a buddy who was taking pottery lessons and "playing with his wheel," John knew he had to change professions. He met master potter E. J. Brown, who comes from one of North Carolina's oldest families of "turners and burners" (the traditional name for folk potters) and

set out to learn his craft. "E. J. Brown taught me things that it would have taken me years to learn on my own," says John.

Now with the help of his wife, Becky, and son, Derrick, John makes one of the largest varieties of functional pottery to be found anywhere in the mountains. From candlesticks to dinnerware sets, from apple bakers to large pitchers, his work is folk pottery at its best: sturdy and simple yet graceful and attractive.

• • • • • • • • • • • • • • •

PRICES
Mugs, $10; casseroles, $25+;
five-piece place settings (mug, bowl, three sizes of plates), $50

LOCATION
Store workshop;
10 minutes east of Old Fort or
10 minutes west of Marion

ADDRESS & PHONE
Rt. 1, Box 222-C
Old Fort, NC 28762
704/724-4083

HOURS
Mon.–Fri., 10 A.M.–5:30 P.M.;
Sat., 10 A.M.–4 P.M.

PAYMENT
Visa, MasterCard, personal checks

• • • • • • • • • • • • • • • •

WOOD SCULPTURE
Glenn Nilsen

O ne look at Glenn Nilsen's wood sculptures tells you that he's spent a lot of time around wild animals. The details that find their way into his work cannot be learned from books.

Glenn grew up on a small farm in northeastern Minnesota, not far from the Canadian border. As a child, he saw moose walk up to his door and bear and wolves roaming the forest. When he got older he hunted the animals for food. Now, living in a wooded

area of western North Carolina, Glenn recreates those animals down to each swirl of hair and tuft of fur.

He begins by making a wire armature and applying wax until he gets an approximation of the finished piece. Then, after cutting a rough wooden shape with a band saw, he uses ever-smaller hand tools to shape the figure, finally working with tiny dental burrs and small wood-burning tools. He paints his carvings with thin coats of acrylic paint, letting the wood show through in places to create subtle shading. Then he mounts the piece on a realistic base, complete with carved underbrush, logs, and dirt.

His northern animals—elk, bison, wolves, moose, bear, and caribou— are often placed in scenes, with or without people. An Indian on horseback, for example, spears a bison in one piece; two elk are locked in battle in another. One of his favorite creations—a young girl riding bareback, hanging onto the mane of a racing black horse—was inspired by a conversation with his daughter, who had just finished reading *Little House on the Prairie.*

PRICES
Small pieces with 1 figure, $100+; large pieces with multiple figures, $2,500+; commissions accepted

LOCATION
Home studio; 15 minutes southeast of Old Fort

PHONE
704/668-9248

HOURS
Call first

PAYMENT
Visa, MasterCard, personal checks

TRADITIONAL CHAIRS
Max Woody

" *I*'m not sure if I've ever sold a chair to someone from North Dakota," says Max Woody, rubbing his salt-and-pepper beard and hitching up his trademark denim overalls. "But I've got one in at least eight or ten foreign countries."

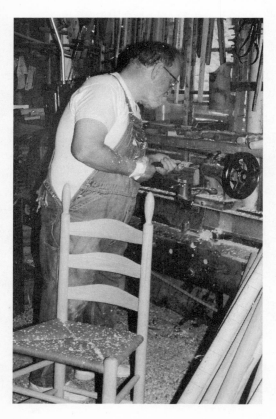

Max's chairs are special. Although all are wooden straight-backs with woven fiber rush seats, each one is custom-made to fit the individual customer. Are you tall and narrow, or short and wide? How high do you want the seat, the back, and the arms? What wood do you prefer: cherry, maple, walnut, oak, ash, or pine? What shape would you like for the back slats and posts? If

*Max Woody
in his studio*

you have an idea of your own, Max will help you with that too.

Max is a sixth generation chair-maker. On his father's side, the men made chairs for other people. On his mother's, they made them for themselves because, says Max, "back then, you either built it, grew it, or did without it." Max learned mostly from his grandfather, because his dad died when he was fifteen.

Max set up a chair shop in 1950, and has been engaged at the family craft ever since. He doesn't do things exactly the way his great-great-grandfather did; he's made a few concessions to technology. For example, instead of smoothing the wood by scraping it with glass, he uses sandpaper. And while he uses muscle-power to run many of his machines, some of which are over a hundred years old, he uses electric-power for others. But each chair is air-dried and "contains no metal at all—no nails, no tacks, no brads." Instead, Max uses wood pegs to ensure a tight fit.

There's a two-year wait for a Woody chair, but he guarantees them unconditionally—even against changing tastes. "We don't ask for a deposit and, when you get them, if you don't like them, you don't have to take them. If you get tired of them, we'll buy them back for what you paid for them, and if they break, we'll repair them free or make you a new one. In forty-six years, I've only had to fix nine chairs. Now that's not too bad, is it?"

Prices
Armless chairs, $175+;
rockers, $275+

Location
Store workshop; 10 minutes
east of central Old Fort,
or 5 miles west of Marion

Address & Phone
Hwy. 70
704/724-4158

Hours
Mon.–Fri., 8:30 A.M.–4:30 P.M.;
Sat., 8:30 A.M.–1 P.M.

Payment
Personal checks

SWANNANOA ·····················

CONTEMPORARY POTTERY

David Nelson

*W*hen David Nelson makes a two-foot-tall lidded container, he's likely to start with fifty pounds of clay—twenty-five for the top and twenty-five for the bottom. First he throws it; then he facets it. Then, with painstaking patience, he prepares it for glaze.

Drawing on techniques he learned from his father, a graphic artist, David has developed an unusual way of applying glaze. Rather than painting on his design, he masks it off, using a special type of tape. He cuts the tape carefully into shapes and

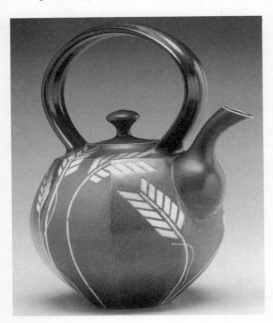

lines that form abstract flowers, stylized leaves, and patterned trellises. Then he sprays the glaze onto the vessel, occasionally manipulating it to get monochromatic shades or graduated colors. When he removes the tape, the design is revealed—stark, clean, and hard-edged.

David Nelson,
pottery teapot

Most of David's glazes are dark in order to highlight the glaze-resist areas.

David used to do production pottery—sets of dinnerware and multiple renditions of specific designs. Now he's making many more one-of-a-kinds. These pieces, he says, will be slightly more expensive but totally unique.

PRICES
Small bowls with fluted edges, $110; teapots, $650; large canisters, $1,200

LOCATION
Home studio; downtown Swannanoa

PHONE
704/299-4828

HOURS
Call first

PAYMENT
Visa, MasterCard, personal checks

GOURD ART
Dyan Mai Peterson

"Gourd art will last forever," says Dyan Peterson, "as long as you don't get it wet or let it sit in the sun. After all, archaeologists have found gourds dating back to 7000 BC."

"Gourds are a great canvas," she continues. "Each one has a different personality." After thoroughly cleaning the gourd, she lets the vegetable's unique shape and size dictate its transformation. Basket gourds, which are generally round, may become baskets, vases or bowls. Bottle and pear-shaped gourds often make superb birdhouses, while dipper gourds, with their long necks, work well as kitchen scoops.

Dyan's main tools are a band saw, a sander, and various weaving and painting implements. After cutting the gourd into the

desired form, she sketches the design with a pencil and then etches it with a wood-burning tool. Often she embellishes the gourd with paints or with natural materials like pine needles, seeds, and feathers.

Her dolls, which come with lamb's wool hair and wonderfully stitched dresses (done by a local seamstress), are reminiscent of old Appalachian playthings; her masks look like native artifacts; her vessels feature everything from representations of birds to abstract gilded designs.

PRICES
Miniature bowls, $15;
baskets, $45–$450;
dolls, $135–$300;
one-day classes, $40

LOCATION
Shop studio; 2 minutes
west of Swannanoa

PHONE
704/299-8200

HOURS
Call first

PAYMENT
Visa, MasterCard,
Discover, personal checks

MISSION FURNITURE
Gary Peterson

"If it doesn't work simple, it won't work with lots of embellishment," says Gary Peterson, who makes the sturdy, honest furniture that he knew as a child. "I didn't know then that it was called mission furniture or that it was being popularized by Frank Lloyd Wright, but I was influenced by it," he says.

Gary was also influenced by master woodworker James Krenov, with whom he spent three life-changing days in Stockholm.

Krenov not only taught Gary about design, he also gave him permission to adapt some of his styles. Now Gary is able to marry the flair of Krenov with the style of the Arts and Crafts movement and transform them into his own unique pieces.

Although he usually has some small items on hand for drop-in customers, Gary prefers to work on commission, designing a particular piece for a particular place. He prefers oak, mahogany, and ash, which are the woods traditionally used in mission furniture, although he sometimes uses walnut as well.

Gary started making furniture in 1972, but he took time off in the late 1980s and began making bird-toys—first for his own cockatoo, then for his friends' exotic birds, and finally for bird lovers across the country whom he reaches through pet stores and his own catalog, B is for Bird Toy. Now he hires people to help him with the toy-making and spends most of his time crafting the fine furniture. "The satisfaction I get justifies the sweat, sawdust, and occasional cut fingers," he says.

PRICES
Fern or magazine stands, $80+;
coffee tables, $350+;
queen-size bed frames, $1,200+;
grandmother clocks, $1,300+;
accepts commissions

LOCATION
Shop studio; 2 minutes
west of Swannanoa

PHONE
704/299-8200

HOURS
Call first

PAYMENT
Visa, MasterCard,
Discover, personal checks

GALLERIES

BLACK MOUNTAIN
Cherry Street Gallery

Features a wide variety of crafts by twenty local artisans.
- **Location:** Downtown Black Mountain
- **Address:** 132 Cherry St., Black Mountain, NC 28711
- **Phone:** 704/669-0450
- **Hours:** Mon.–Sat., 10 A.M.–5 P.M.; Sun., 1 P.M.–5 P.M.

BLACK MOUNTAIN
Seven Sisters

Represents more than 275 artists, most from the Southeast, one-third from North Carolina; features a wide variety of crafts but specializes in pottery and jewelry.
- **Location:** Downtown Black Mountain
- **Address:** 117 Cherry St.; Black Mountain, NC 28711
- **Phone:** 704/669-5107
- **Hours:** Mon.–Sat., 10 A.M.–5 P.M.; Sun., 1 P.M.–5 P.M.
 June–Dec.: also open Fri. evenings until 9 P.M

BAT CAVE

Hickory Nut Gap Inn

*Y*ou can't see Hickory Nut Gap Inn from the road. In fact, unless you know where to look, you won't even see the road. The inn is well hidden, and that's just the way owners Bettina Spaulding and "Easy" (Richard) Batterson like it.

A one-mile gravel road lined with trees and lush ivy winds up to the forty-acre site, complete with a few hiking trails and a long, low, rustic building. Built in 1950 as a retreat for Charlotte businessman Herman Hardison, the house has six bedrooms, each paneled with a different local wood. While these rooms are beautiful, the main rooms truly give this inn its charm.

The screened-in porch, a perfect place to relax in a high-backed rocker and enjoy spectacular mountain scenery, spans the eighty-foot length of the house. The Great Room has a giant stone fireplace, wormy chestnut walls, a piano, and lots of Native American rugs and baskets. A few stairs lead to a small loft where there's a door to another, smaller porch which has, if possible, an even better view.

RATES
$80, double occupancy; two-room suite, $125; includes deluxe continental breakfast; open approximately April–Nov.

LOCATION
2 minutes from Bat Cave

ADDRESS & PHONE
P.O. Box 246, Bat Cave, NC 28710
704/625-9108

PAYMENT
Personal checks

But most of all, there's the Game Room downstairs: two stone fireplaces, a pool table, a sauna, and a bowling alley. For those who tire of these entertainments, there's a television that, says Bettina, gets lousy TV reception but is great for videos, of which they have a wide selection.

All rooms have private baths and ceiling fans to provide natural air conditioning. A phone for guests' use is available in the Great Room.

BLACK MOUNTAIN
The Red Rocker Inn

*T*he Red Rocker Inn, a huge, beige clapboard home with chocolate brown shutters, has all the comforts of an old-fashioned inn, including overwhelming country meals that turn every day into a Thanksgiving feast. Each day Fred Eshleman, a former school administrator from Florida, begins dinner with a blessing. Then up to eighty-five guests—some of whom may be staying at the inn, others from the surrounding area—begin eating... and eating... and eating.

RATES
$55–$115, double occupancy; breakfast and dinner available at extra cost to guests and general public: breakfast, $8; dinner, $16; open April through Oct.

LOCATION
Downtown Black Mountain

ADDRESS & PHONE
136 N. Dougherty St.
Black Mountain, NC 28711
704/669-5991

PAYMENT
Personal checks

Pat Eshleman, Fred's wife, runs the kitchen—developing the recipes and supervising the cooking. A typical meal includes a hot soup or interesting salad, homemade breads and biscuits, at least three vegetables or casseroles, and a choice of a main dish. Then come the desserts—giant servings of homemade pie, cake, or cobbler, all served with ice cream or whipped cream. "This is a vacation," insists Fred. "You can count calories tomorrow!"

The inn has eighteen guest rooms, each with private bath. The rooms have individual names and personalities; "Aunt Madge's Room," for example, has a claw-foot bathtub, pull-chain toilet, and wicker lounge in an oversized bathroom. All are spotlessly clean and eminently comfortable, especially since The Red Rocker is fully air-conditioned. A central pay phone and soft-drink machine are available for guests' convenience.

THE NORTHERN PEAKS

THE NORTHERN PEAKS

BOONE IS THE SECOND-BIGGEST TOWN (after Asheville) in the western North Carolina mountains. Named after Daniel Boone, who is said to have camped here, it is the home of Appalachian State University and a bustling college community. The Appalachian Cultural Museum is also located here and offers a historical look at life in the hills (704/262-3117). A few miles away, the town of Blowing Rock attracts visitors who like the resort atmosphere, the abundant shops, and the terrific view from the windy overlook that gave the town its name.

This is an easy place to find craftspeople; while some are hidden in the hollers, others have working studios right on the main streets of Boone and Blowing Rock.

Tucked between the towns of Boone and Blowing Rock is Tweetsie Railroad, a mini-amusement park that features a narrow-gauge sight-seeing train (704/264-9061 or 800/526-5740).

Nearby there's plenty of outdoor recreation, from alpine hiking in the summer to skiing in the winter. And while Grandfather Mountain is, at 5,964 feet, only moderately high compared to its neighbors, it boasts the highest swinging footbridge in America, a mini zoo, and hiking trails (800/468-7325).

ALUMINUM FLOWERS
Marsha Canterbury

Marsha Canterbury wanted three things: to be a stay-at-home mom, to use her education as a biology naturalist, and to contribute to the family income. Her aunt, Margaret Owen, helped her find a way to do just that. Margaret has a profitable business in Greensboro making sculptured aluminum flowers. She offered to teach her niece all she knew on one condition: the details of the craft must remain a family secret. Marsha began her own at-home business in 1981, building on her aunt's lessons and developing her own style. Now she creates twenty-three varieties of wildflowers and ten varieties of cultivated flowers, which she sells singly or in arrangements.

Making each blossom is a fifteen-step procedure and Marsha, because of her promise, can only hint at the exact process. She buys used aluminum printing plates, cuts the petals and leaves according to pattern, crimps and bends them into shape with a pliers, and spray paints them with acrylic paint. She tries to make each flower as realistic as possible, and includes an information card with each that lists the flower's common and scientific names, where it grows, and when it blooms.

PRICES
Single blossoms, $12; triple blossoms, $26; dogwood sprays, $33–$90; seconds sometimes available

LOCATION
Home studio; 5 minutes east of Banner Elk

ADDRESS & PHONE
P.O. Box 1459
Banner Elk, NC 28604
704/898-8339

BROCHURE
Write for mail order information

HOURS
Call first

PAYMENT
Visa, MasterCard, personal checks

DULCIMERS AND PSALTERIES
Archie Smith

"*E*verybody needs an escape. Some people play golf; I make psalteries and dulcimers," says Archie Smith. Five days a week Archie spends his days teaching modern European history at a local college. Evenings and weekends he "escapes" to his basement workshop where he makes instruments rooted in the history of both Europe and America.

In the last eighteen years, he's made more than 600 psalteries (a European 'song tree' that's played with a bow) and nearly 500 dulcimers (an American lap instrument that's played with the fingers or a small pick). Each is signed and dated by its creator.

To honor the tradition of the dulcimer, which was developed in Southern Appalachia by the Scots-Irish, Archie crafts them from local woods, saving the foreign, exotic woods for his psalteries. Both instruments are "book matched," which means the wood grain on one side mirrors that on the other, and are made with traditional wooden pegs.

• • • • • • • • • • • • • • • •
PRICES
Psalteries and dulcimers, $220–$350, includes carrying cases, instruction books, and (in the case of the psalteries) bows

LOCATION
Home studio; 5 minutes east of Banner Elk

PHONE
704/898-5429

HOURS
Call first; evenings or weekends preferred

PAYMENT
Visa, MasterCard, personal checks
• • • • • • • • • • • • • • • •

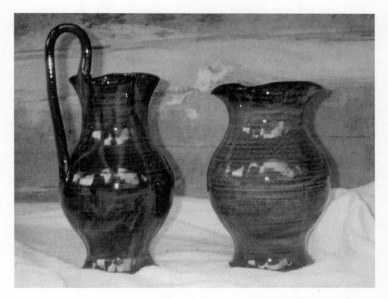

Glenn and Lula Owens Bolick, pottery pieces

TRADITIONAL POTTERY

Lula Owens Bolick and Glenn Bolick

*L*ula and Glenn Bolick's pottery is steeped in tradition. On her side is the craft: her family has worked with clay for five generations. On his is the land: the valley where they live and work has belonged to his family for as long as anyone can remember.

Glenn left the mountains when he was eighteen to find a job. He was working near Seagrove, a small community in central North Carolina that's been a pottery center since colonial times, when

he met Lula Owens. The two fell in love and married three months later. They soon went to work in the pottery owned by Lula's father. The couple spent almost eleven years there learning about traditional pottery. But Glenn "always wanted to get back to the mountains." In 1973 he bought his great-grandfather's house, which dates back to the 1880s, then built a pottery and later a showroom.

PRICES
Cups, $5; tall mugs, $10; bean pots, $22+; owl pitchers with lids, $25

LOCATION
Home studio; 5 minutes south of downtown Blowing Rock

ADDRESS & PHONE
Rt. 8, Box 285, Blackberry Rd. Lenoir, NC 28645
704/295-3862

HOURS
Mon.–Sat., 8 A.M.–5 P.M.; Sun., 1 P.M.–6 P.M.

PAYMENT
Visa, MasterCard, personal checks

Today Lula and Glenn's clayware is much like that of Lula's father and grandfather: sturdy, useful, and handsome. Mugs, bowls, pitchers, and candle holders are wheel-thrown in a dirt-floored workroom ("Dirt floors keep the clay from drying out," explains Lula) and fired in a wood-burning kiln. Most pieces come in three colors: gray, oatmeal, or cobalt blue.

TRADITIONAL POTTERY

Michael Calhoun and Janet Calhoun

*B*ack in the eighteenth century, slaves put ugly faces on milk crocks in an attempt to scare away the devil who they thought made milk go sour. Using somewhat similar reasoning, potters also put frightening faces on whiskey jugs in order to scare off curious children.

The faces fascinated Michael Calhoun, son-in-law of traditional potters Lula and Glenn Bolick. After Michael finished work, he would often go into the pottery and add faces to jugs that the Bolicks had thrown. Eventually they insisted he learn to use the wheel himself; now Michael and his wife, Janet, have a pottery of their own. They make many of the same items, but they add their own signature. Their pitchers, for example, feature a double handle and domed lid, while their pie plates have a distinctive pinecone pattern.

But it's still the face jugs that intrigue Michael. In the front of his workshop, he displays his ever-growing collection of jugs by other Southern potters. He also has developed two face-jug designs of his own. One, a Santa jug, is a best-seller. The other, a hollerin' jug, which features a man with his mouth open wide, is a tribute to his father-in-law, Glenn. As the best hollerer in the mountains— able to yodel down the mountain to check up on his neighbor— Glenn won the National Hollerin' Contest in 1988.

PRICES
Pie plates, $12; water pitchers, $16+; face jugs, price depends on detail

LOCATION
Home studio; 5 minutes south of downtown Blowing Rock

ADDRESS & PHONE
Rt. 8, Box 286 AA, Blackberry Rd.
Lenoir, NC 28645
704/295-5099; 704/295-9860

HOURS
Mon.–Sat., 9 A.M.–5 P.M.;
Sun., 1 P.M.–5 P.M.

PAYMENT
Visa, MasterCard, personal checks

STONEWARE POTTERY
Herb Cohen

*T*he curators of the renowned Mint Museum of Art in Charlotte, where Herb Cohen was acting director before he left to open his own studio, think highly of his work. In fact, they have honored him with a retrospective exhibit, a tribute afforded only to exceptional craftspeople.

Herb's pottery falls into two categories. His line of functional stoneware, including tumblers, bowls, plates, and casseroles, are notable because of their color—some in monochromatic shades of copper red, others in solid tones of deep teal, rich lavender, or vibrant blue with green overplay. His decorative work tends to be more subdued, but equally striking. For example, a free-form sculpture in black and tan carries a multilayered design, while a large plate bordered by Hebrew letters represents God's words to Moses as told in Exodus.

One of the best times to view Herb's work (as well as his partner José Fumero's—see page 100) is at their annual open house held during the last weekend in August and the first weekend in September. The work of other artists is also on display and for sale.

• • • • • • • • • • • • •
PRICES
Tumblers, $15; large casseroles, $135; hand-built sculptures, $600–many thousands; seconds sometimes available

LOCATION
Home studio; 10 minutes south of downtown Blowing Rock

PHONE
704/295-7246

HOURS
Call first

PAYMENT
Personal checks
• • • • • • • • • • • • • •

AREA 3 THE NORTHERN PEAKS

FUNCTIONAL STONEWARE

David Engesath

Much of David Engesath's work is spiritually oriented. His line of white and blue Christian pottery includes a variety of angels, and many pieces feature religious verses. A wedding or anniversary oil lamp, for example, encourages people to "Walk in the light of the Lord" and features two wicks that, when lit, spark one flame. It can be ordered with the couple's name and marriage date written in glaze. In a similar vein, his hand plate, made with the imprint of a child's hand, has the words "Children are a blessing from above" circling the rim. Many people ask that the child's name and birthdate be included. But some of David's pottery is just plain fun. His toilet paper holder is shaped like a masculine hand, while his assortment of attractive dinnerware encourages entertaining.

David usually works on the wheel, and his glazes run the gamut from earth tones to the colors of springtime. Since 1994, when he began summering in North Carolina, he's been using more greens—inspired, he says, by the view from his studio window.

PRICES
Hand plates, $25; helping hands for toothbrushes or toilet paper, $40–$50; wedding or anniversary oil lamps, $50; seconds sometimes available

LOCATION
Home studio; 5 minutes north of downtown Blowing Rock

ADDRESS & PHONE
330 Forest Park Dr.
Blowing Rock, NC 28605
704/295-7402

HOURS
Call first; June–Oct. only

PAYMENT
Visa, MasterCard, personal checks

WOVEN FIBER MOSAICS
José Fumero

*I*magine a painting that's been shattered into small squares, then reassembled. The image is still there, but it has been shifted and rearranged. "This is something new, an original art format," says José Fumero, who calls his paintings "woven fiber mosaics." His technique is both simple and complex, an intricate version of the paper place mats many of us wove as children.

He first makes a collage, using anything from printed pictures and paint to ribbon and metallic papers. Then he forms a warp by cutting the collage into strips varying in width from one-fourth inch to more than an inch. Finally, he takes specially prepared pieces of wallpaper and fabric and weaves these through the design, sometimes letting pieces of the warp "float" to retain the image, other times fragmenting it with the woven strips. The result is a striking mixed-media tapestry.

PRICES
Pictures, $65–many thousands

LOCATION
Home studio; 10 minutes south of downtown Blowing Rock

PHONE
704/295-7246

HOURS
Call first

PAYMENT
Personal checks

José, who is a graduate of the Cooper Union Art School, is an accomplished painter who became fascinated with fabrics during the years he spent designing materials for the airline and automotive industries. But, he says, "I kept getting promoted. Pretty soon I wasn't doing art... so, at age 47, I quit."

DYED AND PAINTED SILK CLOTHING
Laura Holshouser

A single piece of the clothing created by Laura Holshouser may use three or four types of silk, each individually hand-dyed in coordinating colors and patterns. She never works with more than two yards of material at a time, which ensures that each garment is truly one-of-a-kind.

Beginning with white silk, Laura uses a variety of methods to dye the background. Then she's ready for the Shibori technique, a Japanese method of bound-resist dyeing that creates an almost-geometric overlay. She pleats and folds the material, wraps it around a pipe or cylinder, then clamps and binds it with string. This keeps the dye from reaching parts of the fabric as, in a series of compressions,

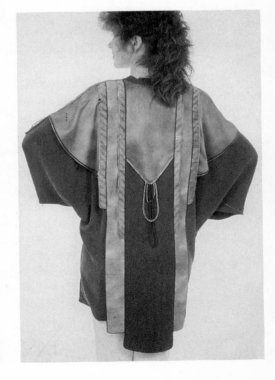

*Laura Holshouser,
silk jacket*

Laura colors her material and creates the stylized yet flowing patterns that distinguish her work.

Once the fabric is ready, she constructs each piece of clothing according to designs she has developed herself. Although her vests and jackets are loose and flowing, they have an architectural flavor, combining the oriental look of a kimono with the ecclesiastical style of church vestments.

Despite her flair with color and her sense of design, Laura doesn't refer to herself as an artist but as a craftsperson, as someone who is concerned above all with technique. "Achieving and maintaining quality and precision in my work is a top priority," she explains.

• • • • • • • • • • • • • • • •

PRICES
Jackets, $250–$2,000;
coordinating solids, $75–$200;
most work by commission

LOCATION
Home studio; 5 minutes north
of downtown Blowing Rock

PHONE
704/295-9255

HOURS
Call first

PAYMENT
Visa, MasterCard, personal checks
• • • • • • • • • • • • • • • • •

CLAY VESSELS
Lynn N. Jenkins

*W*hen Lynn Jenkins was in high school, she signed up to take woodworking. Due to some scheduling snags, she found herself taking pottery instead. It was a lucky mistake.

Today, Lynn creates three types of clay work. She casts small pieces of jewelry, several sizes of heart-shaped boxes, and a variety of Christmas ornaments. She uses the wheel to make a

distinctive line of functional pottery featuring wine and lavender slashes on an off-white background. Lynn's functional pottery spends forty-eight hours in the kiln, where the temperature is raised and decreased slowly to temper the pieces so that they won't crack when placed in an oven or dishwasher.

Lynn has also perfected two designs of decorative pottery: one with a iridescent copper and turquoise glaze, the other with a red stripe across a webbed charcoal-and-white background. Gentle surface cracking makes the characteristic webbed patterns on her decorative pieces. She fires these according to the raku method, which was developed in sixteenth-century Japan. The glaze firing takes only about thirty minutes, during which time the piece is placed into a hot kiln until the glaze glassifies, then plunged into a sawdust-filled metal can. As the pot is transferred from kiln to can, the relatively cool air causes the glaze to splinter. The cracks turn black while the pot smolders in the sawdust, producing the unusual crackled effect.

PRICES
Cast pins and earrings, $8; mugs, $12; casseroles, $25–$35; raku vases, $18–$300

LOCATION
Home studio; 10 minutes south of downtown Blowing Rock

PHONE
704/295-3735

HOURS
Call first; sometimes it is possible to arrange a visit that will coincide with a raku firing

PAYMENT
Personal checks

STERLING JEWELRY
Gaines Kiker

*W*earing cutoff jeans and an old T-shirt, his only mode of transportation a bicycle that is parked in the middle of his studio, Gaines Kiker seems an unlikely person to be making jewelry for the dress-for-success set. Yet the sleek silver earrings, rings, pins, necklaces, and pendants he creates belong on a sophisticated lapel. The most intriguing pieces have moving parts, with links that pivot and turn. "I love everything mechanical," he explains. "If I can make a piece of jewelry *work*, it's that much more fun."

PRICES
Earrings, $24–$88;
bracelets, $40–$1,000;
necklaces, $70–$1,200;
accepts custom orders

LOCATION
Shop studio;
downtown Blowing Rock

ADDRESS & PHONE
4148 Linville Rd.
Blowing Rock, NC 28605
704/295-3992

HOURS
Tues.–Sat., 10 A.M.–6 P.M.

PAYMENT
Visa, MasterCard, personal checks

Gaines learned metalsmithing from the masters. After graduating with an MFA in Fine Metals from East Carolina University in Greenville and winning the 1992 North Carolina Emerging Young Artists Grant, he sent his résumé to Tiffany's. "Why not?" he laughs. "If they'd rejected me, I could always have moved down." But they didn't reject him. Instead, they hired him to apprentice with master silversmith Ubaldo Vitali, who works as the main jewelry repairman for Sotheby's and Christie's auction houses. "He is the king," says Gaines. "He said, 'Forget everything and I'll teach you what you need to know.' So I did and he did." After thirteen months in New York, Gaines

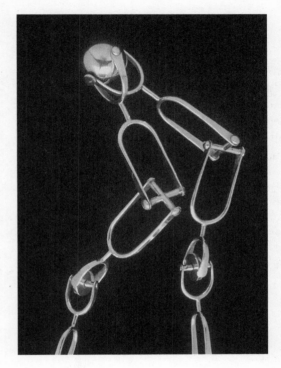

Gaines Kiker,
sterling silver jewelry

went to Italy to hone his skills. Then, finally, he came back to North Carolina.

Firm in his belief that his classical training makes him a better contemporary craftsman, he's developing his own style—making his own jigs so that his work can't be copied, soldering together different pieces of metal to create a layered piece of jewelry and, of course, making things that move.

FELT PUPPETS
Frank Sherrill

*W*alking into Frank Sherrill's living room is like walking into a children's wonderland. All sorts of animals line the shelves: African animals (a purple hippo, a blue-faced gorilla, and a big-eared elephant), farm animals (a pink pig, a black-and-white lamb, a soulful hound dog), and even imaginary animals (a bright green dragon with flames shooting from its mouth). On an adjoining wall are friendly flower people. Carefully constructed from felt, these hand puppets are designed to be a child's best friend.

Frank, an accomplished musician and watercolorist, designs each puppet, sometimes sticking to reality (all flowers, for example, are made from the correct color of felt), other times moving toward fantasy. He refuses to use glue, the quick way to assemble felt. Instead, each puppet is carefully stitched to withstand rough play. A small hoop on the back lets the puppets hang on a wall for display and for easy access.

PRICES
Puppets, $22–$45

LOCATION
Home studio; 10 minutes south of Blowing Rock

PHONE
704/295-9206

HOURS
Call first

PAYMENT
Personal checks

Frank's mother was a toymaker; as a child he helped her sew dolls and stuffed toys. Although he has also made stuffed toys (including a cuddly striped "Boone Coon"), he prefers puppets. "They have a special educational value," he explains, adding that teachers and therapists, as well as parents and grandparents, buy his puppet creations.

GOLD AND SILVER JEWELRY
Ronald Tharp

*R*on Tharp thinks of himself as a sculptor as well as a jeweler. By layering and juxtaposing different textures and colors of precious metals and stones, Ron creates designs that look as good in a cabinet as on a jacket. To this end, many of his pieces come with devices that allow them to be displayed.

Ron's "Olfactory Pin" holds perfume and has microscopic holes that release the fragrance but not the substance; it comes mounted on a slate backing so that it can be hung on the wall. Although Ron's jewelry is streamlined and contemporary, the idea behind this pin dates back to the Baroque period.

But many—if not most—of Ron's ideas

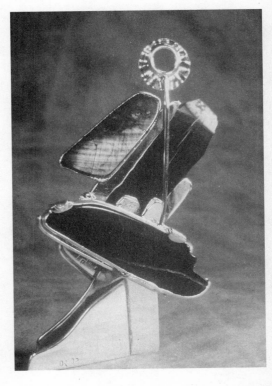

Ronald Tharp, sculptural jewelry

come from his North Carolina home. "My designs have changed since I moved here," he says, adding that after coming from Minnesota to visit a friend, it took him only two days to decide to make the mountains his adopted home.

Now he takes long walks in the woods, leaving his sketchbook at home and letting the shapes, textures, and colors flow into his unconscious. "It all comes out in my work," he says. "I catch the essence rather than reproduce the physical look of my surroundings. My jewelry is a love affair with the earth, not a symbol of artificial status."

PRICES
Sterling silver earrings, $20+;
simple pendants and
broochs, $250+;
olfactory pins, $250;
sculptural jewelry, $1,500+

LOCATION
Shop studio;
downtown Blowing Rock

ADDRESS & PHONE
Fovea Gallery
P.O. Box 1210, Sunset Dr.
Blowing Rock, NC 28605
704/295-4705

HOURS
Mon.–Sat., 10 A.M.–5 P.M.

PAYMENT
Visa, MasterCard, personal checks

FORGED CUTLERY AND CUSTOM SHEATHS
Daniel Winkler and Karen Shook

Eighty-five percent of Daniel Winkler's hand-forged knives are never used. They're bought by collectors, coveted as a symbol of frontier America. The other 15 percent are used often, generally by people who do battle reenactments and need the knives to survive outdoors in the way of their forefathers. A small percent are bought by costume designers, as was the case

when *The Last of the Mohicans* was filmed in western North Carolina. Look close and you'll see Daniel Day-Lewis carrying a Winkler original.

When Daniel Winkler talks about his craft, he speaks of research as often as he speaks of forges, of days spent at the museum as well as days spent in his workshop. That's because he's fascinated by history and obsessed by authenticity. He admits that his production methods are different from those of the early settlers. "Indentured servants are hard to come by these days," he says with a smile. "So I use a power hammer, a milling machine, and an electric sander in their stead." But his knives are accurate reproductions of those used in the past. The handles are made from antler, bone, and wood. If the wood is wrapped in leather, explains Daniel, it represents a knife that was traded to— and adorned by—an Indian.

The sheaths, made by Daniel's partner, Karen Shook, are made from unprocessed rawhide, tanned and preserved by age-old methods. They not only look right, they *smell* right, giving off a pungent odor of smoke and ash. Some— those representing trades to Indians—are decorated with beadwork done by Karen's cousin, Kitty Bumgarner.

PRICES
Knives, $200+; sheaths, $40+; most work done on commission

LOCATION
Home studio; 10 minutes south of downtown Blowing Rock, accessible only by 4-wheel drive

ADDRESS & PHONE
P.O. Box 2166
Blowing Rock, NC 28605
704/295-9156

CATALOG
Write to the above address; enclose $3

HOURS
Call first

PAYMENT
Visa, MasterCard, personal checks

Most of Daniel's knives represent those used in North America
between the time of the French and Indian War through the
Civil War, although a few are reproductions of European or
Japanese knives. "My inspiration," he says, "comes from a time
when the equipment a person carried meant sustenance and
survival. Through my work I hope to preserve the heritage of
utilitarian art."

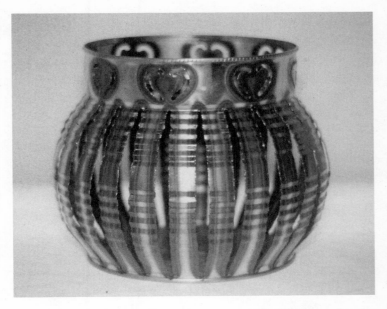

Jerry Colglazier, tin lantern

Tin Craft
Jerry Colglazier

*J*ane Colglazier was desperate. Her daughter was sick and medical bills were piling up. "Lord," she prayed, "we need a way to make extra money." Then she remembered: thirty years earlier she'd watched in fascination as an old man used a torch to carve designs in old tin cans. The intricately cut tin baskets and lanterns sold as fast as he could make them. She approached her husband, Jerry, who had been an industrial arts student in school

and was handy with tools. "Right," he said skeptically. "I'm going to make a living from tin cans."

But that's exactly what happened—and is happening still. Jerry designed candle holders from small soup cans, baskets from midsize cans, and lanterns from gallon containers. He learned how to crimp the edges so they weren't sharp and how to use the torch to make an attractive outline of black against the natural silver color of the can. He decided to finish each sculpture by dipping it in a clear acrylic or polyurethane finish.

Today, the Tin Can Man, as Jerry calls himself, wholesales can creations all over the United States and sells to individuals from as far away as England.

PRICE
Small lanterns, $4; baskets, $10–$16; oil lamps, $40; big lanterns, $60

LOCATION
Home studio; 20 minutes west of downtown Boone

PHONE
704/297-1146

HOURS
Call first

PAYMENT
Personal checks

STAINED GLASS
Dianne Estes and John Estes

Dianne and John Estes are self-proclaimed dropouts. During a two-week vacation along the Blue Ridge Parkway, they decided John should quit his job as a cancer researcher with the University of Alabama in Birmingham so they could move to the mountains. "The land called to us," says Dianne. She had a strong background in stained glass work, and

they decided to make their living with her craft.

Surrounded by high hills and rustling trees, less than a "crow's-mile" from the Tennessee border, they started a glass studio. Dianne creates the designs, cuts the glass, and does most of the soldering. John is responsible for the sandblasting, the copper foiling, and the kiln work. Large repair and restoration work takes up some of their time; the rest is spent on their own products, including angels, Cheshire cats, and mountain scenes—anything that will look good hanging in a window. They also make other items, from nightlights and lamp shades to mirrors and business card holders.

After Dianne draws a pattern, she cuts it out with a special pair of scissors that automatically leaves space for the lead or copper foil that will join the various pieces. Then she lays the pattern on the glass and cuts the glass with a glass cutter. If the piece is to be copper foiled, John smooths and tapes the edges of the glass before applying the foil. If it is to be joined with lead, Diane wraps the glass pieces with lead and then, after soldering, adds a sealing putty. On occasion the Esteses use another technique: glass fusing, in which various pieces of glass are melded in a kiln, creating overlapped designs that work well for plates or bowls.

PRICES
Angels, $7–$95; fused plates, $30+;
landscape panels, $35+;
custom work, $60+ sq. ft.

LOCATION
Home studio; 20 minutes
west of Boone

PHONE
704/297-5936

HOURS
Call first

PAYMENT
Personal checks

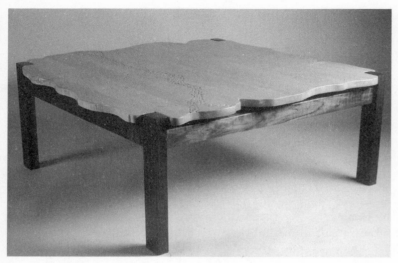

Denise Grohs, wood table

WOOD FURNITURE AND ACCESSORIES
Denise Grohs

"*I* have this desire to make as many different things as I can before I die. I have a couple hundred years of design ideas," says Denise Grohs. To help her accomplish her goal, she employs three woodworkers, but every piece that goes out of her shop has her special imprint: good design and careful craftsmanship.

Denise spends as many hours as possible—usually about half of her work week—personally wielding the saws and drills. (About the only thing she doesn't do anymore is apply the finishing spray because of an allergy to organic solvents.) She makes a wide variety of small items such as tabletop boxes and clocks,

wine racks, lap boards, step stools, and quilt racks.

But her first love is furniture—everything from armoires and rolltop desks to headboards, tables, and chairs. Her hallmark dining room set, consisting of a table and six chairs, is a blend of contemporary and traditional design. Its most distinctive mark—that which often distinguishes Denise's designs—is the combination of two contrasting woods: walnut with ash, white oak with walnut, or cherry with ash or maple.

Recently she's started to experiment with curves and sweeps and has incorporated metal, marble, and glass into her work, making unusual and very modern cabinets and tables.

• • • • • • • • • • • • • • •

PRICES
Wine racks, $10; boxes, $35+;
chairs, $445+; dining tables, $975+;
accepts commissions

LOCATION
Shop studio; 6 minutes
south of downtown Boone

ADDRESS & PHONE
Miters Touch
6858 Hwy. 105 South
Boone, NC 28607
704/963-4445

HOURS
Mon.–Thurs., 8:30 A.M.–5 P.M.;
Fri., 8:30 A.M.–3 P.M.;
Sat., 11 A.M.–3 P.M.

PAYMENT
Personal checks

• • • • • • • • • • • • • • •

FUNCTIONAL POTTERY
Bob Meier

Bob Meier wanted to be a teacher. He was working toward a degree in vocational education, and he needed one more class. The only one that would fit his schedule was pottery. He still remembers the excitement he felt when he first saw a master potter at work. "Watching someone who is good throw on the wheel is fascinating," he says. "It's like the clay has a life of its own." Now Bob, who did get his teaching certificate, spends part of his week in his shop and part of it working with seventh

Bob Meier, pottery tea set

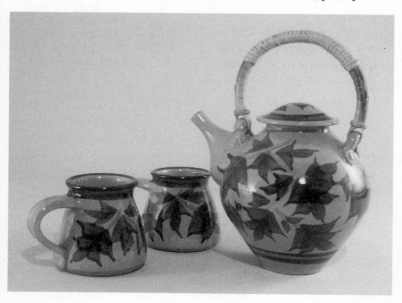

and eighth grade students in the vocational arts lab. Among other things, he teaches them how to throw pots.

When Bob designs a piece, he starts with function. "A piece has to be able to do what it's supposed to do," he says, pointing to two of his more unusual dinnerware pieces, a vegetable steamer that goes from stove to table and a French butter dish that both preserves and serves. He makes a wide variety of platters as well as lamps, casserole dishes, and a communion set with chalice and paten. Many of his pieces feature wide bands, fish designs, and brushed flower motifs that have an Asian flair.

PRICES
Mugs, $12; French butter dishes, $24; vegetable steamers, $50; accepts commissions; seconds sometimes available

LOCATION
Shop studio; downtown Boone

ADDRESS & PHONE
Doe Ridge Pottery
149 W. King St., Boone, NC 28607
704/264-1127

HOURS
Mon.–Sat., 10 A.M.–6 P.M.;
Sun., 1 P.M.–5 P.M.

PAYMENT
Visa, MasterCard, personal checks

BEAD JEWELRY
Zoe Racey

Zoe Racey collects beads every chance she gets, using them to create beautiful jewelry. Her methods and designs are rooted in Native American traditions. She has visited numerous museums and powwows to perfect her skills and learned many of her techniques from master beadworkers and Native American elders.

Using European and Japanese glass beads and nylon thread, Zoe weaves delicate amulet necklaces, one bead at a time. She begins by stringing them in a circle, expanding the circle to a cylinder and finally, when the cylinder is the proper length, sewing it together at the bottom to make a small pouch.

PRICES
Earrings, pins, necklaces, and hair clips, $20–$25; beaded pins with semiprecious stones, $25+; beaded necklaces, $70+

LOCATION
Home studio; 15 minutes east of downtown Boone

ADDRESS & PHONE
105 Briarpatch Ln.
Boone, NC 28607
704/264-7819

CATALOG
Send self-addressed business-size envelope with $.55 postage

HOURS
Call first

PAYMENT
Personal checks

She uses another technique for her woven neckpieces which, as the name implies, are flat blankets of beads. After planning the design on paper, she makes a miniloom with straight pins and a piece of wall board. She strings large beads on waxed linen warp threads and weaves around them with tiny cotton yarn to get a patterned effect.

Zoe makes her pins, necklaces, and earrings in a setting that is as spiritually inspired as her work. The New River, the second oldest river in the world, flows just fifty yards from her home.

FUNCTIONAL STONEWARE AND GARDEN FURNITURE

Brenda Schramm and Mike Biczel

*S*ome of Brenda Schramm's "bad boy mugs" look like Walter Matthau. Others wear sunglasses, have mustaches, and smoke cigarettes. "I tell people they need to name them," says Brenda with a laugh.

Her work is most easily recognized by her contrasting use of texture and color. Many of her designs are made by using a wax resist to repel the glaze, allowing her to reveal the natural tan of the clay against the smoother, colored glaze. This works well for her landscape-inspired kitchenware, on which rustic trees stand against a double-dipped background of green glaze on the bottom and blue on the top. Other patterns are geometric— rims of blue and white triangles above bases of natural clay. Brenda achieves her hard-edged design by cutting into the wet clay with a needle, producing deep lines that keep glazes from running into each other.

Mike, who built her studio, makes cedar chairs and benches for patio or garden. The gently curved seat adds comfort to the straight-backed furniture, which comes in both mission and Southwestern styles.

PRICES
Brenda: mugs, $10–$25;
bowls, $12–$50
Mike: cedar 4' benches with
backs and arms, $200+

LOCATION
Home studio; 10 minutes
east of Boone

PHONE
704/264-1189

HOURS
Call first

PAYMENT
Visa, MasterCard, personal checks

STORYBOOK DOLLS
June Taylor

*D*orothy, as we all know, was used to the flatlands of Kansas before she started her journey down the Yellow Brick Road. But that didn't stop June Taylor, who has recreated Dorothy in one of the hilliest parts of Southern Appalachia. June has spent the last thirty years sewing the upside-down dolls that have delighted children for centuries, and Dorothy is one of her favorite characters. Hold the doll one way and it's Dorothy, smiling above her billowing skirt. Turn her over and under the skirt is the Cowardly Lion—or the Scarecrow or the Tin Man or even, in one of June's more elaborate dolls, the Wicked Witch of the West.

June doesn't spend all her time with Oz characters; she also makes dolls representing other well-known tales. Her Cinderella doll is in raggedy clothes if held one way, in a beautiful ball gown when flipped. Goldilocks's skirts hide the three bears, and Red Riding Hood's skirts cover the wolf wearing Grandma's removable bonnet.

June's doll making is such a popular attraction in the Village of Yesteryear at the North Carolina State Fair that in 1996 she—along with her mother, Elsie Trivette, and sister, Leniavelle Trivette—was invited to Washington D.C. to demonstrate old-time crafts at the Smithsonian.

PRICES
Dolls, $25+

LOCATION
Home studio; 15 minutes
west of downtown Boone

PHONE
704/297-4516

HOURS
Call first

PAYMENT
Personal checks

Appalachian Crafts
Elsie Trivette and Leniavelle Trivette

"*I* guess if you're raised up to do this, you don't think much of it," says Elsie Trivette, as she gestures toward a hand-knotted colonial pillow. In the nearby bedroom there's a full bedspread made the same way, and on the sofa is a hand-crocheted afghan, hand-dyed with vegetable dyes. A spinning wheel sits in the corner, next to an almost-finished hooked-burlap rug.

Elsie, born in 1911, was raised on Beech Mountain, just a few miles from her present home; she learned to spin sheep's wool and dye it when she was just a youngster. By the age of ten she had learned to knot from her mother, and Elsie began making the bedspreads that now have earned her considerable fame.

She begins each bedspread (or pillow) by taking a fresh piece of muslin and laying it atop a completed bedspread, then transferring the design by carefully rubbing a special crayon over the new muslin. Next, she starts knotting—taking thread and working it up and down, through the cloth and into a knot, over and over again, forming groups of knots. Finally, she edges the piece with lace, which she's made by throwing string over a dowel that hangs from a homemade frame. Elsie's not sure how long it takes her to

Prices
Colonial knotted pillows, $25+;
burlap rugs, $85 per sq. ft.;
twin size quilts, $250+;
Leniavelle accepts
commissions for quilts

Location
Home studio; 15 minutes
west of downtown Boone

Phone
704/297-5613

Hours
Call first

Payment
Personal checks

make a spread—"I never did keep count," she says. "I just work a little while at a time, and then I work a little while longer." (Experts estimate that a full-size spread takes at least 500 hours.)

Elsie also makes burlap rugs. "I used to get fifty cents for one of those rugs, and I thought I was rich," she says. Those burlap rugs, about two feet by three feet, now sell for upwards of $400. Considering the work it takes, it's a bargain. First Elsie unravels four big burlap bags. She dyes about half the strings and then, twisting five strings into one, hooks them through the holes in a fifth bag. The result is a dense, tough rug—as durable as the hills.

In 1994, Elsie was given the North Carolina Folk Heritage Award in recognition of her work toward maintaining the craft traditions of Southern Appalachia. She's still working hard, but now she's helped by her daughter, Leniavelle. Leniavelle's specialty is quilting, but she's learned to do everything her mother does, from spinning and quilting to crocheting and rug hooking.

Elsie Trivette with examples of her craft

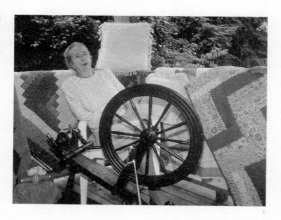

LEATHER WORK
Mark Judson Watkins

*M*ark Watkins has been working with leather since he was
eighteen years old. That was the year he traveled from
south Florida to work as a barker at the Montreal World Fair. He
needed a pair of sandals but couldn't find any that met his
standards. He went to a cobbler, bought the soles, and added his
own leather work. By the end of the summer more than one
hundred people had requested similar sandals.

From there Mark's rise was meteoric. He went back to Miami
and with a buddy opened up shop. A year later he had two stores
and two years after that, three
stores. He was selling sandals, belts,
and watchbands faster than he
could make them. He kept expand-
ing his line, eventually establishing
a large mail-order business. He
learned to make his own shoe soles,
design clothes, sew, tool, and stamp
leather. Now, he says, "I'm a one-
man leather shop." About the only
thing Mark doesn't do is tan and
dye the leather, but he can order
just about any hide in the world,
from pig to python, in a multitude
of colors.

PRICES
Hats, $44; handbags, $75–$250;
vests, $100+; jackets, $400+;
custom orders accepted

LOCATION
Shop studio; downtown Boone

ADDRESS & PHONE
Leather and Silver Gallery
614 W. King St., Boone, NC 28607
704/262-3719

HOURS
Mon.–Sat., 10 A.M.–5 P.M.;
Sun., 1 P.M.–4 P.M.

PAYMENT
Visa, MasterCard,
Discover, personal checks

Functional Pottery
Lucy Hamilton

*L*ucy Hamilton credits many of her designs to the fact that she lives "in the middle of a rhododendron thicket." Her stoneware pottery features leaves that cluster on plates, hang gently on tumblers, and layer in bowls. They have a transparent quality which makes each leaf distinct, yet also lets the one below shine through.

Lucy gets this effect by using a combination of slip (liquid clay) and glaze. Once the wheel-turned piece has hardened to the consistency of leather, she applies the slip with a brush or squeeze bottle. After the item is fired, she dips it into a bucket of white glaze, covering both the natural and slip-covered clay. When the piece is fired again, the slip fuses with the glaze to give depth.

Lucy, who has been a full-time potter since 1974, delights in making complete sets of dinnerware. One of her most popular patterns combines various shades of blue leaves on a white background accented with rims of tan. Another pattern features leaf outlines drawn in tan against a white base.

Prices
Mugs, $15+;
midsize serving pieces, $25–$65;
four-piece place settings, $90+

Location
Home studio; 5 minutes
north of central Newland

Address & Phone
183 Stover Ridge Rd.
Newland, NC 28657
704/733-9819

Hours
Call first

Payment
Personal checks

TURNED-WOOD VESSELS
Alan Hollar

Once you have seen Alan Hollar's work, you'll never again look at the fork of a tree in the same way. Alan's signature pieces are three directional, as they use the part of the tree where the trunk divides into two branches. The trunk becomes a container while the branches are turned (quite literally) into free-form legs.

Alan also makes more traditional pieces. His lidded jars, with top and bottom fashioned out of the same piece of wood, have the sculptural look of fine earthenware pottery. While Alan makes some items over and over again—ring holders, fan pulls, wine bottle stops, ornaments, and garlic crushers—it's the unusual pieces that excite him.

Alan honed his wood-turning skills while doing furniture restoration, a job which still provides a large share of his income. He figured that if he could create new spindles for antique chairs, he could create turned vessels from downed timber. His art pieces, made from local woods such as maple, apple, dogwood, and walnut, are almost entirely made on the lathe. "I'm not interested in carving," he says. "I like to turn, to see how the wood and I can cooperate to show its beauty."

PRICES
Garlic crushers, $6;
ring holders, $25;
bowls and jars, $65–$250;
seconds sometimes available

LOCATION
Shop studio; 10 minutes
south of central Newland

ADDRESS & PHONE
789 Tennant Rd.
Newland, NC 28657
704/733-9157

E-MAIL
AHollar789@aol.com

HOURS
Call first

PAYMENT
Visa, MasterCard, personal checks

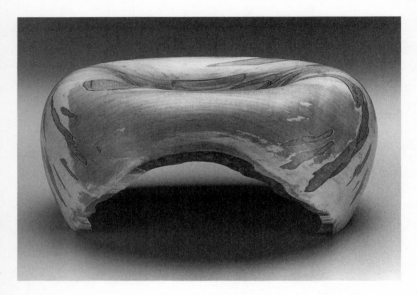

Rodger Jacobs, turned-wood piece

TURNED-WOOD VESSELS
Rodger Jacobs

Visiting Rodger Jacobs presents an opportunity to see woodworking in all its various stages. His large, airy studio sits among twenty-five acres of forest—the source of his raw material. "I believe in using the wood that I find locally," he says. "I like tramping through the woods looking for distressed, burled, or even plain trees. Peaveys [a lumberman's lever] and chain saws are the standard tools of my trade."

Inside the studio, visitors can see his work as it progresses from raw lumber to finished art. There are rough-cut pieces waiting to

be turned on a lathe, formed items in several stages of drying, decorative pieces about to be painted or adorned with beads or nails, and finished pieces ready to be shipped to galleries or exhibitions across the eastern United States.

Much of Roger's work is highly functional, especially the round salad bowls that come in three sizes. But his signature pieces are decorative free-form vessels that seem to float in the air. They're held aloft by small legs, but they have no visual weight. "I call these 'sneaky bowls,'" says Roger, who has written about them for a major wood-carvers' magazine.

When Roger looks into the future, he envisions himself spending an increasing amount of time on decorative work. Now, after a long day turning bowls, he experiments with new forms, adding a line of color here, a row of beads there. "This isn't work," he says. "It's fun."

PRICES
Wine corks, $8;
12" salad bowls, $150;
decorative vessels, $250–$400;
large sculptural pieces, $1,000+

LOCATION
Home studio; 5 minutes
north of central Newland

PHONE
704/733-9819

HOURS
Call first

PAYMENT
Visa, MasterCard, personal checks

WEST JEFFERSON ·····················

WOOD CARVINGS
Tom Wolfe

*Y*ou've almost certainly seen Tom Wolfe's work some
where—or at least the work of some of his protégés. Tom is
one of America's best-known caricature carvers and a prolific
author-teacher as well. He has published almost forty books on
wood carving, offers seminars to aspiring carvers from all over
the United States, and delivers wood-carving instruction via
televised classes on PBS.

Most of Tom's carvings are the product of an active, and some-
what quirky, imagination. There are gnomes and wizards, Santas
and wood spirits, knock-kneed golfers and wide-eyed ball
players. But Tom can also do "true" sculptures, carvings so
realistic that it's hard to believe they were done by the same
man. His thirty-inch-tall sculpture entitled "Oheray" (a Cherokee
word meaning "Land of the Sky")
is a museum-quality depiction of
early life in Southern Appalachia,
complete with lifelike Indians,
trappers, bear, and buffalo.

An admitted workaholic who
carves in the car while his wife
grocery shops, Tom gets restless
when he's not facing a challenge.
His latest goal is to carve animals
from fifty different woods, one
from each state. "Then," he says, "I'll
start on the Canadian provinces."

PRICES
Small cast reproductions, $10;
original carved pieces, $125–$10,000

LOCATION
Shop studio;
downtown West Jefferson

ADDRESS & PHONE
P.O. Box 831
West Jefferson, NC 28694
910/246-9771

HOURS
Call first

PAYMENT
Visa, MasterCard, personal checks

BANNER ELK
Creekside Galleries

POTTERS GALLERY (downstairs) represents approximately eighty craftspeople, mostly potters; 75 percent are from North Carolina. CARLTON GALLERY (upstairs) represents approximately 200 contemporary craftspeople; 85 percent are from North Carolina.
- **Location:** 10 minutes north of central Banner Elk
- **Address:** 140 Aldridge Rd., Hwy. 105, Banner Elk, NC 28604
- **Phone:** POTTERS GALLERY: 704/963-4258,
 CARLTON GALLERY: 704/963-4288
- **Hours:** Mon.–Sat., 10 A.M.–5 P.M.; Sun., 11 A.M.–5 P.M.

BLOWING ROCK
Expressions Gallery

This co-op gallery is run by eighteen local craftspeople who do contemporary work.
- **Location:** Downtown Blowing Rock
- **Address:** 960 N. Main, Blowing Rock, NC 28605
- **Phone:** 704/295-7839
- **Hours:** *Mid-March–June and Nov.:* daily, 10 A.M.– 6 P.M. *July–Oct. and Dec.:* Sun.–Thurs., 10 A.M.–6 P.M.; Fri.–Sat., 10 A.M.–9 P.M.

BLOWING ROCK
Moses H. Cone Mansion

Features crafts by members of the Southern Highlands Craft Guild, who live in nine Appalachian states; crafts are displayed

in the turn-of-century home of textile manufacturer Moses Cone.

- **Location:** 10 minutes north of downtown Blowing Rock
- **Address:** Milepost 294, Blue Ridge Pkwy., Blowing Rock, NC 28605
- **Phone:** 704/295-7938
- **Hours:** *Mid-April–Oct.:* daily, 9 A.M.–6 P.M.

BLOWING ROCK
Starwood Gallery

Folk art and fanciful crafts made by more than 200 artisans from the mountains of North Carolina, Tennessee, and Georgia are featured.

- **Location:** Downtown Blowing Rock
- **Address:** 1087-2 Main St., Blowing Rock, NC 28605
- **Phone:** 704/295-9229
- **Hours:** *June–Oct.:* Mon.–Thurs., 10 A.M.–7 P.M.; Fri.–Sat., 10 A.M.–9 P.M.; Sun., 10 A.M.–7 P.M.
 Nov.–May: Mon.–Sat., 10 A.M.–5 P.M.; Sun., 11 A.M.–5 P.M.

BOONE
Artisans Gallery

Features various crafts, with special emphasis on pottery, wood, glass, and jewelry; approximately one-third of the pieces are made by local crafters.

- **Location:** 2 minutes west of downtown Boone
- **Address:** 1711 Hwy. 105, Boone, NC 28607
- **Phone:** 704/265-0100

- **Hours:** *Jan.–April:* Mon.–Sat., 10 A.M.–5 P.M.
 May–Dec.: Mon.–Sat., 10 A.M.–6 P.M.; Sun., 1 P.M.–5 P.M.

BOONE
Hands Gallery

This co-op is owned and operated by sixteen local artists who make a wide variety of contemporary crafts.
- **Location:** Downtown Boone
- **Address:** 454 King St., Boone, NC 28607
- **Phone:** 704/262-1970
- **Hours:** daily, 10 A.M.–6 P.M.

Lodgings ·······················

Blowing Rock

Gideon Ridge Inn

*L*ook one way from Gideon Ridge Inn and you see the eastern edge of the Blue Ridge Mountains. Look another way and you see Mt. Mitchell, the highest mountain in the eastern United States.

Built in 1939 as a summer home by a Boston industrialist and purchased in 1984 by Jane and Cobb Milner, Gideon Ridge Inn now resembles an English country cottage in both design and flair. The European touches, mostly the work of Jane, who has a master's degree in museum conservation, include original art and an afternoon tea complete with scones and finger sandwiches.

Each of the ten guest rooms has its own personality, complete with antiques, comfortable reading chairs, and private bath. Some rooms have fireplaces, many have views, and one even has a two-person whirlpool tub. The television is relegated to the central living area; the phone is located in a private booth.

Rates
Weekdays: $115–$150, double occupancy; weekends (and entire month of Oct. plus certain holidays): $130–$170, double occupancy; breakfast and tea included; 2-night minimum stay on weekends, 3-night minimum over special holidays; open year-round

Location
5 minutes south of Blowing Rock

Address & Phone
202 Gideon Ridge Rd.
Blowing Rock, NC 28605
704/295-3644

Payment
Visa, MasterCard, American Express, Discover, personal checks

BLOWING ROCK

The Inn at Ragged Gardens

*J*ama and Lee Hyett were just a few weeks from opening their inn when Jama came across a wooden sign bearing this inspiring quotation: "Be not forgetful to entertain strangers for thereby some have entertained angels unawares." It seemed a perfect omen, and the sign now hangs above the front door of the recently renovated Inn at Ragged Gardens. Numerous friends and family members pitched in to help with the renovation. But in the end, it was Lee's architectural and construction know-how (he is a professional contractor) and Jama's interior design instincts that were responsible for the stunning results.

The three-story stone and bark-covered structure was built around the turn-of-the-century. The living room has chestnut-paneled walls, a stone fireplace, and a stone staircase leading to six second-floor rooms, as well as two new third-floor rooms tucked under the roof. All rooms now have private baths (some with Jacuzzi tubs) and fireplaces, but no phones or televisions. The Hyetts want this to be "a retreat," and they've added a host of little touches—such as a second floor butler's pantry well-stocked with gourmet teas, coffees, chocolates, and cookies, and breakfast served out on the veranda when weather permits—to make it just that.

PRICES
$105–$150, double occupancy;
includes full breakfast;
open year-round

LOCATION
Downtown Blowing Rock

ADDRESS & PHONE
P.O. Box 1927, 203 Sunset Dr.
Blowing Rock, NC 28605
704/295-9703

PAYMENT
Visa, MasterCard, personal checks

BOONE

Lovill House Inn

*L*ovill House Inn is one of the oldest homes in the Boone
area, built in 1875 by a decorated Confederate officer
who later became an attorney, a North Carolina state senator,
and a founding trustee of Appalachian State University. But
when Tim and Lori Shahen bought the house it 1993, it was
about to be condemned. They tore linoleum off the floors to
reveal rich and mellow old pine flooring. They salvaged three of
the original five brick fireplaces and most of the wormy chest-
nut woodwork. But for Lori and Tim this wasn't enough.

To blend convenience with the historical, they put double insula-
tion in all the walls to ensure privacy, and a television and
telephone in each room. They outfitted each of the five bed-
rooms with modern, private baths, extra thick mattresses, and deco-
rated them with a combination of antiques and tasteful reproduc-
tions, mostly in hues of burgundy and green.

The Shahens, self-described "natives from everywhere but most
recently from Albuquerque," had had their fill of corporate
America when they escaped to the mountains of Boone. They
personally and personably run the inn, hosting a social hour

PRICES
$85–$130 double occupancy;
includes full breakfast;
open year-round except for March
and the second week in Sept.

LOCATION
1 minute west of Boone

ADDRESS & PHONE
404 Old Bristol Rd.
Boone, North Carolina 28607
704/264-4204
reservations only: 800-849-9466

E-MAIL
shahen@appstate.campus.mci.net

PAYMENT
Visa, MasterCard, personal checks

every evening so guests who want to get to know each other will have the opportunity. "After all," says Tim, "this is an investment not so much in our pocketbooks as in our happiness."

VALLE CRUCIS

The Mast Farm Inn

*T*he Mast Farm Inn is a wonderfully rambling home with an equally wonderful rambling history. The first Mast to leave Germany for the American colonies was John Mast who, as legend tells it, walked from Lancaster County, Pennsylvania, to the hills of western North Carolina. In the late 1700s, his son Joseph exchanged his rifle, his dog, and a pair of leggings for more than a thousand acres of land, and in 1812 his son David built a two-room log cabin on the property. Over the years the Masts prospered, raising corn, tobacco, and grain, gradually enlarging their small farm. In 1885 they built a frame house which, with more than five additions, now forms the main building of Mast Farm Inn.

The old log cabin was converted to a loom house where Josie Mast, the wife of David's grandson, wove coverlets and rugs that today are in the Smithsonian. Other buildings—a barn, meat house, wood house, apple house, springhouse and blacksmith's shop—were constructed until the farm had at least sixteen different buildings, thirteen of which remain today. In 1972, the Mast Farm was placed in the National Register of Historic Places as an outstanding example of a self-contained mountain homestead.

Today, under the ownership of sisters Wanda Hinshaw and Kay Hinshaw Phillip, the inn offers guests their choice of antique-filled bedrooms in the farmhouse or larger quarters in some of the old outbuildings which have been converted into charming cabins. There are no televisions or telephones, just a good night's sleep, a relaxing chat on the porch, and hearty country meals.

PRICES
$75–$125, double occupancy; includes breakfast; cottages, $155–$185; dinner (also offered to nonguests), $15, reservations required; open year-round

LOCATION
Valle Crucis

ADDRESS & PHONE
P.O. Box 704
Valle Crucis, NC 28691
704/963-5857;
toll free: 888/963-5857;
fax: 704/963-6404

E-MAIL
stay@MastFarmInn.com

PAYMENT
Visa, MasterCard,
American Express, personal checks

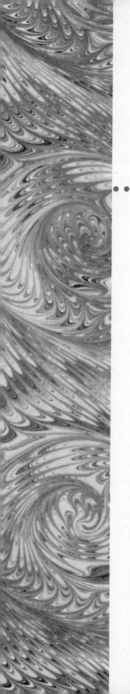

THE HIGH COUNTRY

THE HIGH COUNTRY

MANY ARTISANS FIRST CAME TO the high country to attend classes at Penland School, where they studied with recognized masters. Then, seduced by the tall peaks and narrow valleys, they decided to stay—setting up studios in the surrounding hills. The roads climb as you head north from Asheville, making their way towards Mount Mitchell State Park, home of the tallest mountain in the eastern United States. From the top of the 6,684-foot peak you can, weather permitting, see all the way to the Great Smokies.

Not too far away, Roan Mountain—a midget at a mere 6,285 feet—is famous for its rhododendron gardens that welcome summer with a glorious burst of brilliant color. But here the underground is as rich as the surface. More than fifty different minerals—from aquamarine and emerald to garnet and sapphire—have been mined from the area around Spruce Pine.

Underground treasures are brought to the light of day at the Museum of North Carolina Minerals near Spruce Pine, where raw and polished mineral make up an impressive display (704/765-9483). Want to see more of the area's hidden surprises? Emerald Village in Little Switzerland features a reconstructed mine and a small museum (704/765-6463). And if you want to experience the underground world firsthand, explore the series of large limestone caves at Linville Caverns near Linville (704/765-4171).

CONTEMPORARY POTTERY
Ken Sedberry

Ken Sedberry lives deep in the Toe River Valley, in an old white farmhouse with a startling red roof. Yet his studio is a contemporary building constructed of natural hemlock. The two buildings are indicative of the distinctive work you'll find inside: some pottery fashioned in the bright reds and hot yellows of Central America, where Ken and his family sometimes winter, and some pieces in the softer, more organic shades of the mountains.

Ken's tropical line has a lush intensity. Images of ferns and leaves are interspersed with turtles, frogs, and salamanders, all tumbling in glorious color on earthenware tiles and basins. On the other hand, his dinnerware, which is usually stoneware but occasionally porcelain, is soft and subdued. Water creatures swim across the interiors that are the cool, watery blue of mountain ponds rimmed in earthy orange.

PRICES
Tumblers, $12;
large porcelain bowls, $150–$375;
basins, $650+;
wall sculptures, $2,000

LOCATION
Home studio; 10 minutes
west of Bakersville or
20 minutes east of Penland

ADDRESS & PHONE
47 Mine Creek Rd.
Bakersville, NC 28705
704/688-3386

HOURS
Call first

PAYMENT
Visa, MasterCard, personal checks

Finally, there's his sculptural work: large wall pieces inspired by a Russian wolfhound, and smaller vases with carved masklike designs. Ken's work is varied and difficult to categorize, but his wife, Connie, does it well: "If you're into the conservative look, it's not for you."

An added bonus: when Ken and Connie built a large outbuilding on their property, they topped it with a gallery for Ken's work and a large room for overnight guests. Complete with wide-planked wood floors, an antique double bed, and full mini-kitchen, it's a perfect stopover for those who want both comfort and privacy. The best part: the bathroom features a bright Sedberry basin, the kitchen is outfitted with Sedberry kitchenware, and the sitting area has a Sedberry wall sculpture. (The room costs $55 per night; breakfast is available by special arrangement.)

STRUCTURED BASKETS
Billie Ruth Sudduth

*I*n 1968, on her honeymoon in Cherokee, North Carolina, Billie Ruth Sudduth bought her first basket. Now—after years of buying cheap imports, tearing them up to see how they were made, and experimenting on her own—she's one of only about a dozen basket makers nationwide who are taken seriously as artists. She's been invited to show her baskets in the Smithsonian craft show, a juried exhibition that only accepts about one out of every 250 applicants.

Two years after quitting her job as a school psychologist, Billie Ruth came across the work of Leonardo Fibonacci, an Italian who lived seven centuries ago. Fibonacci described the "Nature Sequence," a formula that involves starting with two ones, adding them to get two, and then adding the last two numbers in the sequence to get the next number: 1, 1, 2, 3, 5, 8, 13, 21, 34, etc. After the first few numbers, the ratios of any two progressing

numbers approximate the Golden Mean (five to eight), which has been used to unify design since the time of the ancient Greeks. Billie Ruth uses the Nature Sequence in her work, pleased with the mathematical structure it gives her weaving.

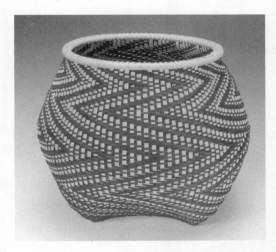

Billie Ruth Sudduth, basket

Her baskets range from whimsical to museum quality, from those based on old-time Appalachian baskets to ones of her own design. Her greatest satisfaction comes from meeting the people who purchase her work. "I like to know that part of what I do is part of these people's environment," she says.

PRICES
Small garlic baskets, $18;
Scottish hen baskets with
custom colors, $1,000+

LOCATION
Home studio; 10 minutes
south of Bakersville

ADDRESS & PHONE
109 Wing Rd., Bakersville, NC 28705
704/688-2399

HOURS
Call first

PAYMENT
Visa, MasterCard, personal checks

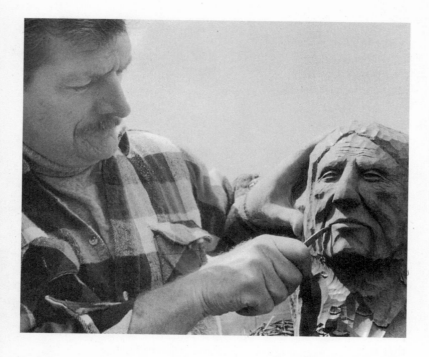

David Boone in his studio

WOOD CARVINGS
David Boone

"Families are like stew. Some just have more pepper than others," says David Boone, who comes from a very spicy family indeed. Go back on his mother's side and you'll find blacksmiths and trackers and bear hunters. Go back on his father's, and there's Daniel Boone, the great frontiersman.

His carvings, which have won prizes in just about every important wood carving exhibition, reflect his heritage. One shows an old man telling a story to two youngsters. ("My granddaddy always had time to tell us a tale," says David.) Another shows a blacksmith with a hole in his hat. ("'If a hat ain't got a hole in it, it ain't done much,' said my daddy.") Other pieces depict events that don't center around the mountains: a Vietnam soldier at mail call, a group of people having a roaring good time at a fifties-style concert.

David sketches his ideas first and then translates them into wood, most often using black walnut, wormy chestnut, buckeye, or basswood. Many of his sculptures have several figures carved out of a single piece of wood; others (like his fifties concert) are an arrangement of several pieces. Most are painted, a multiple-step process that brings out the glint in a character's eyes, the softness of a pair of hard-worn pants. "I like to carve little old funny things, with humor in them," he says.

PRICES
Walking canes, $25;
figures, $150–$3,200
depending on size, complexity,
and awards received

LOCATION
Shop studio; 15 minutes
south of central Burnsville

ADDRESS & PHONE
Rt. 6, Box 382
Burnsville, NC 28714
704/682-2838

HOURS
Call first

PAYMENT
MasterCard, personal checks

STONEWARE POTTERY
Michael Rutkowsky

Michael Rutkowsky's pottery is both elegant and elemental, with clean lines and understated style captured in sandy stoneware. Michael produces items that are functional but unique in form. His coffee mugs, for example, have three distinct parts: a collar, a rounded body, and a long foot (which, conveniently enough, allows it to fit solidly into a car beverage tray). His Irish mugs are narrow cylinders, while his tumblers are tall cones atop steadying bases.

Surface decoration consists of simple borders and squiggles, clay slip (liquid clay), and glaze-trailed lines that add interest without detracting from the essential form. Color—mostly rusts, soft blues, and creamy whites—also enlivens without overpowering. "When it comes to design, the simpler I can do it, the better I like it. Form is first and foremost in my pottery," says Michael.

PRICES
Mugs, $15+; lidded pitchers, $50; casserole dishes, $70; seconds sometimes available

LOCATION
Home studio; 15 minutes northeast of Burnsville

ADDRESS & PHONE
Rt. 2, Box 288-1-A
Green Mountain, NC 28740
704/682-9467

HOURS
Call first

PAYMENT
Personal checks

CLAY SCULPTURE
Jane Willis

There's a whole world of "Little People" sitting on Jane Willis's table—Indian braves paddling canoes, Pilgrims dressed in traditional garb, Amish women sewing quilts, and angels with halos and candles. Some of the figures wear richly flowered dresses; others hold intricately patterned blankets. All are made from clay, and their average height is only about three-and-a-half inches. Many of Jane's little people stand alone, but some are incorporated into wreaths and floral arrangements.

Jane's career started in the mid-seventies when she saw a picture of bread dough roses. She bought one book on bread sculpture and then took off on her own, gradually changing her medium to polymer clay. "I feel like my hands were made to do this," she says.

Her work certainly necessitates precise movements and steady hands. The miniature quilts, for example, are made by pressing tiny hearts out of one piece of clay, overlaying it on another, and making tiny stitch marks in a squared pattern. The pressed hearts are then combined to become flower petals for other sculptures.

PRICES
Single figures, $9–$24;
three-figure wreaths, $50+

LOCATION
Home studio; 1 minute
west of Burnsville

PHONE
704/682-9727

HOURS
Call first

PAYMENT
Visa, MasterCard, personal checks

CROSSNORE •

Crossnore Weavers

*F*ive women work the old eight-harness looms at Crossnore School, weaving items according to the same patterns and methods that women have used for generations. The capes, placemats, rugs, and blankets are created with a special purpose: money generated by sales goes to provide a safe, healthy environment for children whose parents can't properly care for them at home. Mary Martin Sloop would be proud.

In 1909, Mary Martin Sloop, fresh from completing her medical training in Pennsylvania, arrived in the North Carolina mountains. Mary was appalled at the conditions. Cabins were without electricity or running water. The basic diet consisted of hog meat and grease; making moonshine was the main industry. The old-time craft of weaving was being forgotten.

PRICES
Place mats, $9; rugs, $22–$80; afghans, $85-$115; seconds sometimes available

LOCATION
Shop studio; downtown Crossnore

PHONE
704/733-4660

HOURS
Mon.–Fri., 8:30 A.M.–5 P.M.; Sat., 9 A.M.–4 P.M.

PAYMENT
Visa, MasterCard, Discover, personal checks

Mary began a series of lifelong crusades: she campaigned against child marriages and backwoods liquor stills; she built a church, hospital, and school; and she reinvigorated the craft of handweaving. Today Crossnore is a seventy-two-acre campus supported largely by the sales of handwoven clothing and home furnishings. Each item recalls the traditional way of life and helps promote a better life for the children of today.

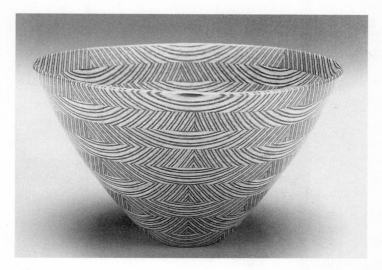

Buzz Coren, laminated wood bowl

LAMINATED WOOD VESSELS AND DESK ACCESSORIES
Buzz Coren

I magine taking a wood slab, cutting it into concentric rings, then stacking the hollow circles to make an inverted cone. Buzz Coren does this all the time—but he has taken this relatively simple procedure and turned it into high art. Buzz begins by making a complex piece of laminated wood that often incorporates hundreds of individual bits of wood and veneer arranged in an intricate pattern. He cuts this wood into concentric circles, then spins the rings until a kaleidoscopic pattern emerges. After gluing this into place, he sands and shapes, refines and finishes. The result is a bowl that is highly patterned and visually stunning.

Stack lamination is extremely time-consuming, and most woodcrafters prefer creating vessels on a lathe. But Buzz had been making wooden desk accessories and jewelry for years, and was familiar with lamination and veneers. He began making bowls in his spare time, and soon galleries began requesting his work.

Now Buzz is at a turning point. While he enjoys making the desk accessories and jewelry, he'd like to spend more time creating his unique vessels. "These offer technical challenges and unlimited design possibilities," he says.

• • • • • • • • • • • • • • •

PRICES
Jewelry, $10–$50;
desk accessories, $12–$25;
vessels, $95–$1,000

LOCATION
Home studio; 10 minutes
south of Micaville

PHONE
704/675-4661

HOURS
Call first

PAYMENT
Visa, MasterCard, personal checks

• • • • • • • • • • • • • • •

HAND-BUILT PORCELAIN

Lydia Jo Craven and Ian Craven

*L*ydia Jo Craven has been working with clay since she was seventeen, but a twenty-five year stay in Spain and France helped forge her distinctive style. She found herself fascinated by beautiful pieces of old lace, many of them 200 to 300 years old, and slowly amassed quite a collection. What would happen, she wondered, if she pressed the lace into the clay?

She rolled a piece of porcelain clay into a wafer-thin sheet, imprinted the lace design, and formed the delicate sheet into a variety of shapes—small vases that hold a single stem, larger bag

vases, and free-form plates, cups, and bowls. Husband Ian took charge of the glazes, developing his own formula to give depth to the designs without overwhelming them. His colors have a translucent character that complement the lace patterns.

The Cravens don't exhibit in galleries or shows. The only place to find their work is in the showroom connected to their home or in private collections throughout the United States.

PRICES
Small bag vases, $50;
large "patchwork" bowls, $400+

LOCATION
Home studio; 5 minutes
south of Micaville

ADDRESS & PHONE
1692 Hwy. 80 South
Micaville, NC 28755
704/675-9058; 800/764-2402

HOURS
Sun. and Jan.–March: call first
April–Dec.: Mon.–Sat., 10 A.M.–5 P.M.

PAYMENT
Personal checks

POTTERY AND DREAM CATCHERS
Mary Foley and Bill Grover

"*J*nktomi, the Spider Spirit, will help you remember your dreams," said a Cherokee medicine woman as she offered to teach her friend, Mary Foley, how to make dream catchers. In time Mary learned how to tie the six-pointed design that creates a web when framed by branches or pottery circles, and she also learned to pay attention to her dreams. After all, according to Native American legend, it was the Spider Woman who came down to earth to teach her children how to make pottery.

Mary had been trained as a watercolorist, but she'd always been fascinated by clay. Finally in 1985, enchanted by the look of raku

pottery, she decided to give it a try. About the same time Bill Grover, a computer analyst, decided he too was ready for a change. They set up home and studio atop a tall peak, and now Mary dedicates herself to clay work while Bill handles the firing.

Most of Mary's work is wheel-turned, although she sometimes makes forms by the extrusion process or by hand-building. Many of her pieces feature lace designs which she gets by imprinting the wet clay with pieces of lace made by Bill's great-aunt, Grace. "She made lace into her nineties, and she'd be pleased to know her art keeps on going," says Mary.

PRICES
Vases, $8–$14;
dream catchers, $15–$35;
angels, $19+

LOCATION
Home studio; 20 minutes
south of Micaville

ADDRESS & PHONE
Grovers Pots and Rocks
3640 Seven Mile Ridge Rd.
Burnsville, NC 28714
704/675-9633

HOURS
Call first

PAYMENT
Personal checks

GARDEN SCULPTURE

Richard Kennedy and Becky Gray

Dick Kennedy credits his wife, potter Becky Gray, with getting him started on outdoor art. They were on a trip to France, admiring the ornamental stonework that surrounded the châteaux, when Becky decided she wanted to sculpt a piece for a garden. There was one problem: the clay she used for her pottery couldn't withstand the weather.

Dick devised a plan. Becky would design the original piece, and

he would cast it in specialty stone to resemble the hand-carved statuary they'd seen in Europe. He now uses Becky's designs as well as those of several other local artists. He makes molds of their originals and recreates them according his own formula, using tiny particles of sandstone, marble, granite, or olivine that enable him to recreate the look of antique stone. "This allows people to get the work of contemporary artists and to have it in a medium that looks better than common cement but is more affordable than hand-carved stone," he explains.

He currently has more than twenty designs, ranging from a twenty-eight-inch tall figure of St. Fiacre (his best seller) to an eight-inch plaque of an angel. Other popular pieces include a child's garden seat, a birdbath, and a rabbit patterned after an antique piece from England.

PRICES
Small angel plaques, $42; antique-green statues of Pan, $485

LOCATION
Home studio; 15 minutes south of Micaville

PHONE
704/675-5286

HOURS
Call first

PAYMENT
Visa, MasterCard, personal checks

FUNCTIONAL POTTERY
Pete McWhirter and Kim McWhirter

For Pete McWhirter, making pottery is about two things: freedom and tradition. Freedom because he doesn't have to have a nine-to-five job; tradition because he's carrying on work begun by his parents.

• •

Pete's parents came to western North Carolina after a stint doing missionary work in Paraguay. His father found work painting signs, which led in a roundabout fashion to painting pictures. His mother, who'd been trained in art, began working with a local potter. In just a few years, the two opened their own pottery shop.

"I grew up going to craft shows," says Pete. "I like the gypsy life. I like not being dependent on someone else for a paycheck." When his dad died, Pete and his wife, Kim, began to help his mom in the shop. When his mother died in 1992, Pete and Kim had learned enough to proceed on their own.

"These 'critters' were started by Mom," says Pete, pointing to a series of mugs and bowls decorated with whimsical birds, cats, mice, and butterflies. "She used to doodle things like this on her term papers when she was in school."

Now Pete has expanded on his mother's lighthearted drawings by developing "Happy Bones," mugs that feature merry skeletons. He also has a line of dragon mugs and tiny people vases. They make you smile, and that, says Pete, is good. "That's what they're meant to do."

PRICES
People vases, $8;
dragon mugs, $20–$25;
large bowls and vases, $30–$60

LOCATION
Shop studio; 5 minutes
south of Micaville

ADDRESS & PHONE
4088 Hwy. 80 South
Burnsville, NC 28714
704/675-4559

HOURS
Mon.–Sat., 10 A.M.–5 P.M.

PAYMENT
Personal checks

HANDMADE PAPER IMAGES
Beverly Plummer

*H*appy faces and playful animals fairly dance off the walls of Beverly Plummer's studio. Her handmade paper images are rendered in crayon-bright colors and made with layer upon layer of paper fiber.

While her dressed stick-figure folks and square houses have the spontaneous feel of child-art, Bev's methods are highly disciplined. She begins her paintings with natural materials such as cotton, beating the fibers into pulp and then adding pure pigment to get the vivid shades that are her trademark. After the pigment sets, she collects the colors onto a screen, one atop the other, occasionally letting them blur, but usually arranging them

Beverly Plummer in her studio

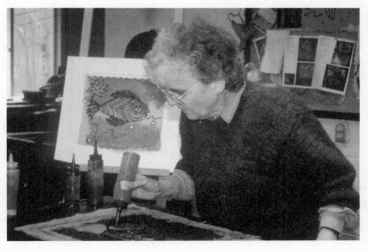

• • • • • • • • • • • •

PRICES
Paper paintings, $85–$1,500

LOCATION
Home studio; 10 minutes
south of Micaville

ADDRESS & PHONE
2720 White Oak, Left
Burnsville, NC 28714
704/675-5208

HOURS
Call first

PAYMENT
Personal checks

so that each color remains clear and strong. Finally she removes excess liquid, using both a vacuum from beneath the screen and a press on top. After several weeks of drying, voilà—the paper-paintings are ready for mounting and framing.

MIXED-MEDIA PICTURES AND JEWELRY
Bobby Wells

"*I* felt like a fish out of water until I came to western North Carolina," says Bobby Wells, who grew up in New England, went to college in California, then moved to North Carolina in the early 1970s. "I was a craftsperson surrounded by non-craftspeople. Here there's a real craft community."

For a long time Bobby was captivated by weaving—a large loom dominates her studio—but recently she's been experimenting with other media. "My work changes because my life is so full," she says, explaining how travels to Bali and Peru have influenced her art.

Her landscapes, which are constructed of whorls and squares of

patterned clay, have an Asian delicacy and complexity, while her masks are broad fields of strong color. Her masks begin with a piece of hand-woven fabric but incorporate a variety of paints and feathers. Her jewelry and landscape paintings are constructed of polymer clay. All of her work reflects a deep love for texture, pattern, and color.

Bobby Wells, clay painting

PRICES
Jewelry, $18–$56; masks, $250–$350; landscapes, $400+

LOCATION
Studio; 15 minutes south of Micaville

PHONE
704/675-4041

HOURS
Call first

PAYMENT
Personal checks

POTTERY AND FABRIC CRAFTS
Cynthia Bringle and Edwina Bringle

Cynthia Bringle has a goal: to replace all the plastic in your kitchen with pottery. Along the way, she'll also be glad to replace your standard bathroom sink with a distinctive clay bowl and the picture in your living room with a three-dimensional raku wall painting.

Cynthia, who began her career as a painter, has been using clay as a "dimensional canvas" for more than thirty years. Her pieces contain intricate brushwork designs that enhance the sculptural form. Only rarely does she make two pieces exactly alike. She even customizes her dinnerware sets according to the wishes of her clients.

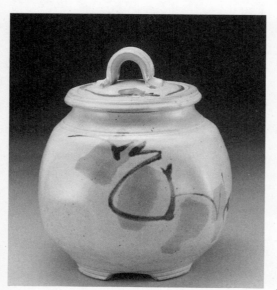

Twin sister Edwina, a fiber arts instructor at the University of North Carolina at Charlotte, uses yarns, fabrics, and paints to create a similar splash. Her painted and embroidered canvases, mixes of abstract and representational

Cynthia Bringle, pottery vessel

art, are bright and colorful. Her woven shawls, blankets, and scarves combine hues that in lesser hands would be garish, but in Edwina's hands soothe and delight. "I just love color," says Edwina. Her woven wool Bringle Bear, a teddy for adults, is of special note.

PRICES
Cynthia: spoon rests, $5;
four-piece place settings, $110;
large wall pieces, $1,500+
Edwina: weavings, $40+;
Bringle Bears, $150;
machine-embroidered
canvases, $650+

PAYMENT
Visa, MasterCard, personal checks

LOCATION
Shop studio; 1 minute
from Penland School

ADDRESS & PHONE
Penland School Rd.
Penland, NC 28765
704/765-0240

HOURS
Call first

FUNCTIONAL POTTERY
Jon Ellenbogen and Rebecca Plummer

*H*ave you ever heard a spider bark? Neither have Jon Ellenbogen or Rebecca Plummer, but that didn't stop them from naming their studio Barking Spider Pottery. Jon explains, "We just liked the name.... It makes people smile."

The Ellenbogen/Plummer studio is a passive solar building that sits on the banks of the Toe River and is surrounded by tree-covered mountains. In this picture-postcard setting, Jon, a native

New Yorker, and Rebecca, a Pennsylvanian, make pottery that is sold in all parts of the United States. The two met at a ceramics class at the Penland School of Crafts, chucked their former careers (he was a rocket scientist, she a philosopher), and after an apprenticeship in California set up shop near their old school.

Their specially formulated clay produces platters, mugs, and serving pieces that are durable as well as oven-, dishwasher-, and microwave-safe. While most of their functional pottery is earth-toned, their Christmas bells and balls are bright with stripes of red, blue, purple, and green.

PRICES
Dessert cups, $8; Christmas bells, $12; mugs, $18; canister sets, $120

LOCATION
Home studio; 1 minute from Penland School

ADDRESS & PHONE
Barking Spider Pottery
Box 50, Conley Ridge Rd.
Penland, NC 28765
704/765-2670

HOURS
Daily, 9:30 A.M.–4:30 P.M.

PAYMENT
Visa, MasterCard, personal checks

FLAME-WORKED GLASS
Shane Fero

S hane Fero's small, richly detailed figures—sometimes standing alone, sometimes sitting atop spirit vessels or forming the stems of goblets—live somewhere in the realm of the surreal. These supernatural figures tickle the imagination, suggesting mythological stories and fantastic worlds.

Shane makes his creations with a combination of glassblowing and lampwork. "The sculptural process consists of the manipula-

tion of glass rods in a flame torch, alternately adding and cooling the molten glass in sequential steps until the desired form takes shape," he explains. "The blown work is achieved by the controlled forcing of air into clear glass tubes [and adding] colors in an overlay technique."

Each year Shane has more than thirty gallery exhibitions, displaying his work across the United States and in Europe.

PRICES
Goblets, $175+; chalices, $190+; spirit vessels, $290–$500; other pieces, up to many thousands

LOCATION
Studio; 1 minute from Penland School

ADDRESS & PHONE
P.O. Box 266, c/o Penland School
Penland, NC 28765
704/765-0755

HOURS
Call first

PAYMENT
Personal checks

FIGURATIVE POTTERY
Jane Goslin Peiser

*W*alk into Jane Peiser's studio and you find you're in another world. Have you been transported back to medieval Europe? To ancient Persia? Jane's not likely to give you the answer; for the most part she's content to speak through her work. Her sculptures tell intricate stories of dignified women who light the way with giant candles, of haloed angels who sit by gardens of living green, or of mythical horses who carry cream and sugar to the dining table. Her creations are strong but delicate, fanciful but figurative.

They are also unique. Jane developed her method, which she

• •

sometimes compares to making refrigerator cookies, by trial and error. After coloring porcelain clay, she rolls it into flat slabs of different shades. She then piles the slabs atop each other and, in a complicated process, she slices-reassembles-and-rolls, slices-reassembles-and-rolls, until at last she has thin sheets in a mosaic pattern of tiny squares. This, finally, is the material from which her figures are composed.

PRICES
Small mosaic buttons, $2;
mosaic tumblers, $80;
large statues, $2,000+

LOCATION
Home studio; 2 minutes
from Penland School

PHONE
704/765-7123

HOURS
Call first; afternoons preferred

PAYMENT
Cash, traveler's checks

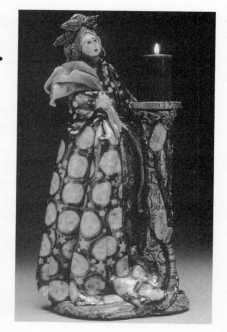

*Jane Goslin Peiser,
pottery sculpture*

GLASS ART
Rick Beck and Valerie Beck

*A*t first glance, Rick and Valerie Beck's studio looks like a home for carousel ponies and other fanciful animals from a children's fairy tale. But look again. These horse heads and horned creatures—some in checkerboard patterns, others with random splashes of bright color—are made of glass.

The Becks's creations are made of colored glass encased in clear glass, giving them a layered appearance. To get this look, Rick uses a Swedish technique that involves painting, blowing, and casting. Val specializes in blown pieces, especially large flowered vessels that sparkle with clear, bold colors.

While smaller pieces like paperweights and ornaments are now their most popular items, the Becks's larger works are quickly becoming known in galleries across the United States and in Europe.

A photograph of the Becks's work appears on the front cover of this book.

PRICES
Small pins, $15; sculptural pieces, $50–$8,000

LOCATION
Home studio; 2 minutes east of Spruce Pine

PHONE
704/765-0168

HOUR
Call first

PAYMENT
The Becks welcome visitors to their studio and display room, but they are not set up to make sales. Their work can be found at the Twisted Laurel Gallery in Spruce Pine (see page 175) and the Trillium Gallery in Little Switzerland.

GLASS ART
Gary Beecham and Mary Lynn White

*F*used designs of clear crystal mix with lengths of color to form geometric shapes inside a spherical paperweight. Bright rods of vividly colored glass embedded in a thick-walled vessel bloom forth like a multihued chrysanthemum frozen in time. Gary Beecham's glass art, designed with the help of his wife, jewelry-maker Mary Lynn White, is sleek, smooth, and sophisticated.

Having studied in Germany, Gary combines old European traditions with new American style. Realizing that he could never go "beyond the fragility the Venetians have achieved," he began developing heavier pieces in which the delicacy of design and color are contained within heavier walls of clear glass.

"My technique of first making color overlay rods, then fusing them into patterns, lets me suspend tubes and rings of pure color within my work. This process allows me adequate time to conceptualize and to make changes during the design stage, and frees me to concentrate totally on the form while blowing. I try to bring the forms into harmony with the ethereal quality I strive for in the colored patterns," says Gary.

● ● ● ● ● ● ● ● ● ● ● ● ● ● ● ●
PRICES
Gary: paperweights, $125+;
larger pieces, $1,200–$6,000+
Mary Lynn: jewelry, $15–$50

LOCATION
Home studio; 3 minutes
east of Spruce Pine

PHONE
704/765-5308

HOURS
Call first

PAYMENT
Personal checks
● ● ● ● ● ● ● ● ● ● ● ● ● ● ● ●

Gary's work is part of the permanent collections of museums throughout Europe (Belgium, Germany, Austria, Denmark, and France) and across the United States.

Gary Beecham, glass paperweights

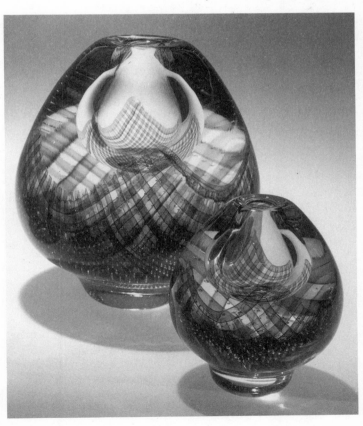

GLASS ORNAMENTS
Richard Crisp

*R*ichard Crisp was one of western North Carolina's best wood-carvers until, in the early 1990s, his arthritis began to interfere with his art. One of his friends suggested he change his wood shop into a glass shop, and within six months Richard had mastered a new craft. Now the downstairs of the old barn near his home is outfitted for glassblowing while the upstairs loft is filled with the sparkle of glass rather than the dust of wood.

Glass balls glowing with holiday reds and greens or autumnal rusts and golds swing from the ceiling, delicate bells hang from stands, and sleek round perfume bottles sit alongside decorative glass flowers on shelves. As cofounder of Cristtle Glass, which wholesales across the country and sells retail in western North Carolina, Richard makes thousands of glass items—especially ornaments—every year. "Surprisingly though, only about half my business revolves around Christmas," he says. "People today display ornaments year round."

PRICES
Round ornaments, $17–$22; teardrop ornaments, $24; flower sculptures, $80; seconds sometimes available

LOCATION
Home studio; 10 minutes east of Spruce Pine

PHONE
704/765-5301

HOURS
Call first

PAYMENT
Personal checks

KALEIDOSCOPES
Alice Houser

A lice Houser had no idea what she was getting into when she bought toy kaleidoscopes for her two children in the early 1980s. She became as fascinated as the youngsters, and soon her friends began giving her other scopes, which she displayed in wine racks. Years later she attended a course in kaleidoscope making at Penland School. She quickly learned the necessary skills—glass cutting, lens grinding, lampworking, sandblasting— and then the real fun began. She was free to design.

Alice's specialty is custom-made kaleidoscopes. Aside from the traditional bits of glass, she uses leaves, seashells, even baby teeth to form the repeat patterns typical of scopes. But that's not all. She'll wrap a marriage certificate on the outside and put antiqued jewelry on the inside to commemorate a twenty-fifth wedding anniversary. She'll work with a birth announcement and the beads from a newborn's hospital bracelet to celebrate a baby's arrival.

"Trying to capture the delicacy of a snowflake or the intense variety of fall leaves and 'bottling' it in a kaleidoscope has given me a new appreciation for the infinite imagination and awesome re- sourcefulness of God," she says.

PRICES
Kaleidoscopes, $36–$85

LOCATION
Home studio; 5 minutes southwest of Spruce Pine

ADDRESS & PHONE
429 Pond Rd.
Spruce Pine, NC 28777
704/765-0362

HOURS
Call first

PAYMENT
Personal checks

TRADITIONAL FURNITURE
Arval J. Woody

*C*arolyn and John Kennedy, Jr. each had one. They've been displayed in the Smithsonian in Washington D.C. and the American Craft Museum in New York, written about in a *National Geographic* book, and ordered by folks from as far away as Finland. In 1995 they earned their creator, Arval J. Woody, one of the highest honors in his field when he was designated a North Carolina Living Treasure.

Each chair in Woody's Chair Shop is handmade in the time-honored early American method once used by Woody's great-great-grandfather. There are no nails or glue; instead the carefully crafted pieces are interlocked and air-dried to make high-quality heirloom furniture.

The chairs come in three different designs, five different woods, and a variety of styles. All have woven seats.

PRICES
Towel holders, $15; chairs, $150–$250

LOCATION
Store workshop; 3 miles south of Spruce Pine

ADDRESS & PHONE
Woody's Chair Shop
110 Dale Rd., Spruce Pine, NC 28777
704/765-9277

BROCHURE
Write to the above address; enclose a self-addressed business-size envelope with $.32 postage

HOURS
Mon.–Fri., 8 A.M.–5 P.M. or by appointment

PAYMENT
Personal checks

Woody, born in 1920, doesn't make the chairs himself anymore. Instead, while nine skilled artisans craft furniture under his watchful eyes, he works on smaller items—like clocks, vases, spatulas, wine holders, and bread knives. "I'm officially retired," he says with a twinkle in his eyes. "Now I'm playing."

WOOD-HANDLED POTTERY
Nancy Fargo

"*The beauty of clay is that it's organic, malleable*," says Nancy Fargo. "*It's a dichotomy to make pieces with pure, straight lines.*" For this reason, Nancy's decorative items have an intentional irregularity. Large lidded bowls feature series of circling ridges, sets of graduated canisters are squared, faceted, or textured, and trays are tweaked into flowing asymmetry.

Wood handles give Nancy's work an added dimension. She collects branches of mountain laurel from the woods, strips the bark, cuts the branches to size, sands them, oils them to a satiny finish, and attaches them to special brackets that she designs into her pieces. This juxtaposition of wood and clay have become her trademark.

At age forty, Nancy took stock of her life and her career as a psychiatric social worker. It was time, she decided, to devote herself to pottery, which she had loved since she was a young girl. Today she has a large studio in the hills near Weaverville, where she produces a full line of functional items as well as her wood-handled specialty pieces.

PRICE
Mugs, $16; small bowls, $20; wood-handled pieces, $50–$300

LOCATION
Home studio; 10 minutes east of Weaverville

PHONE
704/645-2762

HOURS
Call first

PAYMENT
Visa, MasterCard, personal checks

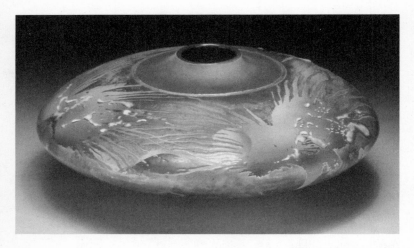

Steven Forbes-deSoule, pottery vessel

Contemporary Vessels
Steven Forbes-deSoule

"*L*iving here, it's hard not to be influenced by the mountains," says Steven Forbes-deSoule, a native Midwesterner who came to North Carolina after a long stint in Atlanta.

While some of Steven's work may be inspired by the mountains and, in some cases, the ocean, he often approaches landscapes from an unusual perspective. Many of his large globular vessels resemble planetary worlds erupting with color and texture. His pieces—neither fully pictorial nor totally abstract—are at the same time serene, symmetrical, and often rimmed with a regal band of gold.

Steven also makes hand-built pieces that are free-flowing forms,

wavy sculptures, or shard-shaped wall pieces. He frequently inserts a stone into the clay, or maybe a watch face, to add interest. "Philosophically," he says, "I try to achieve a balance between conscious control and the more subtle, unconscious forces that permeate physical reality."

By using a combination of glazes and acrylics and firing each piece individually according to the Japanese technique of raku, he gets the variety of colors and textures that distinguish his work. He juxtaposes smooth, flat surfaces and crackled, iridescent ones, just as he combines controlled shapes with organic, free-flowing lines.

PRICES
Cylinder vases, $50+; wall pieces and larger vessels, $200–$1,000; tile murals, $165 per sq. ft.; seconds occasionally available

LOCATION
Home studio; 10 minutes east of Weaverville

ADDRESS & PHONE
143 David Biddle Tr.
Weaverville, NC 28787
704/645-9065

HOURS
Call first

PAYMENT
Visa, MasterCard, personal checks

BASKETS AND BOWLS

Patti Hill and John Hill

In New Orleans, Patti Hill owned and ran a frantically successful restaurant; John was an equally successful commercial real estate broker. One day in 1986, when John was only forty-four and Patti even younger, they stopped running. Now they live a frugally comfortable life in the North Carolina mountains, growing most of their own food (Patti regu-

larly wins awards for her canning; John harvests honey from his bees), traveling by motorcycle, and making a variety of baskets and bowls.

John, who taught himself wood-turning, makes pens, bowls, and grooved bases for many of Patti's baskets. Patti hand-dyes reeds—from rustic browns to bright reds and purples—then friction-fits them into the grooves and begins weaving, sometimes creating wonderful original designs, other times following traditional patterns.

Many of her baskets are based on Shaker models, such as her four-footed basket that, when viewed upside down, looks like a stylized cat's head. Some have double walls with the inner basket having a completely different weave structure from the outer. And some—like her signature piece, which resembles a large wok—have tight-fitting lids to hide whatever is stored inside.

Patti's baskets are in such demand that she has trouble keeping up with orders. "Maybe," she speculates, "you can get caught up in the rat race wearing bib overalls just like you can get caught in it wearing three-piece suits."

A photograph of Patti's work appears on the front cover of this book.

PRICES
John: pens, $38; bowls, $40–$200
Patti: small Shaker baskets, $150+;
cathead baskets, $200+;
lidded wok baskets, $650+

LOCATION
Home studio; 10 minutes
east of Weaverville

ADDRESS & PHONE
6 Jump Cove Rd.
Weaverville, NC 28787
704/645-6633

HOURS
Call first

PAYMENT
Personal checks

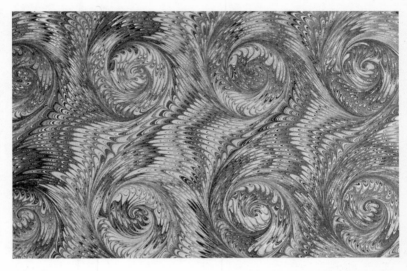

Mimi Schleicher, marbled paper

MARBLED PAPER AND FABRIC
Mimi Schleicher

R ainbow hues float on the surface, and kaleidoscopic patterns emerge. With a smooth sweep of her arms, Mimi Schleicher lays a piece of paper atop the water and captures a moment of time, a unique and unrepeatable print.

Marbling—the art of producing colored patterns on paper, on fabric, or occasionally on another surface—is an ancient art that dates back to twelfth-century Japan. The current technique, which involves pulling rakes or combs through drops of suspended paint, was developed in Turkey as a way to deter forgery.

Today marbling is most often used for bookbinding and in graphic design, but in Mimi's hands it also becomes pictures, note cards, legal pad holders, checkbook covers, miniature book brooches, silk scarves, and a host of other things.

Mimi's career in marbling started when her mother, a skilled marbler, became overwhelmed with orders and asked for her help. Today Patty is semiretired and concentrates mostly on bookbinding and creating designer books. Mimi does most of the marbling and has been featured at galleries across the country and in The Renwick Gallery at the Smithsonian Institute. Together they've written two books and produced a video on marbling.

PRICES
Cards, $12;
paper 18" x 23", $12–$14;
birthday calendars, $22;
silk scarves, $32–$42

LOCATION
Home studio; 2 miles
north of Weaverville

ADDRESS & PHONE
P.O. Box 1005
Weaverville, NC 28787
704/645-5392

HOURS
Call first

PAYMENT
Personal checks

CERAMIC SCULPTURE
Kathy Triplett

Kathy Triplett loves archaeology, junkyards, and water. It's an unusual combination, but it has inspired her to create sculpture which is strikingly contemporary yet often dusted with the patina of age.

Her teapots, for example, aren't anything like the ones on an

average stove top. Often two-and-a-half feet tall, Kathy's teapots are a juxtaposition of forms and colors that belong in a museum rather than a kitchen. "The teapot is a traditional form, but it's evolved into a type of sculpture," says Kathy. Her pots—as well as her wall

PRICE
Mugs, $20; tiles, $28+;
teapots, $600+

LOCATION
Home studio; 15 minutes
east of central Weaverville

PHONE
704/658-3207

HOURS
Call first

PAYMENT
Visa, MasterCard

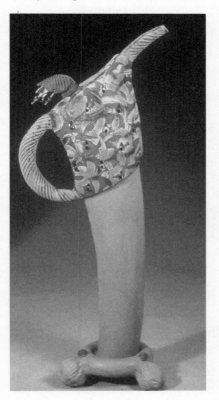

sconces and other work—often feature vivid colors applied in a way that produces a matte finish.

Her work is usually on display at Blue Spiral 1 in downtown Asheville (see page 42) or at her home studio, a scenic two-mile drive up a graveled road.

Kathy Triplett, ceramic sculpture

GALLERIES ····································

MARS HILL
The Gallery

Features contemporary and traditional crafts by approximately
thirty local artists.
- **Location:** Downtown Mars Hill
- **Address:** 8 Main St., Mars Hill, NC 28754
- **Phone:** 704/689-5520
- **Hours:** Mon.–Fri., 10 A.M.–5 P.M.; Sat., 10 A.M.–4 P.M.

MARS HILL
Hayden Gallery

A wide variety of contemporary crafts, 90 percent of which are
made by North Carolinians, are displayed in this old carriage
house filled with history and antiques.
- **Location:** Downtown Burnsville
- **Address:** 7 S. Main St., Burnsville, NC 28714
- **Phone:** 704/682-7998
- **Hours:** *Jan.–March:* by appointment
 April–Dec.: Mon.–Sat., 10 A.M.–5 P.M.

MICAVILLE
Toe River Crafts

This co-op, owned and run by fifty local craftspeople, shows a
mixture of traditional and contemporary works.
- **Location:** 15 minutes south of central Micaville
- **Address:** Rt. 80 South, Burnsville, NC 28714
- **Phone:** 704/675-4555

- **Hours:** *May, Sept, and Nov.–Dec.:* Fri.–Sat., 10 A.M.–5 P.M.;
 Sun., noon–5 P.M.
 June–August and October: Tues.–Sat., 10 A.M.–5 P.M.;
 Sun., noon–5 P.M.

PENLAND

Penland Gallery

Displays contemporary crafts made by Penland school students and teachers (many of whom are professional artisans experimenting with new techniques).
- **Location:** Penland School
- **Address:** Penland School Rd., Penland, NC 28765
- **Phone:** 704/765-2359
- **Hours:** *Mid-April–mid-Dec.:* Tues.–Sat., 10 A.M.–noon and
 1 P.M.–4:30 P.M.; Sunday, noon– 4:30 P.M.

SPRUCE PINE

Twisted Laurel Gallery

Contemporary crafts are featured with a focus on the work of local glass artisans.
- **Location:** Downtown Spruce Pine
- **Address:** 333 Locust Ave., Spruce Pine, NC 28777
- **Phone:** 704/765-1562
- **Hours:** *Jan.–March:* Fri.–Sat., 10 A.M.–5 P.M.
 April–Dec.: Tues.–Sat., 10 A.M.–5 P.M.

Lodgings

BARNARDSVILLE
The Hawk & Ivy

*A*ccording to the language of flowers, ivy, which clings and spreads, represents faithfulness and fidelity. According to the traditional beliefs of Native Americans, hawks, with their sharp eyesight, symbolize clear spiritual vision. So when Eve Davis, a renowned floral arranger, and her husband James, son of a Presbyterian minister, saw the old country house in Barnardsville, they knew they had found the perfect place for their bed-and-breakfast: it was near the Ivy River and a hawk was flying overhead.

RATES
$50–$80, single occupancy;
$65– $90, double occupancy;
includes full breakfast;
open year-round

LOCATION
3 minutes east of Barnardsville

ADDRESS & PHONE
133 North Fork
Barnardsville, NC 28709
704/626-3486

PAYMENT
Visa, MasterCard, personal checks

Built in 1910, the house stands on twenty-four acres of mountain meadow, with a large flower garden and an even larger vegetable garden. There's a rustic barn, which Eve and James grace with flowers and linen-covered tables for large celebrations, a gazebo which sometimes serves as a site for weddings, and a pond which is good for swimming.

The rooms, fixed up by former contractor James, are filled with antique family furniture. The main house, where Eve, James, and their two children live, has one guest room with an extra-long double bed on the main floor. There's no television, but the room is air-conditioned and partially accessible to the disabled.

The other three rooms, which have televisions, are in a nearby guest cottage. Two main-floor rooms share a kitchen, sitting room, and bath. One room has a double and a twin bed; the other has two twins. The upstairs room, which again has a fully equipped kitchen and is air-conditioned, has sleeping space for four (a double and two singles) and a breathtaking view of the meadow.

But while the rooms—many of which are decorated with local crafts—are delightful on their own, the abundance of flowers gives them a special charm. Eve has loved flowers for as long as she can remember. In 1983, she and James bought a large home in Atlanta, and she planted her flowers. Over the next few years a national commercial was shot on her property, and she was featured in special issues of *Better Homes and Gardens, Country Home, Veranda*, and *Southern Living*. Soon she was doing floral arrangements for some of Atlanta's biggest weddings.

Many of her Atlanta clients have followed her to The Hawk & Ivy, coming for a respite in the mountains or asking her to arrange not only flowers but entire weddings or reunions. "We've created a special place for people," she says, "one where they can find peace surrounded by nature."

BURNSVILLE
NuWray Inn

*T*he written records of NuWray Inn go back to 1833 when the town of Burnsville was founded. At that time, it was a log structure with eight rooms. But oral history has it that the core building has been used for lodging ever since the 1700s, when it was a stagecoach stop for those traveling from Asheville to Boone.

Today the NuWray Inn is a delightful three-story, twenty-six-room lodge that's listed on the National Register of Historic Places. Modern amenities welcome guests without diluting any of the old charm. Rooms that once housed Thomas Wolfe, O. Henry, and Elvis Presley are furnished comfortably with both antiques and television sets. A courtesy phone is available in the common room.

Promptly at 6:30 every evening during the high season, and on weekends during the winter, a reginaphone (precursor of the phonograph player) announces a big family style dinner in the dining room.

RATES
$70–$90, double occupancy; includes a hearty country breakfast; dinner (open for nonguests as well), $12; Sunday brunch, $14; open year-round

LOCATION
Downtown Burnsville

ADDRESS & PHONE
Town Square, P.O. Box 156, Burnsville, NC 28714
704/682-2329; 800/368-9729

PAYMENT
Visa, MasterCard, American Express, personal checks

MOUNTAIN SHADOWS

Mountain Shadows

THE BLUE RIDGE MOUNTAINS, WHICH ripple south from Pennsylvania to Georgia, are a geologically distinct part of the Appalachian range. They're old mountains, sculpted by eons of erosion into gentle hills and hidden hollers, rising in layered rows for more than five hundred miles. Their peaks graze the clouds, forming a natural boundary between the colonial east and the first frontier.

Driving west from Asheville, these mountains stand proud on the horizon, resplendent in hues of blue and purple. Whether you zip down Interstate 40 or meander along the scenic Blue Ridge Parkway, you'll see the peaks of Great Smoky Mountain National Park, the section of the Blue Ridge that lies between North Carolina and Tennessee.

As you tour this beautiful area, make sure to take time to stop along the way. In Mars Hill, you can experience the mountain past at the Rural Life Museum (704/689-1424). Waynesville offers two terrific stops: the North Carolina Handicraft Museum, a historic house filled with crafts, and the Stompin' Ground Dance Hall, where you can experience mountain clogging up close and personal. (Reach the museum at 704/452-1551 and the Dance Hall at 704/452-1551.) If the clogging whets your appetite for some exercise and excitement, try whitewater rafting; many area outdoor/sport companies offer guided rafting trips.

FORGED AND CAST METALWORK
Steve Kayne

*I*n fifty-plus years of blacksmithing, Steve Kayne, who started learning the craft when he was eight years old, has made things for every room of the house. "I start with the hinges on the front door and go on to the toilet paper holder in the bathroom," he's proud of saying. He's outfitted the homes of some pretty well-known people, including Clint Eastwood. He's made reproductions for the government, tables for the current owner of the Biltmore Estate, and hardware for folks in just about every state and many foreign countries.

Steve—with the help of his wife, Shirley, and two longtime assistants—makes both hand-forged and cast items, original designs and reproductions, items in a variety of metals (steel, brass, copper, and bronze), and several different finishes (black, pewter, antiqued, and polished). His shop includes three forges and a fully equipped foundry.

PRICES
Colonial spice hooks, $6;
fireplace tools, $40+;
Dutch oven doors, $1,200+;
commissions accepted

LOCATION
Home studio; 10 minutes
east of Canton or
5 minutes west of Candler

ADDRESS & PHONE
100 Daniel Ridge Rd.
Candler, NC 28715
704/667-8868
Fax: 704/665-8303

E-MAIL
Kaynehdwe@ioa.com

CATALOG
Write to the above
address; enclose $5

HOURS
Call first

PAYMENT
Visa, MasterCard, personal checks

His interest in and talent for metalsmithing isn't too surprising, considering that his family claims Tubalcain, the blacksmithing

son of the biblical Cain, as a direct ancestor. (True, there's no way to get absolute proof of this, but when Steve was in the Navy, the FBI checked his ancestry, and they agreed that yes, it could be so.) Whether or not Tubalcain is one of his forefathers, Steve has proof positive that there's been a smith in his family for at least four generations. He hopes his son will one day carry on the tradition.

Steve Kayne, forged iron door hardware

CONTEMPORARY WOOD LAMPS
Sarah McCrea

S arah McCrea was making wearable art in Miami not too long ago. Although business was good, she wasn't making enough to buy the kind of furniture she wanted. There seemed to be only one solution: she'd have to take a woodworking course and make her own chests and tables. There, among the nails and sawdust, she fell in love twice. First, she met the man whom she'd eventually marry and who would lead her to live near his family in North Carolina. Second, she devoted herself to woodcraft and divorced herself from wearable art.

Sarah is now a sought-after craftsperson whose works are sold in galleries across the United States. Although she occasionally creates furniture on commission (like the pieces she did for the North Carolina Arboretum), her main love is sculptural lamps. Her finely turned disks are gently rounded, looking somewhat like smooth, mysterious flying saucers in miniature size. After staining them—usually in natural tones but occasionally in deep, rich colors— she carefully arranges the disks, one atop another. Sometimes she makes short, squat stacks of only a few disks; other times she piles many into tall, slender towers.

PRICES
Candleholders, $85–$135; lamps, $250–$500

LOCATION
Home studio; 10 minutes west of Canton

PHONE
704/627-0730

HOURS
Call first

PAYMENT
Personal checks

FUNCTIONAL STONEWARE
Sarah Wells Rolland

"*M*otion" is a word that Sarah Rolland uses a lot. At first it seems like a strange word to use in describing stationary objects like mugs, vases, and platters, but somehow it fits. Sarah's glazes flow and glisten, giving her work a feeling of movement.

Sarah wheel throws all of her pieces, but she also shapes the clay after it has become leather hard. The rims of her platters are rippled or waved, her teapots are squared, and some of her bowls have carved areas that create a lacy effect. After bisque-firing the green clay in one of two electric kilns, she applies the glaze in several distinct steps.

"It's a sloppy process," she admits, "and very labor intensive." First she pours several layers of glaze over each piece. Then she removes the glaze from accent areas like handles or rims. Finally she applies another layer of glaze by airbrush. As the glaze heats in the final firing, it moves and melds, colors blending to create the feeling of motion.

• • • • • • • • • • • • • •
PRICES
Mugs, $14; baking dishes, $38;
large platters, $110;
lamps with shades, $180;
dinnerware on commission

LOCATION
Home studio; 15 minutes
south of Canton

ADDRESS & PHONE
324 Smokey Cove Rd.
Canton, NC 28716
704/648-0770

HOURS
Call first

PAYMENT
Visa, MasterCard, personal checks
• • • • • • • • • • • • • • •

TRADITIONAL MUSICAL INSTRUMENTS

James Trantham

*E*very autumn, Jim Trantham, director of and participant in the Village of Yesteryear at the North Carolina State Fair, goes to Raleigh, dresses in an old-fashioned costume, and tells folks about the traditional mountain dulcimer. "This kind of music is part of our culture here in the mountains," he says quietly as he displays a variety of stringed instruments.

Jim loves music—he and his son, Doug, perform at festivals throughout the region—so it seems natural that he'd learn to make instruments. "I grew up here in the mountains," he says, "and I was taught that if you want something, you make it yourself." Now he makes a host of instruments: lap dulcimers, hammered dulcimers, psalteries, lap harps, banjos, and a hard-to-find and even harder-to-play hurdy gurdy (a stringed instrument played by turning a crank).

"The true backcountry craftsmen are things of the past," he says, talking about legendary old-timers like toymaker Willard Watson and dulcimer maker Ed Presnell, who passed some of his knowledge on to Jim. Now Jim, as the next generation, is keeping the mountain traditions alive by making handsome, well-crafted instruments.

PRICES
Psalteries, $140; lap harps, $225; lap dulcimers, $280–$320; hammered dulcimers, $750–$1,150

LOCATION
Home studio; 5 minutes south of Canton

ADDRESS & PHONE
1052 Coffee Branch Rd.
Canton, NC 28716
704/648-3329

HOURS
Call first

PAYMENT
Visa, MasterCard, personal checks

Leicester ·······························

Traditional Brooms
Ralph Gates

*T*he first year that Ralph Gates made brooms, he grossed less than he'd paid in taxes the year before. Does he regret leaving his job as a systems engineer who worked on the Apollo project? Not at all. Instead of a stress-filled office in Florida, he works out of a former country store adjacent to his home and looks out on one of the most beautiful valleys in North Carolina.

When the Apollo project ended, Ralph and his family escaped to Tennessee. There Ralph learned Appalachian broom-making from an old man who'd learned it from his grandmother who in turn had learned it from her grandmother. Now Ralph figures he's making brooms pretty much the way they did back in 1700—except that he uses a power sander once in a while and buys his broom corn from Mexico.

Ralph finds wood for his handles in the nearby forest, sands it satin smooth, sorts the broom corn by size, and ties it onto the handle using time-honored techniques. Then he finishes the handle with two to six coats of lacquer and attaches a small cord for hanging.

PRICES
Small hearth or cobweb brooms, $12+; standard brooms, $26+; large specialty brooms, $200+; broom-making kits, $9–$48

LOCATION
Home studio; 25 minutes west of Leicester

ADDRESS & PHONE
8 Willow Creek Rd.
Leicester, NC 28748
704/683-9521

BROCHURE
Call or write for descriptive brochure

HOURS
Call first

PAYMENT
Personal checks

Ralph's a favorite at craft fairs. With his curly gray beard, country overalls, and three styles of brooms—light, wispy cobweb brooms, fireplace hearth brooms, and full-size sweeps—this former space engineer is a perfect reminder of times past.

Ralph Gates, broom

FUNCTIONAL STONEWARE
Cat Jarosz

*T*he tall pitcher is slender and looks delicate, but "it's meant to be *used*," says Cat Jarosz. It's made out of four separate pieces of clay—top, bottom, foot, and handle—and carefully designed not to tip or drip.

The same is true of the rest of her pieces. Function is primary, and Cat produces an exceptionally complete line of kitchenware. In addition to the usual mugs and casseroles, she makes specialty items like small espresso cups with saucers, salt and pepper sets, and honey pots with dippers.

Each piece has a distinctive look, a special ribbed texture that, although it is formed on the wheel, suggests layers of spiraling coils. So as not to compete with this unusual texture, Cat deliberately downplays her glaze, choosing a subtle oatmeal with undertones of mauve and blue.

● ● ● ● ● ● ● ● ● ● ● ● ● ● ● ● ●

PRICES
Mugs, $14;
soup tureens with ladles, $80;
three-piece canister sets, $130;
seconds sometimes available

LOCATION
Home studio; 15 minutes
east of Leicester

ADDRESS & PHONE
1177 Bear Creek Rd.
Leicester, NC 28748
704/683-3747

HOURS
Call first

PAYMENT
Personal checks

● ● ● ● ● ● ● ● ● ● ● ● ● ● ●

NATURE CRAFTS
George Knoll, Elaine Knoll, and Gladys Smith

When George Knoll left New Jersey for the North Carolina mountains, he had no intention of becoming a woodcrafter. But as he walked around the hills, he saw huge chunks of fallen wood—maple, black walnut, apple, dogwood, cherry, locust, oak, persimmon, willow—and he couldn't bear to let it go to waste. He began making vases, using only a drill and sandpaper, and before he knew it, he was in business. He bought enough woodworking tools to fill his basement and pressed his wife, Elaine, and sister, Gladys Smith, into helping him. Together they make a full line of handsome wood products.

George's signature item is a small box shaped like a maple leaf, an intricately crafted piece that requires almost 300 cuts on the band saw. He works with Elaine and Gladys to produce handsome one-of-a-kind lamps, the design of each base dependent on the type and shape of the found wood. Some are sleekly smooth; others more rustic and partially covered with bark. When Elaine couldn't find shades that looked good with these bases, she decided to make her own. She and Gladys now sandwich a

PRICES
Vases, $6–$40; lamps, $80–$200; maple leaf boxes, $98

LOCATION
Home studio; 3 minutes west of Leicester

ADDRESS & PHONE
P.O. Box 398, Leicester, NC 28748
704/683-3512

CATALOG
Write to above address; enclose $1

HOURS
Call first

PAYMENT
Personal checks

variety of local ferns, leaves, and grasses between special papers and form them into shades, sometimes adding trim of leather or suede.

The trio has gradually added other products to their selection of nature crafts. George continues to make his original vases as well as a classic, rectangular jewelry box, while Elaine and Gladys produce a line of brightly decorated gourd birdhouses.

STONEWARE POTTERY
Sharon Nirado Sloan

At first glance, you may think that Sharon Sloan makes three very different types of pottery: a purely functional line of mugs, hurricane lamps, and lotion jars, an organic line of smoky vessels adorned with gemstones and leather, and a delicate embossed line decorated with pink, blue, and yellow wildflowers. But talk to her for a few minutes and you'll find out that all three styles spring from the same source: a deep love for the mountains.

Sharon moved to western North Carolina in 1987 and was overwhelmed by its beauty. The glazes on her functional pottery are an attempt to capture those feelings—the dark green of the pine trees after the deciduous trees have lost their leaves, the soft green of moss-covered trees in the summer, the deep blue of a mountain midnight.

She began making vessels that seem to spring from the earth, using a very primitive firing method that involves smoldering the wheel-thrown pots in a container of smoking sawdust. But

it's Sharon's latest technique that gives her the most pleasure—a method she devised to capture the actual feel of Carolina wildflowers.

She begins by pressing flowers into a slab of clay to make a negative impression. After removing the flowers, she fires the clay to create a permanent mold. By laying a thin sheet of clay atop this mold and pressing gently, she transfers the impression and, upon lifting the sheet, has a relief image of the flowers. She gently rolls this clay into a vase, teapot, or lamp base, then glazes it in colors that duplicate the clear, springtime hues of nature's wildflowers.

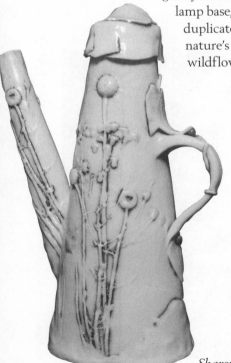

Prices
Mugs, $10; hurricane lamps, $35; vases, $350+; seconds sometimes available

Location
Home studio; 10 minutes southwest of Leicester

Address & Phone
34 Cabin Cove Dr.
Leicester, NC 28748
704/683-1174

E-mail
Deshua@aol.com

Hours
Call first

Payment
Visa, MasterCard, personal checks

Sharon Nirado Sloan, stoneware pitcher

Maggie Valley

Wood Mosaics
Jerry LaPointe

Back in Florida, Jerry LaPointe had a body shop where he restored antique cars. But in 1989 he and his wife decided they'd had enough of the population crunch, traffic, and crime, and they moved to a smaller home tucked in the hills of Haywood County. Jerry read a book on intarsia and said, "I can do that." Now, while he still occasionally restores Model Ts, he spends most of his

Jerry LaPointe, wood mosaic

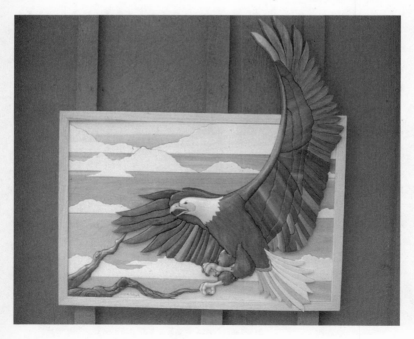

time cutting out hundreds of small pieces of wood and assembling them, puzzle fashion, into detailed pictures.

Intarsia differs from the more familiar marquetry, where the pieces of wood are inlaid to create a flat, two-dimensional picture. With intarsia each individual piece of wood is approximately three-quarters of an inch thick, which allows for rounded edges and, on occasion, for differing depths. Jerry begins by selecting the proper woods for each picture. For a desert picture, he selects wood with alternating streaks of dark and light in order to create shadows amongst the dunes, while for his panda-in-a-tree he finds a piece of knotted wood to simulate gnarled branches.

He then planes the selected woods and cuts the individual pieces with a bandsaw. It's not unusual for a picture to be composed of eighty or ninety separate pieces of wood, each of which must be sanded and glued into place. Jerry finishes the picture by applying a coat of clear sealer which enhances the natural color of the wood.

PRICES
Small bears, $65; sports figures, $175–$225; large, more elaborate pictures, $1,500+

LOCATION
Home studio; 5 minutes west of Maggie Valley

ADDRESS & PHONE
Rt. 1, Box 514
Maggie Valley, NC 28751
704/926-3409

HOURS
Call first

PAYMENT
Visa, MasterCard

APPLIQUÉS AND QUILTS

Juanita L. Metcalf

Juanita Metcalf has been sewing since she made her first apron in the third grade. After years of teaching algebra and geometry at the local high school, she retired and became a full-time quilter and sewer. "Now, you come back here and substitute for us when you get tired of sewing," said her principal. "I will," answered Juanita. She hasn't been back a day yet. She's too busy.

Fresh ideas come to her faster than she can make them: appliquéd wall hangings of dogwoods and pine trees, holiday banners, Christmas tree skirts, reversible vests, place mats in an elongated Dresden plate design, quilted hats, bedspreads, cloth games... The list is limited only by her imagination. Juanita's favorites are the wall hangings—"I never do two alike," she says—and the checkerboard games that come complete with a bag of painted wooden playing pieces so children of any age can compete in the age-old game of strategy.

PRICE
Hot pads, $5;
wall hangings, $90-$150;
king-size bedspreads, $1,000+

LOCATION
Home studio; 15 minutes
west of Maggie Valley

ADDRESS & PHONE
Rt. 3, Box 230-A, Clyde, NC 28721
704/627-8529

HOURS
Call first

PAYMENT
Personal checks

PORCELAIN POTTERY

Terance K. Painter

C ollege was a confusing time for Terance Painter. Most of his friends were studying to become lawyers and doctors and he... well, he liked art. "But art," he says, "was not recognized as a viable profession." Dutifully he studied to become an electrical engineer until he read Thoreau's words: "If a man does not keep pace with his companions, perhaps it is because he hears a different drummer."

"That passage made me feel a lot better about myself," Terance says with a satisfied look in his eyes. He took a pottery course, and "within two weeks," he says, "I knew what I'd been made for."

Today at Different Drummer Pottery his distinctive pottery shows the influence of the Sung Dynasty (AD 960-1280). Surface decoration and function are equally important as loopy swirls and dabbed flowers play against backgrounds of his trademark glazes: mountain glade (a serene, cool blue-green), evening crest (a dusty sunset pink), veiled mist (evening blue), stormy meadow (speckled gray and white), and snowbound (a strong blue and white). Most of his pieces feature intricate handles that resemble twisted braid.

PRICES
Ornaments, $12; dinner plates, $38; pictorial plaques, $36–$150; large platters, $130; seconds sometimes available

LOCATION
Shop studio; downtown Maggie Valley

ADDRESS & PHONE
704 Soco Rd.
Maggie Valley, NC 28751
704/926-3850

HOURS
Mon.–Sat., 9 A.M.–5 P.M.

PAYMENT
Visa, MasterCard, personal checks

Terance's background as both a native North Carolinian and as a painter is evident in another of his products: porcelain tiles in bas-relief that feature scenes of Southern Appalachia. Their detailed, slightly old-fashioned appearance is reminiscent of an etching overlaid with color.

Terance's work is only available at his studio. He refuses to wholesale because he enjoys meeting his customers. "Actually," he says, "I like to talk about as well as I like to make pots."

FUNCTIONAL POTTERY
Dennis Pitter and Benjamin Burns

Dennis Pitter knows how the Smoky Mountains got their name, and it has nothing to do with mist or fog or atmospheric layers. Instead, he explains, the well-known smoke is the result of thousands of puffs from the pipes of the Gappees, carefree little folks who sit around their campfires and smoke the nights away in nearby Soco Gap. To memorialize these gnome-like creatures, Dennis replicates them in clay. But the Gappees are only part of the special pottery featured in the studio that Dennis shares with Benjamin Burns.

Dennis also makes rosebud candelabra in a deep, coppery red. And Benjamin, whose work often features Japanese-style brushstrokes, has developed a unique silvery-black glaze that makes a stark contrast against the rich greens and spotted grays of many of his bowls and platters. Even his more traditional line (which he wholesales across the United States) is unusual, depicting an Appalachian sunset where red mountains are rimmed with light blue, navy, and amber.

Dennis Pitter, pottery menorah

Although both potters produce vivid, well-made pieces, and although most of their pottery is functional as well as decorative, each man has his own style. "Of course," says Benjamin, "no two potters do the same kind of work because pottery reflects the soul of the artist."

PRICES
Dennis: Gappees, $10;
menorahs, $95
Benjamin: mugs, $16;
candy bowls, $22;
large platters, $125–$150

LOCATION
Shop studio; 5 minutes
west of Maggie Valley

ADDRESS & PHONE
Rt. 19, Soco Rd.
Maggie Valley, NC 28751
704/926-6258

HOURS
Usually 8 A.M.–dark

PAYMENT
Personal checks

Mars Hill. .

Nancy Darrell

Nancy Darrell lives deep in the mountains of Madison County, one rocky mile off a rural gravel road. She's surrounded by fifty acres of trees, water, and serenity—all of which are reflected in her line of fine porcelain dinnerware.

Using a palette of soft greens, blues, golds, and pinks, she depicts the landscape of Southern Appalachia against a creamy white background. Her broad brushstrokes and delicate dots are often highlighted with a thin dark line, echoing the circle that rims most of her pieces. Although her dishes coordinate, each one is different: a pine tree nestled in the hollows on one, a sunset slipping behind the mountains on another, a peaceful snow scene on a third.

In 1995, Nancy began experimenting with another design: brown leaves against a moss green background. Some of her pieces, such as a canister set featuring a landscape with green accents, use both motifs.

PRICE
Mugs, $16; bowls, $14–$70; large vases, $65–$80; seconds sometimes available

LOCATION
Home studio; 45 minutes north of Mars Hill

PHONE
704/656-2731

HOURS
Call first

PAYMENT
Personal checks

TRADITIONAL BROOMS

Kim English and Douglas Haggerty

Kim English and Doug Haggerty make more than thirty types of brooms—hearth sweeps, stove sweeps, cobweb sweeps; golf brushes, wok brushes, hearth brushes; car whisks, table whisks, and gardeners' whisks.

Kim, who's a seventh-generation mountain man, and Doug, who hails from upstate South Carolina, pride themselves on working in a manner similar to that of their ancestors. Each of the thirty-one steps they follow to make their sweeps is done entirely by hand, using only simple tools indigenous to mountain culture. While their brooms could certainly be used to clean the dust off a cabin floor, most folks prefer to hang them on a wall or stand them by a fireplace. Each broom has an "extra touch"—a distinctive pattern in the weave, a special flair in the wood—that makes it decorative as well as utilitarian.

As an offshoot of their broom-making business, Doug makes woven "snowflakes" to adorn Christmas trees or serve as wall hangings. More recently, he's designed a series of woven tulips. Both snowflakes and tulips come in a variety of colors.

PRICES
Snowflakes, tulips, $10–$25;
table whisks, $15;
plain kitchen brooms, $50

LOCATION
Home studio; 10 minutes
north of Mars Hill

ADDRESS & PHONE
Sweeps, Etc.
Rt. 2, Box 135, Crooked Creek Rd.
Mars Hill, NC 28754
704/689-5122

HOURS
Call first

PAYMENT
Visa, MasterCard, personal checks

MARSHALL

COPPER JEWELRY
Aaity Olson

*T*he road to Aaity Olson's studio—nicely paved but full of twists and turns—goes up, up, and up some more. Finally, there's a short gravel driveway and then one of the most beautiful views this side of heaven. The hills of Madison County ripple off into the distance, layers of peaks in shades of blue and purple.

Although Aaity is a fine portrait artist, as is evidenced by the canvases that adorn her walls, she gave up oils for copper in the mid 1980s. Now she creates earrings, pendants, and bracelets decorated with detailed images and filigrees. Many of her pieces have a Western flair and are replete with buffalo, eagle, and wolf, while others reflect the Northeast and feature loons, weathervanes, and geese. An increasing number capture the rhythms of her adopted home of North Carolina. "This area," she says, "is filled with a characteristic peace that I hope will emerge in my design."

Most of Aaity's jewelry is made by the process of etching, whereby part of the metal is dissolved away. As a result her work is large yet lightweight. It is finished in different ways: by oxidizing to get a dull gold, by flaming to bring out deep reds, or by painting to get a variety of colors. In some cases she adds beads or charms.

PRICES
Copper earrings, $20–$45; silver and copper earrings, $65+; bracelets, $80–$250

LOCATION
Home studio; 15 minutes southeast of Marshall

PHONE
704/649-3826

HOURS
Call first

PAYMENT
Personal checks

CUSTOM JEWELRY
Diannah Beauregard

"*I*tems mean more to a person if they're made exclusively for them," says Diannah Beauregard. Although she makes some jewelry to sell through galleries, she specializes in custom pieces that reflect a buyer's personality and his or her inner needs. Often she uses astrological charts to give her insight. If, for example, the wearer's chart reveals that she or he is experiencing psychic turmoil, she might incorporate a turquoise into her design because of its sedative qualities.

Diannah enjoys exploring her creativity. One of her latest explorations involves fusion inlay, a technique in which fine gold and silver are fused together to create intricate designs with an antique patina.

She produces jewelry of all types, from plain gold chains to complex bolo ties, wedding band sets, bracelets, and pendants. Most of her pieces incorporate a variety of precious stones.

PRICE
Silver and gold earrings, $26+; custom necklaces, $500+, depending on complexity and materials

LOCATION
Home studio; 10 minutes west of Waynesville

PHONE
704/452-5244

HOURS
Call first

PAYMENT
Personal checks

BRAIDED RUGS
Linda Bledsoe and Ron Bledsoe

*L*inda Bledsoe wanted a rug for her home—the old-fashioned, braided kind that she remembered from her childhood—but she couldn't find one she liked. So she took a class and learned how to make the rug herself. Then when her teacher retired, she began making rugs for others. "I was concerned that this craft was getting swallowed up," she says.

Today she and husband Ron—both retired schoolteachers—braid, sew, and teach from their small shop just a few blocks from Main Street, Waynesville. "People who come to this area want traditional crafts," says Linda. "You won't believe the number of people who visit us and say, 'My mother used to do that.'"

Braiding rugs is not as easy as it looks. It takes practice—lots and lots of it—to make the braid even and to sew the braided strips so that they'll lie flat. The Bledsoes make their rugs with wool purchased from mills all over the country, including the famed Pendleton mill in Oregon. While most of their rugs are oval or round, they can also make squares or rectangles. "It just takes a different kind of braid," says Ron.

PRICES
Braided rugs,
approximately $12 per sq. ft.

LOCATION
Shop studio; 1 minute
from Waynesville

ADDRESS & PHONE
Rug Braider's Niche, Etc.
411 Branner Ave., Ste. 5
Waynesville, NC 28786
704/452-9707

HOURS
Usually Mon.–Fri., 1 P.M.–6 P.M.,
or by appointment

PAYMENT
Personal checks

FANCIFUL FUNCTIONAL POTTERY
MaryEtta Burr and Dane Burr

*W*hat happens when a no-nonsense potter meets a whimsical artist? They get married, that's what. And they blend their skills to create joyful, decorative pottery.

MaryEtta Burr was raised in Iowa with, she says, straightforward Midwestern values. "My parents thought 'art' was a waste of time. Everything had to be functional." Dane, on the other hand, "never had a functional idea in his life." When the two met, they soon realized they were a perfect match, professionally as well as personally.

Now working together in a small studio near downtown Waynesville, they've developed a unique line of sunburst plaques, rosy-cheeked mermaids, and fanciful figures that rattle when you shake them and weight down paper when you set them. Called "shakerweights," the rattles satisfy Dane's lust for the fanciful while the desktop use satisfies MaryEtta's need for the functional.

Photographs of the Burrs's work appear on the front and back covers of this book.

PRICES
Mugs, $16; big bowls, $55; decorative sculptures, $75–$500

LOCATION
Shop studio; downtown Waynesville

ADDRESS & PHONE
261 N. Wall St.
Waynesville, NC 28786
704/456-7400

HOURS
Daily, 10 A.M.–5 P.M., except major holidays

PAYMENT
Visa, MasterCard, Discover, personal checks

COUNTRY BASKETS
Nancy Hawley

"*I* do what the grapevines tell me to do," says Nancy Hawley, holding a large, rustic basket that measures nearly six feet around the rim. "And they're always suggesting new ideas."

Each of Nancy's baskets is unique. She works with a variety of materials, most of which she collects in her own front yard. She coils the needles of the loblolly pine into small baskets—some round, others oval. She also uses lovegrass, honeysuckle, and freckled cattails. Sometimes she accents the natural color of her materials by dipping them into dye made from found walnuts.

Nancy doesn't restrict herself to using only natural things. Sometimes she weaves in bits of colored yarn, store-bought beads, or feathers. This gives her work added texture, color, and design. "I like variety," she says. "And I like to know that at least one of my baskets will appeal to almost anyone."

PRICES
Small coiled baskets, $20–$30;
large Smoky Mountain
country baskets, $50–$75

LOCATION
Home studio; 10 minutes
west of Waynesville

ADDRESS & PHONE
121 Hidden Ridge
Waynesville, NC 28786
704/456-6657

HOURS
Call first

PAYMENT
Personal checks

TEDDY BEARS AND ART DOLLS

Gail Holt

*G*ail Holt shares her house with her husband, two dogs, and a menagerie of hand-made bears. Some of the bears wear vests, jackets, and bloomers. Others are dressed for the holidays— in red and green for Christmas or star-spangled navy for the Fourth of July. The mohair bears are for collectors, made from material that often runs more than $150 a yard, but the fake-fur bears can be enjoyed by either children or adults.

In the same room where she makes her bears, Gail also makes art dolls. These fabric statues stand approximately twenty inches tall and represent everything from Indian princesses to Zodiac empresses; all have hand-painted faces and fanciful clothes.

"They're inspired by fabric," says Gail, gesturing towards shelves and shelves of colorful yardage. "I buy it every chance I get, and then it tells me what to make."

Some of her cloth told her to make Victorian angels adorned with lace and flowers. Similar in form to the fabric statues but with long legs and wings that let them fly from a monofilament wire, they are proving to be one of her most popular items.

PRICES
Art dolls and angels, $35–$50;
Teddy bears, $35–$100

LOCATION
Home studio; 10 minutes
southwest of Waynesville

ADDRESS & PHONE
343 Big Cove Rd.
Waynesville, NC 28786
704/456-4477

HOURS
Call first

PAYMENT
Personal checks

WOOD CARVINGS
Ron Mayhew

*W*hen Ron Mayhew was nine years old, he made a little kitchen stool for his neighbor. He's been working with wood ever since, full time since the early 1980s. Often his pieces are multiple figures carved out of a single piece of wood, made with methods that date back to the early Renaissance. Many of his tools, such as chisels, gouges, and mallets, are more than one hundred years old; he doesn't use any electrical equipment.

PRICES
Individual figures, $200+;
multi-figured pieces, $10,000+

LOCATION
Home studio, 20 minutes
south of Waynesville
Shop, 10 minutes south
of Waynesville on US 276

ADDRESS & PHONE
Wood N Craft Shop
U.S. 276, Waynesville, NC 28786
704/648-2820

HOURS
April–Dec.: Mon.–Sat., 10 A.M.–5 P.M.,
or by appointment

PAYMENT
Visa, MasterCard

Ron rarely sketches his wildlife figures beforehand and he never makes clay molds. Instead, he studies skins that he borrows from a nearby natural history museum; from these skins he is able to imagine the live creatures as they once were. "I just see things three-dimensionally," he says. "It's my gift." This gift earned him one of the most coveted awards in his field: a red ribbon at the World Championship Wildfowl Carving Competition.

His larger pieces—like the carving of nine fish or his award-winning pair of egrets—often take several months to complete. For this reason he rarely has a large inventory. The best place to view his work is at The Wood N Craft Shop which he co-owns with his

mother, Jean. He works just a few miles away in a secluded grove of loblolly pines and is willing to meet with folks who are interested in his carvings.

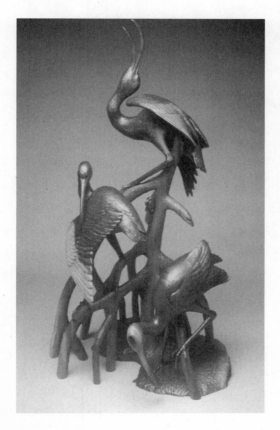

Ron Mayhew, wood wildfowl carving

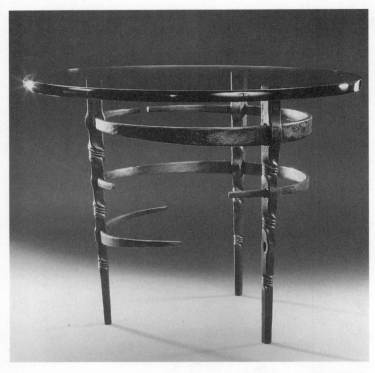

Daniel Miller, ironwork table

CONTEMPORARY IRONWORK
Daniel Miller

"*I* can make huge, fancy, French wedding cakes, but I prefer nice, wholesome nine-grain buns," says Daniel Miller, using a food metaphor to explain his preference for clean, contemporary lines. Working from a shop high in the hills over

Waynesville, he concentrates on making "architectural ironwork" where the design is determined by the function.

While Daniel does large works like gates and railings on commission, he also enjoys making smaller items. Combining ancient blacksmith techniques with modern welding and machining procedures, he makes soaring candelabras and tables that seem to float on air. Most have a subtle meaning, although Daniel admits that sometimes that meaning isn't clear even to him until long after the piece is finished.

One of his tables, for example—a round glass top resting on three iron legs joined by broken circles—was created to show the continuity of generations. The bottom rung, little more than an arc attached to one leg, represents children who have little responsibility for supporting the family. The second rung is a three-quarter adult circle, formed to help both the children below and seniors above. The top circle, the seniors, is almost complete, broken only by a small space that allows room for spiritual growth.

Several of Daniel's fire screens and door hinges can be seen at The Swag (see page 219), a nearby lodge known for its examples of fine arts and crafts.

PRICES
Candelabra, $150+;
door hardware, $300+;
fire screens, $700+;
architectural commissions accepted

LOCATION
Home studio; 10 minutes
west of Waynesville

PHONE
704/456-9330

HOURS
Call first

PAYMENT
Personal checks

CONTEMPORARY WOOD FURNITURE

David W. Scott

"*C*raftspeople owe so much to tradition," says David Scott. At first this seems like a surprising statement, coming as it does from a man whose own work is far from traditional. David's trademark three-legged stools, some with bentwood backs, are sleekly contemporary. His lightning bolt end table which, as the name suggests, has a distinctive zigzag top, is starkly modern. "But the materials and the methods are much the same as they always were," he explains.

David uses a variety of hardwoods, including walnut, cherry, ash, maple, and oak, many of which are native to Southern Appalachia. On occasion he combines these with showier figured woods. Legs are often lathe-turned; stool backs and rocking-chair runners are made by bent-lamination, a process which involves gluing together many thin strips of wood.

All of his furniture is sanded and rubbed to a satiny-smooth finish and comes in a variety of sizes and heights.

PRICES
Small stools, $95; hall tables, $1,100

LOCATION
Home studio; 12 minutes east of Waynesville

PHONE
704/627-8823

HOURS
Call first

PAYMENT
Visa, MasterCard, personal checks

HANDWOVEN CLOTHES
Liz Spear

"*This is dressed up for me,*" says Liz Spear, sitting in cross-legged comfort in jeans and white shirt. She smiles, well aware that the clothes she crafts for others are a far cry from what she chooses for herself. Her handwoven, carefully sewn items are sleek and sophisticated, the kind of outfits that women wear when they're sitting behind a desk in an executive suite or sipping coffee at a power lunch.

Liz begins by weaving her own yardage. She favors natural yarns, making most of her material 90 percent cotton, with some rayon for richness and gloss. Then she moves into the sewing room, using the lessons she learned long ago from her mother to fashion a smartly styled jacket or vest, complete with handmade buttons and full lining. The result is a finished garment that's made to last.

"My clothes are for people who admire art-to-wear but know that most of it is impractical," she says. "I want to make things that can really be worn, that can be enjoyed."

PRICES
Hats, $40; long vests, $180; shirts, $180–$280; jackets, $220–$350

LOCATION
Home studio; 10 minutes east of Waynesville

ADDRESS & PHONE
207 Howell Mill Rd.
Waynesville, NC 28786
704/456-3173

HOURS
Call after 9 A.M.

PAYMENT
Personal checks

SCOTTISH TARTANS
Marjorie Warren

*T*he soft sounds of Scotland make their way into Marjorie
Warren's voice when she talks about tartans and clans. She
has just a whisper of an accent, but it's enough to make you feel
sure that she knows what she's talking about. "As a child in
Glasgow, I didn't think too much about my Scottish heritage,"
she says. "But now my weaving keeps me in touch with my
roots." Marje weaves items in traditional plaids. She also helps
people and organizations design
their own tartan fabrics—develop-
ing patterns of strong reds, navies,
and greens, or using a Scottish
palette which, she says, "recalls the
blue of the lochs and burns, the
purple of the heather, the browns
and blacks of the peat bogs, and
the red of the lichens."

Although she designs tableware,
blankets, and scarves, she gets
particularly excited when she talks
about her dance sashes. "These are
contemporary heirlooms," she says,
fingering one of the silk sashes that
are used for Scottish country
dancing and ceremonial occasions. She works a delicate gold
thread into the pattern, adding a sparkle to the scarf when seen
in the right light.

Marje's "pladdies" are sold all over the world. She recently

PRICE
Place mats, $12 (minimum order, 12);
stadium blankets, $150;
dance scarves, $300

LOCATION
Home studio; 5 minutes
west of Waynesville

ADDRESS & PHONE
304 Crum Dr.
Lake Junaluska, NC 28745
704/452-0782

HOURS
Call first

PAYMENT
Personal checks

designed a tartan for Billy Graham's dining room at Montreat, a dance scarf for the wife of a United States Ambassador, and a Carolina tartan for the governor's mansion in Raleigh. In addition, she leads small group textile tours to Scotland.

Virtually all of Marje's tartans are special order. "Big mills can't afford to make small pieces of special plaids," she says, "but I can fill that niche. I work with people from start to finish."

CORDED FABRIC RUGS
Sheree White-Sorrells

\mathcal{T}he twelve-foot-wide loom almost fills the back room of Sheree White-Sorrells's studio. "They're only about a half-dozen looms this big in the United States," she says proudly.

PRICE
Rugs, $20–$120 per sq. ft.;
small woven bags, $20+;
sofa pillows, $55+

LOCATION
Shop studio;
downtown Waynesville

ADDRESS & PHONE
84 N. Main St.
Waynesville, NC 28786
704/452-4864; 800-573-9087

HOURS
Tues.–Sat., 11 A.M.–5 P.M.

PAYMENT
Discover, personal checks

Sheree's designer rugs are made from high-end fabrics, often upholstery cloth that, by virtue of its design, makes her work appear heavily patterned. Often she has the fabric rolled and stuffed to form thick cords which she then weaves, an innovative technique that's become her trademark. Except for occasional place mats, pillows, and purses that she sells from her studio, most of Sheree's work is done by commission. "People rarely buy a rug off the wall.

They want certain colors, certain designs," she explains. "We do a lot of talking back and forth."

In the future Sheree hopes to start weaving clothes from soft, luxurious fibers. She also works with leather. "I can work with anything that can be put into linear form," she says. "Regardless of the fiber I'm using, I find weaving to be a wonderfully comfortable involvement. It provides mental solitude and spiritual refreshment."

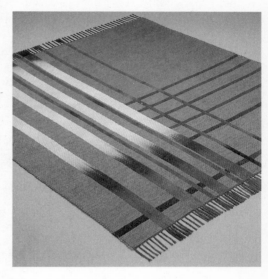

Sheree White-Sorrells, corded fabric rug

GALLERIES

Earthworks

Represents more than 200 artists who emphasize the environment and wildlife, featuring a large selection of Native American crafts, including some from North Carolina.
- **Location:** Downtown Waynesville
- **Address:** 110 N. Main St., Waynesville, NC 28786
- **Phone:** 704/452-9500
- **Hours:** *Jan.–March:* Mon.–Sat., 10 A.M.–5 P.M.; Sun., 1 P.M.–5 P.M. *April–Dec.:* Mon.–Sat., 10 A.M.–6 P.M.; Sun., 1 P.M.–5 P.M.

The Glass Giraffe

Displays a variety of glass work, all by local crafters.
- **Location:** Downtown Waynesville
- **Address:** 110 Depot St., Waynesville, NC 28786
- **Phone:** 704/456-6665
- **Hours:** Mon.–Fri., 10 A.M.–6 P.M.; Sat., 11 A.M.–6 P.M.

CANTON
Pisgah View Ranch

Occupying two thousand acres in the shadow of Mt. Pisgah, Pisgah View Ranch is North Carolina at its best—down-home comfort with warm friendships, good food, and great beauty. The property has belonged to the same family since before 1790. "It was my great-great-great-great-grandparents who built the original log cabin," says Phyllis Parris, who now owns and runs the ranch with her brother, Max Cogburn.

Phyllis and Max's great-grandfather built the main farmhouse around 1875. It's a wonderfully rambling building that now houses the ranch's office, eating areas, and public rooms. Guests have been welcomed since the turn of the century, when Grandmother Davis began lodging travelers en route to Asheville. In the early 1940s daughter Ruby and her husband Chester Cogburn took over, gradually adding twenty-four cottages to the grounds. Some are single units, but others have up to eight rooms, making a total of forty-eight units with varying combinations of double and single beds. Some cottages have a living room, a fireplace, and/or a porch; all have air-conditioning and television.

RATES
$50–$80 per person, double occupancy; children 2–6, half price; includes three meals daily and all activities except horseback riding ($12 per hour); meals served to nonguests with advance reservation: breakfast, $7; lunch: cold cuts, $6, hot plate, $8; dinner, $13; open May–Oct.

LOCATION
25 minutes east of Canton

ADDRESS & PHONE
Rt. 1, Candler, NC 28715
704/667-9100

PAYMENT
Personal checks

Some guests come just to sit under the old apple tree where they can gaze at the mountains, but many people want to work off the big country meals that are served family style three times a day. The ranch has a heated swimming pool, tennis court, shuffleboard, horseshoes, table tennis, horse-back riding, and miles of good walking to help people feel less guilty about devouring the bacon-and-egg breakfasts and fried chicken dinners.

After dinner most folks congregate in the big barn for some rousing entertainment—bingo games, a magician, a country band, folk singers, square dancers, and mountain cloggers. It's no wonder that Phyllis and Max don't do much advertising; they don't need to. Many of their guests first came to the ranch as children and are now returning with their own children. "It's that family atmosphere," said one man, a Miami lawyer who flies in for the weekend as often as he can. "It slows me down, helps me remember what's important."

WAYNESVILLE
Balsam Mountain Inn

"*J*est a few years ago, that old inn was a rotting mess up on the hill," says an elderly local gentleman. "Then Miss Merrily Teasley got hold of it, and I can't believe the difference. Why, that old house is all prettied up for a dance!"

That it is. Balsam Mountain Inn stands proudly on twenty-six acres of prime mountain land, surrounded by layered ridges that rise to more than 6,000 feet. The porches are lined with old oak rockers and the rafters hung with graceful ferns; the lobby is

filled with wicker and oak antiques, oriental rugs, and a host of plants; the library has a comfortable sofa plus more than 2,000 well-read and inviting books. Each guest room has its own personality and—in concession to modern times—firm new boxsprings and mattresses and private baths.

Don't expect telephones or televisions, though; except for a downstairs phone that is available for guests' use, these modern contraptions are banned from the premises. Balsam Mountain Inn today, as in the past, is a place to relax.

RATES
$90–$135, double occupancy; includes breakfast; lunch and dinner available at extra cost to both guests and general public; open year-round

LOCATION
10 minutes west of Waynesville

ADDRESS & PHONE
P.O. Box 40, Balsam, NC 28707

PHONE
704/456-9498

PAYMENT
Visa, MasterCard, personal checks

WAYNESVILLE
The Swag

On the day Deener Matthews agreed to buy a church, her husband, Dan, was out of town. Deener made the decision on her own. "It was the scariest thing I ever did," she says.

Today that church—a log and stone structure built in 1795—forms the heart of The Swag, a country inn that travel connoisseur Andrew Harper named one of the twelve best country hotels in the *world*. Sitting astride a 5,000-foot peak, The Swag (Appalachian-talk for a slight dip in a ridge between two

mountains) is a model of rough-hewn elegance. Continental cuisine is served in a notched-log dining room where a bearskin hangs on a two-story stone fireplace. Plush robes, steam showers, whirlpool baths, hazelnut coffee beans for in-room coffee grinders, CD players, and small refrigerators are in bedrooms that have exposed beams, planked floors, and hand-wrought iron fixtures. "God is in the details," reads a sign posted on one of the log walls; Deener spares no efforts and attends superbly to every detail.

Of course, God also works in mysterious ways. The Swag actually never was intended to be an inn. The Matthews simply wanted a family home, one large enough to double as a retreat for members of Dan's congregation. (Dan was then an Episcopal clergyman in nearby Nashville; he now serves as rector of the historic Trinity Church in New York City.) The Matthews began by purchasing 250 acres of land not far from Waynesville. Then they started scouring the mountains of North Carolina and Tennessee for five other old buildings. The church and cabins—at least one of which dated back to the Civil War (according to newspapers that were glued to the walls and spoke of Lincoln in the present tense)—were disassembled and their

RATES
$190–$440, double occupancy; includes 3 meals a day for 2 people and most activities; 2 night minimum; meals served to nonguests with advance reservation: lunch, $14; dinner, $40; Sunday brunch, $17; open Mid-May–October

LOCATION
20 minutes northwest of Waynesville

ADDRESS & PHONE
Rt. 2, Box 280-A
Waynesville, NC 28786
704/926-0430; 704/926-3119;
800-789-7672
Fax: 704/926-2036

PAYMENT
Visa, MasterCard, Discover, personal checks

logs hauled to the Matthews's land, where they were used to form the main building of the current inn.

In 1982 they added the Chestnut Lodge—four bedrooms, a library, and a racquetball court—to accommodate more folks during church weekends. To finance the addition they opened their home to a small number of paying guests who were in the area for the Knoxville World Fair. The idea of The Swag as country inn was born.

Today guests stay in eighteen rooms—some in the main house, some in the lodge, some in two other buildings constructed more recently—and enjoy walking the two-and-a-half mile nature trail (complete with swinging bridge and waterwheel), taking more vigorous hikes in the adjacent park, floating on a spring-fed pond, playing croquet or badminton, and relaxing on hammock-outfitted platforms. Guests can also peruse the work of numerous local artisans in the loft-shop.

THE WESTERN MOUNTAINS

THE WESTERN MOUNTAINS

SCIENTISTS SAY THAT THE HAZE in Great Smokies comes from a mix of humidity and the organic compounds produced by the many trees. But the Cherokee who, after all, were there long before the scientists, see it differently. They say the famous smoke dates back to a long-ago time when the Cherokee smoked the peace pipe with their enemies.

At first, as you drive into these mountains, you're likely to believe the scientists. But as you spend more time surrounded by thick forests, rippling streams, and gentle lakes, legends from way-back-when capture your imagination. Learn some old-time tales as you search for crafts on the Qualla (Cherokee) reservation, and enjoy traditional music and dance on Friday nights at the John C. Campbell Folk School (800/365-5724).

To explore the area outside of your car, try the Nantahala Outdoor Center near Bryson City; this is a starting point for raft, canoe, kayak, and bicycle trips (704/488-6900 or 800/232-7238). Other attractions to consider: the Fontana Dam (near the resort community of Fontana), which at 480-feet is the highest dam in the eastern United States, and the Franklin Gem and Mineral Museum, a historic building filled with minerals, fossils, and Indian artifacts. Call 800/849-2258 for information about the dam and 704/369-7831 for details on the museum.

FORGED METALWORK
Gary Thompson

Gary Thompson can trace his family tree back at least to the mid-1700s, and he always keeps coming across black-smiths. Ancestor Peter Thompson settled in Lenoir, North Carolina, in 1754 and became a smithy who worked for both the Patriots and the British during the Revolutionary War. He survived the war and went on to produce more blacksmiths, down through Gary's great-grandfather (who augmented his income by making moonshine) and grandfather.

Then the Thompsons left the trade. Gary's dad and uncles couldn't make a living forging metal, so they branched out into construction and other trades. Now Gary's glad to return to the family tradition. In 1990, he apprenticed at John C. Campbell Folk School and realized that it combined all the things he loved: art, engineering, tool making, recycling, and physical activity.

He lives and works in a home built by his mother's great-grandfather, where he concentrates on forging functional pieces: plant hangers, coat hooks, dinner bells, latches, and hinges. But occasionally he has time to make specialty items that are purely decorative, like table-top weathervanes and flower sculptures.

PRICES
Wall fern holders, $10;
wall coat racks, $35;
reproduction hearthware, $80+

LOCATION
Home studio; 1 minute
south of Andrews

PHONE
704/321-5769

HOURS
Call first

PAYMENT
Personal checks

ZENWARDIAN POTTERY
Lee Davis

*L*ee Davis has a name for the type of pottery he does: Zenwardian. "I strive for simplicity and keep going until every square inch is decorated," he says jokingly. "And I work until I achieve the spontaneity I want!"

The approach may sound contradictory, but the results are delightful. Lee's trademark functional pottery features simple lines and monochromatic tones coupled with complex surface decoration. The effect is similar to a pen-and-brush drawing covered with a watercolor wash.

Lee Davis in his studio

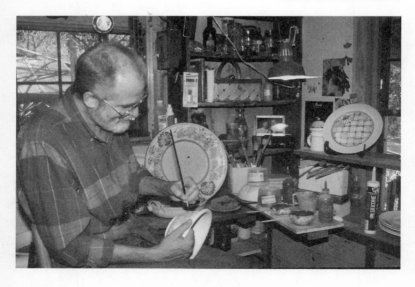

In addition to plates and bowls in various sizes, Lee fashions other kinds of kitchenware: round bread bakers, egg ramekins, and soufflé dishes, all of which come with instructions and recipes.

In stark contrast to his embellished dinnerware, Lee's decorative line is strikingly simple. His tumbling waterfalls—large bowls in which water gently ripples over staggered outcroppings—are solid black, broken only by artfully placed white "rocks." In these pieces the Zen influence overpowers the Edwardian.

PRICES
Egg ramekins, $6;
bread bakers, $24; soufflé dishes, $36;
waterfall fountains, $175–$325

LOCATION
Home studio; 2 minutes
west of Brasstown

ADDRESS
157 Mason Rd.
Brasstown, NC 28902

PHONE
704/837-7430

HOURS
Call first

PAYMENT
Personal checks

TURNED-WOOD VESSELS
Lissi Øland

"This is tough work. I get enough exercise that I don't have to go to aerobics," says Lissi Øland. She uses a tractor to drag huge logs into her large workshop, an ax to split them, and an engine hoist to lift them. When they're finally on the lathe, she climbs onto her chair and, using tools designed with the help of her late husband, Knud, spins the wood into giant bowls and vases.

She finds the work addictive. When Knud was alive, he did the turning and she was responsible for the sanding. "Now I know why I didn't get a chance at the lathe," she says with a broad smile. "This is fun!" The fact that the Southern Highland Guild granted her solo membership proves that she's well qualified to continue her husband's work. Lissi lives and works only a few minutes from John C. Campbell Folk School. In fact, her home once belonged to Marguerite Bidstrup, who cofounded the school. The two met while Lissi was still in Denmark and Marguerite was visiting to study the Danish "folkhøjskole."

Lissi makes good use of her "addiction," turning wood logs into everything from small salad bowls with even edges to uniquely shaped vases that flow with the patterns and irregularities of the wood.

PRICES
Small bowls, $25; lidded boxes, $45; large vases with uneven edges, $1,500+

LOCATION
Home studio; 2 minutes south of Brasstown

ADDRESS & PHONE
Rt. 1, Box 75, Brasstown, NC 28902
704/837-2273

HOURS
Call first

PAYMENT
Visa, MasterCard, personal checks

FORGED METALWORK
Elmer Roush

Elmer Roush couldn't find the right kind of hinges for a colonial-style cabinet he was making in Virginia, so he decided to make his own. That was back in the late 1970s, and he hasn't worked with wood since. "This is what I like to do," he

says, pointing to a variety of steel fireplace utensils, candle holders, letter openers, and hinges.

Elmer trained first in the United States, but in 1987 he went to Czechoslovakia to perfect his skills. "During the Industrial Revolution blacksmithing nearly died out in this country," he explains. "But in Central Europe the tradition of ornamental iron work continued. We have some outstanding smiths, but they have more."

Now he does commission work and wholesales his small pieces across the country. His reproduction pieces are so accurate that they mimic the original to within one-eighth of an inch. But he also makes contemporary items, some straightforward, others whimsical. His wizard and snake candle holders are especially popular. "I use a horse rasp (an equine nail file) to get the scale effect," he confides.

In 1996, Elmer agreed to act as resident blacksmith for John C. Campbell Folk School. In addition to overseeing the department, he teaches several classes to beginning smithies.

PRICES
Dinner bells, $12–$15;
candle holders, $20–$80;
fireplace sets, $80–$350

LOCATION
Shop studio; on campus of John C. Campbell Folk School in Brasstown

ADDRESS & PHONE
Rt. 1, Box 97-A
Brasstown, NC 28902
704/837-8665

CATALOG
Send self-addressed 9" x 12" envelope with $.80 postage

HOURS
Call first

PAYMENT
Personal checks

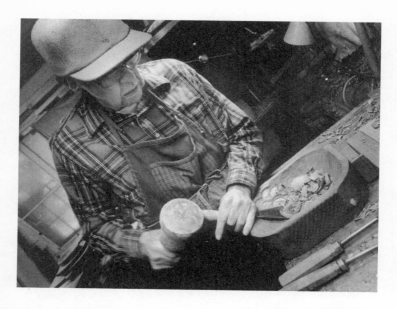

Fred Smith in his studio

CARVED WOOD TRAYS AND BOWLS
Fred Smith

Fred Smith is carving bowls out of trees he planted when he came to Brasstown, not long after the end of World War II. "I came down here (from my home in Tennessee) to see a friend, and I got stuck," he says. He started working in the wood shop at John C. Campbell Folk School. With the encouragement of Olive Dame Campbell, one of the founders of the school, he began creating trays and bowls. One of those bowls is in the permanent collection of the Smithsonian.

Over the years, Fred has developed an efficient method for making his distinctive gouged items, using machines to rough out each piece but finishing it by hand. Working in a two-room cabin near his home, he begins by cutting a "blank" with his bandsaw. He puts this two- or three-inch thick square or rectangle into a drill press so he can quickly remove some of the inner wood. Then he clamps the piece securely to a table and carves the inside more precisely, hitting the gouge with a wood mallet, taking out one shaving at a time. Later he carves the back with a knife, shaping it to conform to the inside. Finally he hand-sands the piece and finishes it with two coats of clear lacquer.

PRICES
Small cracker trays, $11; individual salad bowls, $38; large trays, $235

LOCATION
Home studio; 2 minutes south of Brasstown

PHONE
704/837-2274

HOURS
Call first

PAYMENT
Personal checks

PORCELAIN POTTERY

Lisa Tevia-Clark and James Tevia-Clark

*L*isa and James Tevia-Clark produce pottery that looks as old as the ages. The regal forms look like relics from the past, miraculously preserved and retrieved by archaeologists. The dominant glaze is the color of overripe berries, and it appears to have been rubbed off in spots, revealing the dry mud base underneath. The surface designs are intricate impressed patterns that hark back to ancient Persia.

Lisa, who has been a potter since the early 1970s, has developed many of her own tools. The bands of design that are a hallmark of her work are produced by rolling a handmade patterned wheel around the circumference of the piece, while the button and medallion details are made with hand-carved stamps. "Of course, sometimes I use ready-made patterns," she explains with a smile, pointing to a crosshatched design that came from the bottom of her son's tennis shoes.

While most of Lisa's work is wheel-thrown, some of the larger pieces also involve a degree of hand-building. The narrow-necked pieces, for example, have to be made in two parts and assembled later, because Lisa must be able to put her hand inside the base in order to properly impress the designs. In addition, many of the sculptural pieces feature highly decorated "arms" and "hats" that have to be made separately and attached before firing.

Jim, who also has superior craft credentials, recently has turned from working with wood to working with clay. He helps Lisa with the large pieces, especially the slab-built platters, and is responsible for organizing shows and display areas.

PRICES
Small bowls and platters, $36–$60;
vases, $180–$500;
larger pieces, $600–$1,200;
seconds sometimes available

LOCATION
Home studio; 3 minutes
south of Brasstown

PHONE
704/837-8256

HOURS
Call first

PAYMENT
Visa, MasterCard, personal checks

BOOKBINDING AND WEAVING
Virginia Turnbull

*D*ifferent types of books, explains Virginia Turnbull, have to be bound in a special ways. If the pages of a scrapbook aren't separated near the binding, the book will bulge when mementos are inserted. She is free to bind other books in more unusual ways—such as pop-up books that have interlaced pages and display books that unfold to make tabletop sculptures. Virginia also takes special care with cover materials, sometimes marbling the paper herself, other times inlaying designs into leather, incorporating silk, or plaiting ribbon into decorative patterns.

Virginia's love for pattern and design also shows up in her weaving. She has seven looms in her home, some that are able to handle rugs as wide as forty inches. She often uses weave patterns that are derived from the Shakers and edges her wool or cotton rugs with bands of material to give a finished look. One of her most unusual woven pieces is a "ruana," a wrap inspired by clothing worn by women in Colombia.

PRICES
Pop-up and display books, $35+;
scrapbooks, $65+;
wool ruanas, $300+; book
restorations, priced individually

LOCATION
Home studio; 3 minutes
southeast of Brasstown

PHONE
704/837-8388

HOURS
Call first

PAYMENT
Personal checks

MIXED-MEDIA SCULPTURE
Sandy Webster

"*T*his is like when I was a kid," says Sandy Webster. "I spend my days cutting and pasting and playing." Sandy "plays" with almost everything—with paper, paint, and clay, with fabric, yarn, and beads, with twigs, branches, and old weathered boards. It is all raw material for her art.

Sandy's work, as you might imagine, is wildly inventive. To show her love for her mountaineer neighbors, she used clay, fabric, wood, and reeds to create three country men cheerfully and humorously bellowing ballads. To emphasize the need for cooperation, she used a long ax handle as a longboat, with clay and twig men as rowers who must work together. To express her outrage over the slaughter in the former Yugoslavia, she constructed a coat out of an old blanket and patched it with fabric copies of newspaper photos of injured adults and crying children as well as reproductions of letters she has exchanged with President Clinton.

You never know quite what you'll find when you visit Sandy Webster. There's only one thing you can count on: whatever you find, it will be totally unique.

PRICES
Jewelry and small purses, $24–$75; sculptural pieces priced individually

LOCATION
Home studio; 3 minutes south of Brasstown

PHONE
704/837-3971

HOURS
Call first

PAYMENT
Personal checks

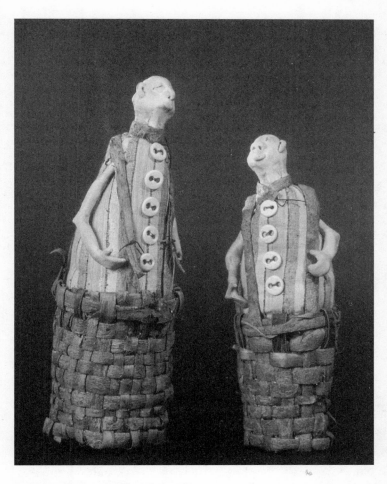

Sandy Webster, mixed-media sculpture

BRYSON CITY........................

ASSEMBLAGE ART
Steve Clobridge

"*I* use whatever works," says Steve Clobridge, whose slice-of-life scenes often contain bits of old wood, tin, plaster, clay, and wire. Extending about four inches from the wall to give a feeling of dimension, his scenes are based partly on places he's been, partly on imagination.

There are nautical scenes with rowboats and bait shacks, mountain scenes with sheds and barns and cabins, city scenes with bordellos and taverns. Most include one or more human figures, sculpted out of plastic-based clay and painted with acrylic.

Steve's work as an artisan began almost by accident when he was restoring a home in Colorado and living "about fifty miles from the nearest 7-Eleven." To while away the time, he began making bird feeders out of wood scraps. He made birdhouses that looked like saloons and barns and houses until, he says, "I had a whole ghost town of bird feeders, so I decided to get rid of the birds, add the people, and I just went on from there."

Now Steve makes birdhouses two days a week and concentrates on his scenes the rest of the time. But the birds still get mighty fancy homes—often in the shapes of churches, cabins, and, on occasion, outhouses.

PRICES
Birdhouses, $20–$50; scenes, $75+; special orders accepted

LOCATION
Home studio; 5 minutes west of Bryson City

PHONE
704/488-6503

HOURS
Call first

PAYMENT
Personal checks

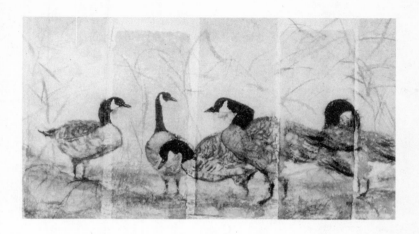

Elizabeth Ellison, paper and watercolor collage

Paper and Watercolor Collage
Elizabeth Ellison

*G*o up some creaky stairs to a studio above the old Clampitt Hardware and you're likely to find Elizabeth Ellison stripping the pulpy flesh from large green stalks that she gathers down by the river. If you catch her on the right day, she may be cooking the stripped fibers, beating them into paper-preparedness, or pouring the resultant slimy mass onto hand-made frames. Eventually she'll have some wonderfully tex-tured handmade paper, speckled and shaded according to the type of plant she uses.

It's a long, often tedious process, but one that adds fascinating depth to Elizabeth's watercolor paintings. "People who know me

were surprised when I took this up," she says with a laugh. "I like watercolor because it's so immediate, and here I am doing papermaking which is slow and somewhat scientific. But handmade paper works so well with my paintings."

PRICES
Watercolor cards, $15;
watercolor and paper collages,
$100—many thousands

LOCATION
Shop studio;
downtown Bryson City

ADDRESS & PHONE
159 Main St., Bryson City, NC 28713
704/488-8782

HOURS
May—Aug. and Oct.:
Mon.–Sat., 10 A.M.–5 P.M.;
Sept. and Nov.–April: call first

PAYMENT
Visa, MasterCard, personal checks

Elizabeth has been using watercolors since the mid-1960s; over the years she's developed many different styles, but the predominant theme of her work is nature. She also frequently explores Native American subjects, partly because she's one-eighth Occancechi (Eastern Sioux), partly because western North Carolina is home to many Cherokee.

STAINED GLASS
Stephen True

S ome of Stephen True's stained glass creations hang in windows (a large landscape depicting a mountain sunset, for example, or another of a desert summer). Some hang overhead, like his big rectangular lampshades for dining or pool rooms, while platters, trays, and candle lamps in the shape of pyramids sit on table tops. Still others are tables, pieces of furniture that combine wood and light panels with dazzling effect.

Stephen, who opened his studio in 1996, has enough ideas to keep him busy for lifetime. It is obvious that, given his choice, he'd concentrate on large one-of-a-kind items, but he also makes a variety of small suncatchers featuring everything from abstract patterns to wildflowers.

Using fusion techniques as well as copper foil, he often juxtaposes a variety of glasses and colors in a single item. Glass beads often highlight his work, making a field of wildflowers in a landscape or an accent on a small suncatcher.

PRICES
Small suncatchers, $5–$60;
candle lamps, $45+;
large landscapes, $500+;
furniture with light panels, $1,200+

LOCATION
Shop studio;
downtown Bryson City

PHONE
704/524-9200

HOURS
Call first

PAYMENT
Personal checks

CHEROKEE •••••••••••••••••••••••••

Rowena Bradley, Alyne Stamper, Betty Toineeta, and friends

*A*lyne Stamper began doing beadwork at age eight, carefully following her grandmother's instructions. Rowena Bradley learned to weave with river cane before she was seven and uses many designs handed down by her elders. Betty Toineeta is learning to finger weave through the lessons of her mother, who has spent years demonstrating the craft at the Oconaluftee Indian Village.

These women are all members of the Eastern Band of the Cherokee Nation, and their crafts hark back to a time when the Cherokee governed more than 135,000 square miles of eastern North America. Much was lost in 1838 when the Cherokee were forced out of their homeland and were marched cross-country to Oklahoma and beyond. But a few Cherokee refused to leave their ancient homeland. Instead they hid out in the Smokies, escaping the "Trail of Tears" and remaining to pass on their traditions. Their crafts are many and varied, including beadwork, finger weaving, pottery making, wood carving, mask making, and basket making.

• • • • • • • • • • • • • • • •

PRICES
Rowena: baskets, $300–$800
Alyne: small jewelry, $15;
wall hangings, $300
Betty: belts, $40; scarves, $125

ADDRESS & PHONE
Oconaluftee Indian Village
US 441 North, Cherokee, NC 28719
704/497-2315; 704/497-2111

HOURS
Mid-May–mid-Oct.:
daily, 9 A.M.–4:30 P.M.

PAYMENT
Visa, MasterCard, Discover,
American Express, personal checks
• • • • • • • • • • • • • • • •

Rowena Bradley,
cane basket

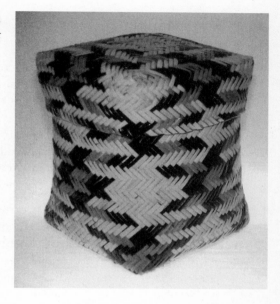

The best way to see Cherokee women and men working at these crafts is to visit the Oconaluftee Indian Village, a recreation of an eighteenth-century village. Adults are charged a nine dollar entrance fee; children ages six to thirteen are charged five dollars. Guides lead groups of no more than thirty people on a tour that takes approximately an hour. Following the tour, visitors are welcome to wander at will, returning to talk at greater length with individual craftspeople.

Those who want to purchase Indian crafts should check out Qualla Arts & Crafts Mutual, widely considered to be one of the most outstanding Indian owned and operated crafts cooperatives in the country (see page 260). Medicine Man Crafts, owned by the knowledgeable Tom Underwood, is also a good stop for craft seekers (see page 259).

BEAD JEWELRY AND WOOD CARVINGS
Rita Owle and Dewey Owle

*M*uch of Rita Owle's beadwork is rooted in the past. As her grandmother taught her beadworking techniques, she also told her the stories behind the craft. Rita learned, for example, that when the Real People, as the Cherokee called themselves, were forced to walk west, their tears brought forth corn plants with seeds the color of grief and the shape of tears. Today these seeds form the basis of Rita's corn chain, a delicate strand of beads that encircles the neck or wrist.

She also learned the story of the dream catcher, a hoop traditionally made of bent branches and strung with webs of sinew. Indians of many tribes hang them above their beds, believing that bad dreams will be caught in the web while good ones will slip through the center hole and bring happiness to the sleeper. Now Rita makes small dream catcher earrings, as well as large dream catcher wall pieces that feature beaded Indian princesses.

Except for the corn chains, she works almost exclusively with hex beads, so named because they are hexagon-shaped rather than round. The flat sides mean that each bead can fit snugly against its neighbor, therefore allowing Rita to create intricate patterns.

She makes a large number of items, including more than ten designs of earrings, most of which come in a variety of colors.

Rita's husband Dewey is a skilled wood-carver. He learned woodworking from renowned carver Amanda Crowe, and has been making dancing bears, deer, swans, and other wildlife for more than thirty-five years. Unlike many mountain carvers who leave gouge marks on the wood and sometimes add paint, Cherokee tradition stipulates that the finished carving be satin smooth and treated only with clear lacquer to bring out the color and grain of the wood.

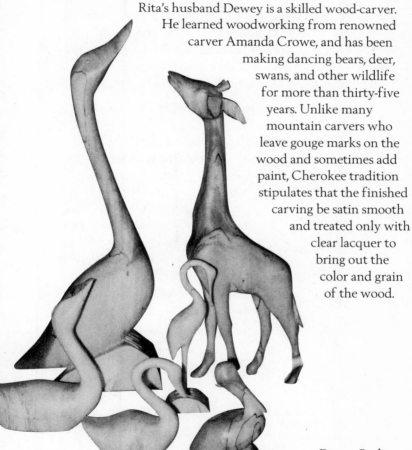

Dewey Owle,
wood wildlife carvings

FRANKLIN ··························

WROUGHT IRON FIREPLACE ACCESSORIES
Randolph Bulgin

*B*eing downsized out of a job was one of the best things that ever happened to Randolph Bulgin. He returned to the work he really loved, to the work done by two generations of Bulgins before him: blacksmithing. It was, he says, "like they threw a rabbit into a brier patch. This is where I belong."

Randolph remembers when he used to look out the window, through the leaves of an old maple tree, to see the arc of fire made by his dad as he worked late at night down at the forge. Later the senior Bulgin and his blacksmithing were highlighted in volume five of the well-known *Foxfire* series. Today Randolph, who often uses tools made by his grandfather and father, specializes in fireplace screens and accessories, usually designing them according to the customer's specifications. He also makes standard items, ranging from fireplace stands to candle holders.

In 1996 he turned a nearby building into a display room. There, alongside samples of his own work, are mementos from his past: turn-of-the-century equipment and photos of former Bulgin blacksmiths.

·····················
PRICES
Fireplace tools, $25+;
fern stand, $200+;
fireplace screen, $300+

LOCATION
Home studio; downtown Franklin

ADDRESS & PHONE
P.O. Box 541, 751 W. Main St.
Franklin, NC 28734
704/524-4204

CATALOG
Send self-addressed 9" x 12"
envelope with $.55 postage

HOURS
Call first

PAYMENT
Personal checks
·····················

WOOD CARVINGS
Hal McClure

*H*al McClure sold his first wood carving—a rooster—when he was four years old. He explains, "I thought everyone carved. Mom did."

Hal's mother, Sue, was one of the well-known Brasstown carvers, hired by John C. Campbell Folk Art School to produce small, realistic wood animals which were sold in the school's gift shop. Every Friday, young Hal at her side, Sue rode the mail truck to Brasstown where she'd turn in the hundred or so carvings she'd done during the week. In the early days (the late 1940s) she was paid $1.25 for each piece, minus ten cents for the wood.

Sue carved for more than forty years, although not always for the folk school. She managed to raise five children on that income, putting two of them through college. "She was making a living," says Hal, "and that's how I look at what I do. I'm just trying to make a living."

Over the years Hal has made a living at various jobs, but he always returns to carving. "It's like breathing to me," he says. "Perfection is not attainable, but it's something to strive for." Today his realistic depictions of more than eighty-five types of animals come close enough to perfection to be displayed in the Smithsonian and collected by people throughout the United States.

PRICES
1½" animals, $10; 6" animals, $55; 18" human figures, $700+

LOCATION
Home studio; 5 minutes south of Franklin

PHONE
704/524-8539

HOURS
Call first

PAYMENT
Personal checks

DRIED FLOWER ARRANGEMENTS
Stephanie Nieuwendijk

When Stephanie Nieuwendijk was growing up outside of Sydney, Australia, she loved to help her parents in the garden. "Mum, what's the name of that flower?" she used to ask. As she got older, her question changed to: "Mum, what would you think if I decided to be a flower designer?" Stephanie began working with a florist and earned her degree in floral arrangement. Then she spent several years traveling and working in Europe, learning different arrangement styles and methods.

Stephanie dries many of her own flowers in her glassed-in sun porch, hanging them upside down so the stems will dry straight. She then combines them with other flowers, some grown in the United States, others imported from Europe and Australia.

Stephanie also uses a variety of decorative materials, like ribbons, bows, baskets, and vases. Recently she's started to incorporate her flowers into old window frames to make one-of-a-kind wall hangings. She replaces the glass panes with mirrors or curtains and decorates the wood borders with ivy and berries. Sometimes she also hinges together old doors and refinishes them to make flower-enhanced room dividers.

PRICES
Wheat sheaves, $15+;
flower-filled baskets, $30+;
garlands, $30+;
accepts custom orders

LOCATION
Home studio; 20 minutes
north of Franklin

PHONE
704/524-4299

HOURS
Call first

PAYMENT
Personal checks

PORCELAIN AND STONEWARE POTTERY
Marcia Bugg

"People who buy nice pots have nice furniture," says Marcia Bugg. "It's important to make pottery that won't scratch tables and shelves." One reason Marcia is so aware of furniture is that her husband, Dana Hatheway, is a master furniture maker, specializing in handcrafted Windsor chairs. The other reason is that she pays attention to the smallest of details. A look at her seconds table shows that she often rejects things that other potters consider first quality.

Many of her forms are unique: a berry bowl that lets you wash and serve in the same container, a vegetable steamer sloped so that it sits comfortably atop any number of pots, a flower arranger that makes it easy for even a novice to create a beautiful display. Her glazes tend toward copper red and muted green, the result of wood ash.

Marcia has two big studio sales each year, one in November and one in June. Call for precise dates and hours.

PRICES
Floral arrangers, $25;
berry bowls, $35;
veggie steamers, $60;
seconds sometimes available

LOCATION
Home studio; 10 minutes
southwest of Hayesville

PHONE
704/389-3596

HOURS
Call first

PAYMENT
Personal checks

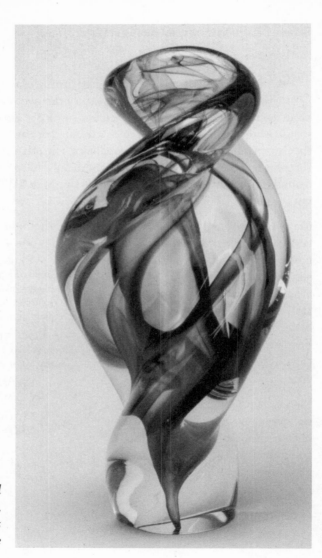

*David
Goldhagen,
blown glass
sculpture*

BLOWN GLASS SCULPTURE
David Goldhagen

*T*here's probably no better place in the country to see a glassblower in action than David Goldhagen's studio. Visitors enter through a small gallery, ablaze with the rainbow shades of David's swirling glass forms. They proceed to a loft at the rear where they have a clear (and safe) view of the entire glassblowing process, from the time David begins assembling his materials until the piece is finished and ready for sale.

David uses traditional glassblowing techniques, eschewing the use of molds. Every piece, even those that measure more than three feet in diameter, begins as a bubble of glass. Working with glass at temperatures of more than 2000° F, David adds color after color, often working with ten or fifteen pounds of molten material, spinning the glass until the flowing form satisfies his critical eye.

David is known for his large pieces, but he makes smaller ones as well. His candlesticks, spiraling coils of color, are especially popular, as are his Christmas ornaments (which he makes only during the preholiday season).

PRICES
Christmas ornaments, $20; small sculptures, $125+; candlesticks, $280 a pair; menorahs, $600

LOCATION
Shop studio; 5 minutes east of Hayesville

ADDRESS & PHONE
Goldhagen Art Glass Studio
Rt. 5, Box 1748
Hayesville, NC 28904
704/389-8847

HOURS
Call first

PAYMENT
Visa, MasterCard, personal checks

STACKED WOOD VESSELS
Robert St. Pierre

ob St. Pierre looks at his showroom filled with sleek wooden vessels and shakes his head in amazement. "If you'd told me in the early 1970s that today I'd be where I am now..." his voice trails off. Then he adjusts his cane, straightens his back, and tells his story. Back in 1970, Bob was in a body cast, the result of a car accident. He was in a coma for two months, in a cast for nearly four years, and had more than two dozen operations. His wife divorced him.

Twelve years later, remarried but without a steady job, he built a vanity cabinet. His wife asked him to make a vase as well. Although he "knew wood," having grown up near a lumber mill, he didn't know wood turning. And he didn't have a lathe. His wife persisted, and finally Bob constructed a vase. He used a bandsaw and a jigsaw to cut a series of circles, stacked them on top of each other, glued them in place, and sanded the edges until they

blended together. Now that vessel, which Bob has tucked carefully away, is worth thousands of dollars.

He showed the piece at a fair given by his wife's garden club. People were amazed that it wasn't lathe-turned. He entered it in another show and won second place among 600 pieces of sculpture. In just the next six years he won over 200 awards. Today his work is in collections around the world, and more than 200 people a week visit his studio.

Despite his success, he continues to make smaller pieces that are affordable for the average person. "People deserve to see how something is created and to own a little piece of that," he says.

PRICES
Pencil holders, $20–$28; lamp bases, $65+; salad bowls, $150+; large sculptural vessels, $1,000+

LOCATION
Shop studio; 15 minutes northeast of Hayesville

ADDRESS & PHONE
St. Pierre Wood Pottery
1 Compass Meadows
Hayesville, NC 28904
704/389-6639

HOURS
Daily, 11 A.M.–5 P.M.

PAYMENT
Visa, MasterCard, personal checks

Robert St. Pierre, stacked wood vessel

CLOTH SCULPTED DOLLS
Jacqueline Casey

*J*ackie Casey doesn't make Raggedy Anns, but she does make a "Ms. Raggedy Anna," a sophisticated young lady who, although she has the traditional red and white striped shirt and eyelet-laced overskirt, is fashionably slender and regally self-assured. This, says Jackie, is the cuddly tot grown-up.

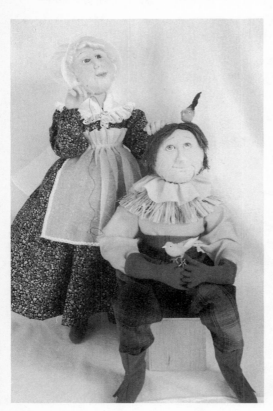

With a quirky imagination and a deft needle, Jackie creates a special world of intricately crafted dolls with delicate painted features. Many of her figures are inspired by characters in history and fiction: her "Queen Elizabeth" wears a rust-colored dress of brocade and velvet, while "Pollyanna" comes dressed in

Jacqueline Casey, cloth sculpted dolls

playful gingham. Some are presented in tableaux form, such as two elegantly-clad women complete with sequined vests and fur stoles, who are having a tea party.

While Jackie still makes all cloth dolls shaped with needle and thread, she now also makes figures with heads and hands of sculpted clay or with molded clay heads covered with stretch fabric. These new techniques allow her to make more expressive features.

Since a rave review in *Contemporary Doll Collector*, Jackie's been swamped with orders. Still, she sometimes has dolls available in Old Cupboard Antiques and General Store, which she co-owns with her husband.

PRICES
Single dolls 18"–24" tall, $300+

LOCATION
Home studio above shop;
8 minutes southwest of Murphy

ADDRESS & PHONE
Old Cupboard Antiques
and General Store
Rt. 2, Box 405, Murphy, NC 28906
704/837-4114

HOURS
Call first

PAYMENT
Personal checks

PAINTED AMERICANA
Bette Kaufman

Bette Kaufman's realistic paintings speak to the heart, depicting the red-roofed barns, tumbling waterfalls, and lush greenery that make up rural America. While she occasionally paints on canvas, Bette most often uses pieces of genuine Americana as her backdrop. Flowers decorate a basket top, bucolic pastures adorn a saw blade, a bubbling stream flows across an old coal shovel. Bette uses most anything, first subjecting the item to a five-step process that removes the rust and prepares the surface to accept the paint.

Although she's only been in North Carolina since 1994, she's become good friends with people who've lived here for generations. They bring their cast-off farm and kitchen implements to her studio; Bette then transforms assorted pans, rolling pins, and shovels into lasting treasures.

PRICES
Rolling pins, $18–$35;
handsaws, $45;
canvases, $125–$500;
prices discounted if you bring your
own rustic item in for painting

LOCATION
Home studio; 10 minutes
west of Murphy

ADDRESS & PHONE
157 Nottely Valley Rd.
Murphy, NC 28906
704/837-3651

HOURS
Call first

PAYMENT
Personal checks

PICTORIAL QUILTS
Sandra S. Rowland

*S*andra Rowland doesn't just make quilts, she tells stories with them. She gestures towards her "Story Block" quilt in which each block has the raw materials for an imaginative tale. One block has a huge button and the words "Do Not Push." Another has an arrangement of triangles. Are they sailboats, pyramids, witch hats, or maybe teepees?

"Estrogen Comes and Goes" pictures a mother and her teenage daughter engaged in an argument. A long zigzag fabric makes a wall between them, emphasizing the back-and-forth nature of

Sandra S. Rowland, quilt

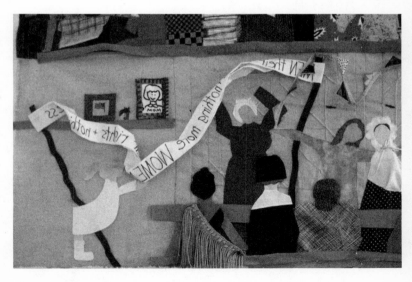

both their disagreements and their understandings. Words, stitched and stamped, help to make the point: "Hold on," "Let go," "Come," "Go."

PRICES
Small wall quilts (30" x 30"), $75+; large wall quilts, $800+

LOCATION
Home studio; 8 minutes east of Murphy

PHONE
704/837-2320

HOURS
Call first

PAYMENT
Personal checks

Two things can be considered central to Sandra's work: her use of fabric and her use of words. Patterns are used in unusual ways; different types of swirls, for example, make a beanstalk in one quilt, fish scales in another. Words, sometimes scattered singly, sometimes in long quotes, appear in almost every quilt.

MINIATURE MOUNTAIN CABINS
Vader Campbell and George Wells

R obbinsville native Vader Campbell had been building full-size homes for years. Then in the mid-1990s, he and Vermonter George Wells decided to go small. Using scrap lumber and found stones, the two began to make "more-or-less to scale" eighteen-inch-tall replicas of log cabins.

They shape pine and cedar into logs, hand-cutting the ends so they'll dovetail together. They split the shingles with a hunting knife. They shatter rocks until they get pieces the right size for foundations and chimneys, which are often partially covered with dried moss. Occasionally Vader or George add a bit of wallpaper or some lace curtains to the interior, but for the most part, says George, "our job is to build them and other people can decorate them." While some of the cabins have open backs to make the decorating easier, most are closed.

Each cabin is different—some designed by Vader or George, others made to duplicate an existing structure. They've just finished a replica of nearby Nantahala Lodge which, they say, was particularly challenging because of all the stonework.

PRICES
Miniature cabins, $85–$160; commissions accepted

LOCATION
Shop studio; downtown Robbinsville

ADDRESS & PHONE
The Work Shop
Rt. 3, Box 100
Robbinsville, NC 28771

PHONE
704/479-2409

HOURS
Mon., Tues., and Thurs.–Sat.,
9 A.M.–5 P.M.

PAYMENT
Personal checks

FUNCTIONAL STONEWARE

Karen Mickler

Karen Mickler's pottery is gracefully elegant. The mugs and vases aren't made with straight verticals; instead they taper gently. The handles on her casseroles have a soft curl. The patterns—which shine through the glaze in the natural color of the clay—are swirling loops inspired by the wings of a bird.

Her turquoise and blue pottery is always functional, but sometimes in surprising ways. Along with the mugs, canisters, and casseroles, she makes pedestal bowls, napkin holders, and large umbrella holders.

Karen and husband Bruce DeGroot own a fifty-acre plot of land in conjunction with other members of the DeGroot family. There, surrounded by state and national parklands, they work together to grow their own food and run a small cheese operation. Made from unpasteurized milk obtained from their own Jersey cows and according to Karen's recipe, the mild, moist cheese—which has the texture of Havarti and the flavor of Jack—can be purchased at the pottery.

PRICES
Spoon rests, small vases, $5; napkin holders, $20; casseroles, $46; pedestal bowls, $125; seconds sometimes available

LOCATION
Home studio; 25 minutes northwest of Robbinsville

ADDRESS & PHONE
Rt. 2, Box 176E, Yellow Branch Rd. Robbinsville, NC 28771

PHONE
704/479-6710

HOURS
By appointment

PAYMENT
Visa, MasterCard, personal checks

BRASSTOWN

Craft Shop at John C. Campbell Folk School

A wide variety of mostly traditional but some contemporary crafts can be found here. The shop represents more than 200 artisans, almost all of whom live in the Appalachian mountains.

- **Location:** Central Brasstown
- **Address:** 1 Folk School Rd., Brasstown, NC 28902
- **Phone:** 800/FOLKSCH (800/365-5724)
- **Hours:** Mon.–Sat., 8 A.M.–5 P.M.; Sun., 1 P.M.–5 P.M.; closed Thanksgiving and Christmas

BRASSTOWN

Round & Smooth Wood

Specializes in wood items, especially wood-turned vessels, and represents thirty artisans, 65 percent from western North Carolina.

- **Location:** Central Brasstown
- **Address:** 10936 Old Hwy. 64, Brasstown, NC 28902
- **Phone:** 704/837-8663
- **Hours:** *Jan.–May:* Mon.–Sat., 10 A.M.–6 P.M. *June–Dec.:* Mon.–Sat., 9 A.M.–6 P.M.; Sun., noon–5 P.M.

CHEROKEE

Medicine Man Crafts

Specializes in crafts made by members of the Cherokee Nation.

- **Location:** Downtown Cherokee

- **Address:** U.S. 441 North, Cherokee, NC 28719
- **Phone:** 704/497-2202
- **Hours:** *June–Sept.:* daily, 9 A.M.–8 P.M.
 Oct.–May: daily, 9 A.M.–5 P.M.

CHEROKEE
Qualla Arts & Crafts Mutual

This gallery is Native-American owned and operated and specializes in crafts made by more than 300 members of the Eastern Band of the Cherokee Nation.
- **Location:** Downtown Cherokee
- **Address:** U.S. 441 North, Cherokee, NC 28719
- **Phone:** 704/497-3103
- **Hours:** *Jan.–March:* Mon.–Sat., 8 A.M.–5 P.M.
 April–mid-May and Nov.–Dec.: daily, 8 A.M.–5 P.M.
 Mid-May–Aug.: Mon.–Sat., 8 A.M.–8 P.M.; Sun., 8 A.M.–5 P.M.
 Sept.–Oct.: Mon.–Sat., 8 A.M.–6 P.M.; Sun., 8 A.M.–5 P.M.

FRANKLIN
Maco Crafts, Inc.

Traditional mountain crafts from more than 300 western North Carolina artisans are featured along with a large selection of quilting supplies.
- **Location:** 5 minutes south of Franklin
- **Address:** 2846 Georgia Rd., Franklin, NC 28734
- **Phone:** 704/524-7878
- **Hours:** *June–Oct.:* Mon.–Sat., 9 A.M.–5:30 P.M.; Sun., 1 P.M.–5:30 P.M.
 Nov.–May: Mon.–Sat., 10 A.M.–5 P.M.

ANDREWS
The Cover House

*W*hen Gale Lay announced that she wanted to turn the old Cover House into a bed-and-breakfast, her family and friends told her that they thought she was crazy. But Gayle, a licensed contractor and an interior decorator, persisted. She put in a new electrical system, new plumbing, and an air-conditioning system, stripped hundreds of feet of wood, redid all the walls, then decorated. Today, the three-story home that once belonged to Giles and Lilly May Cover (Lilly May was the first woman elected to the North Carolina legislature) is one of the proudest and most welcoming structures in Andrews.

Much of the furniture once belonged to Gayle's grandmother and great-grandmother. The dining room suite came from a secondhand store in Alabama; although the storekeeper said it once belonged to Robert E. Lee, Gayle refuses to make that claim. The ground floor room, which has limited handicap accessibility, is dominated by a king-size bed. The four rooms on the second floor have beds ranging from double to king. The telephone for guests' use is tucked in a private cubby on the second floor; visitors can watch television in the living room.

RATES
$75–$80, double occupancy; apartment, $120 per night or $700 per week; includes full breakfast; open April–Dec.

LOCATION
2 minutes from Andrews

ADDRESS & PHONE
34 Wilson St., Andrews, NC 28901
704/321-5302; fax: 704/321-2145

PAYMENT
Visa, MasterCard, personal checks

Gayle recently added a midsize apartment in a separate building

behind the house. With a television, phone, two bedrooms, a living room, good-sized kitchen, and laundry room, this is a home-away-from-home for guests.

Andrews
Walker Inn

*I*n the parlor of Walker Inn is an old painting of an unsmiling, stern-faced woman. This is Margaret Walker, a nineteenth-century frontierswoman, and she had every reason not to smile. On October 6, 1864, twenty-seven drunken, brawling men forced their way into her home. These "bushwhackers"— deserters from both the Union and Confederate armies—were out for revenge. A month earlier three of their gang had been killed; now they wanted the heads of "the best five men in the valley." Margaret's husband William, the village judge and postmaster, was one of these men.

The bushwhackers forced William onto a horse and galloped off with him; Margaret followed. She rode for nearly twenty miles before giving up and returning home. In her diary she states that "I wept for three years. Two pillows were so stiffened by salt tears that they crumbled to pieces." Though she wept by night, by day she turned her home into one

Rates
$40–$55, double occupancy; some rooms have private baths; includes full breakfast; open April–Nov.

Location
2 minutes east of Andrews

Address & Phone
39 Junaluska Road, P.O. Box 1567
Andrews, NC 28901
704/321-5019

Payment
Visa, MasterCard, personal checks

of the finest inns in the region, expanding the 1840s cabin to accommodate guests. The Walker Inn was often frequented by stagecoach passengers on the Franklin-Murphy route.

Margaret died in 1899, and the inn changed hands over the years. Then, in 1972, it was purchased by granddaughter Margaret Walker Freel, who returned many of the family belongings to the premises. After Margaret Freel died in 1982, the inn languished until 1987 when it was purchased by current owners, Peter and Patricia Cook.

Today, visitors can see much of the building's pioneer beginnings. The hand-hewn logs of the original building, although coated with white paint, are very much in evidence. The old wrought iron door hinges and latches are affixed to old planked doors, and bubble glass window panes gently distort the view from the large parlor. Patricia and Peter know that restoring the home, which is listed on the National Register of Historic Places, is a mammoth task, one that will take years to complete. In the meantime, Walker Inn is comfortable, the innkeepers gracious, and the history absolutely fascinating.

BRYSON CITY

Hemlock Inn

Sunday at half past noon, and all other days at 8:30 in the morning and at 6:00 in the evening, the bell at Hemlock Inn summons guests to a hearty meal. Waiters load the tables with juice, grits, bacon, and eggs in the morning and with meat, vegetables, relishes, and dessert in the evening. People eat—and talk—until they're completely satisfied.

It is the mealtime conversations that spring up around those large round tables that give Hemlock Inn its special atmosphere. No one wants to leave—the table or the Inn. And when they do, they keep coming back.

"I been coming here twenty-three years," said one elderly gentleman.

"Really? We've only been coming for twelve," answered a tablemate.

Situated only three miles from a back entrance to the Great Smoky Mountains National Park, the inn opened its doors in 1952. Now owned and run by Morris and Elaine White, it has twenty-six units (including rooms in the Inn and several cottages), no televisions or individual telephones, and a delicious informality. Guests sit on porch rocking chairs to watch the sun rise and set over the mountains, hike on the short trail on the property or the longer ones in the park, play shuffleboard, table tennis, or bridge, and of course, talk.

PRICES
$122+, double occupancy; includes breakfast and dinner; nonguests can dine by prior reservation: breakfast, $7; dinner, $13; open May–Nov.

LOCATION
5 minutes northwest of Bryson City

ADDRESS & PHONE
P.O. Drawer EE
Bryson City, NC 28713
704/488-2885

PAYMENT
Visa, MasterCard, Discover, personal checks

ROBBINSVILLE

Snowbird Mountain Lodge

*R*obert Rankin first saw Snowbird Mountain Lodge when he was a backcountry ranger in the Great Smoky Mountains National Park. A few years later, in 1985, he and his wife-to-be, Karen, stayed there for a romantic weekend and began to fantasize about owning it. Ten years after that, the property went up for sale. Robert, who has a background in business as well as in outdoor recreation, and Karen, who's a culinary graduate of the New York Restaurant School in Manhattan, became the new owners of a rustic inn set on almost one hundred acres of prime mountain land.

The lodge, which opened in 1941, is on the National Register of Historic Places, partly because it's the last major building in the United States built from chestnut (the trees died out as a result of a blight), and partly because it played such an important role in bringing tourists to the North Carolina mountains in the post-World War II years. It's a two-story building made of logs, stone, and siding, with an abundance of porches and an even greater abundance of views. From the

RATES
$115–$130, double occupancy; includes three meals; open mid-April–mid-Nov.

LOCATION
15 minutes west of Robbinsville

ADDRESS & PHONE
275 Santeetlah Rd.
Robbinsville, NC 28771
704/479-3433

PAYMENT
Visa, MasterCard, personal checks

front porch you can look out on the tree-covered hills of Nantahala National Forest. From Sunrise Point, a ten-minute walk up the property, you can see the southern tip of the Smoky

Mountains. "When the sun inches up over the mountains, it's like God is operating a dimmer switch," says an appreciative Robert.

Inside, the main room is designed for relaxing, with a big stone fireplace, leather sofas, upholstered chairs, and more than 2,500 books. The twenty-two guest rooms are comfortably rustic with paneled walls and furniture that was handcrafted by locals back in the early 1940s. Each room includes a private bath and coffeemaker and, says Robert proudly, *"ex*cludes a telephone and television." (There's a central telephone for guests' use and a daily newspaper for those who can't live without it.)

Room rates include three meals: a simple but filling breakfast (eggs, waffles, oatmeal, or fruit bowl), a bag lunch (sandwich, chips, fruit, and dessert), and an elegant dinner.

AREA 7

· ·

THE ROLLING
FOOTHILLS

THE ROLLING FOOTHILLS

INTERSTATE 26 SPEEDS SOUTH OF Asheville, passing the small town of Hendersonville, crossing a high pass near Saluda, and leading down to the rolling hills near Tryon. Down here near the South Carolina border is horse country, an area dotted with pastures and show rings, where the steeplechase is a major summer event.

To the west, the hills become mountains—not the giant peaks of the north, but tall enough to support a plethora of waterfalls. High Falls drops 125 feet, Rainbow Falls cascades 200 feet, and the upper part of the two-tiered Whitewater Falls tumbles 441 feet to become the highest waterfall in the eastern United States.

The Great Smoky Mountain Railroad in Dillsboro offers scenic round-trip excursions throughout the area on rail lines that date back to 1891; call 704/586-8811 or 800/872-4681 for details on getting out of the car and onto the train. Poetry lovers will want to stop in Flat Rock to visit the Carl Sandburg Home National Historic Site, where the famed poet and biographer liver his last twenty-two years (704/693-4178). In Brevard, the Cradle of Forestry offers visitors the opportunity to see local crafters demonstrate old-time hill skills (704/877-3130). Brevard is also home to the Brevard Music Center, which is the site of a rich offering of concerts, recitals, operas, and musicals; call 704/884-2019 for performance schedules during your visit.

WOVEN ACCESSORIES
Nancy MacDonald

Nancy MacDonald works in the same house where she was born, a rustic log cabin that still belongs to her grandparents. Nancy's loom is set up in the living room in front of the old stone fireplace that keeps the five-room cabin toasty in the winter. It's a fifty-six-inch-wide, four-harness hand loom, big enough to let her make everything from large area rugs to narrow table runners.

Nancy's designs are eclectic; she rarely makes the same thing twice. But there is a common thread running through her work: she only uses natural yarns in her weaving, usually cotton but occasionally wool.

In addition to her own work, Nancy stocks a small selection of fiber crafts from other artists and a large selection of yarns and fiber-art supplies. She gives dyeing classes in the winter while others use her studio to give knitting and spinning workshops.

PRICES
Baby blankets, $45; rag rugs, $350

LOCATION
Shop studio; 10 minutes south of Brevard

ADDRESS & PHONE
2475 Greenville Hwy.
Brevard, NC 28712
704/883-YARN

HOURS
Tues.–Sat., 10 A.M.–6 P.M.

PAYMENT
Personal checks

FUNCTIONAL POTTERY AND TRADITIONAL COVERLETS
Dwight Pigman and Suellen Lankford Pigman

Dwight Pigman says any resemblance his work shares with medieval pottery is accidental, but he isn't surprised when people feel the power of the past. He was heavily influenced by some Kentucky folk potters who lived near him when he was a child and, although he has a college degree in pottery, he still prefers many of the old-time methods.

Dwight throws his pots on a treadle wheel and for years fired them in a wood kiln, only recently switching to gas. He uses wood ash glazes to give his vessels a textured, orange-peel effect that adds to their rugged look. The deep designs that look carved but are actually imprinted make Dwight's work distinctive. He makes most of his stamps from wood, a few from clay, then pushes the spirals, rectangles, or slashes deep into the clay after it has been formed but before it is completely dry. Finally, he sets most of his pieces on a small rim of clay, a finishing mark that lifts the pot up on its own pedestal.

PRICES
Dwight: mugs, $8+;
medium casseroles, $80+;
teapots, $300+;
seconds sometimes available
Suellen: scarves, $45+;
comforters, $450+;
commissions accepted

LOCATION
Shop studio; 5 minutes
east of Brevard

ADDRESS & PHONE
Southern Expressions
2157 New Hendersonville Hwy.
Pisgah Forest, NC 28768
704/884-6242

HOURS
Tues.–Sat., 9 A.M.–6 P.M.

PAYMENT
Visa, MasterCard, personal checks

One of Suellen Lankford Pigman's favorite childhood stories was about an uncle who had taken a coverlet on his westward journey. Today Suellen and husband Dwight sleep under that very cover, and Suellen makes similar ones that are intended to be passed down to future generations.

Using cotton warp on a four-harness floor loom, she weaves cotton or wool to make patterns like Pine Bloom, Whig Rose, and Lovers' Knot. In the past Suellen used com-

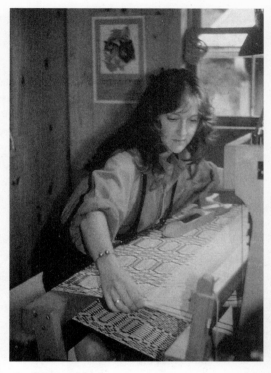

Suellen Lankford Pigman in her studio

mercial yarns, but now she's spinning much of her own wool and coloring it with natural dyes from walnut hulls, sassafras, or mistletoe.

The Pigmans built the gallery Southern Expressions to display their own work as well as that of other artisans, most of whom live in Southern Appalachia.

APPALACHIAN CHAIRS
Michael Whitmore

Michael Whitmore knows how to use fancy equipment, but he prefers to make his Appalachian chairs the old-fashioned way. He begins by splitting felled pieces of red or white oak, using a wedge and ax to split the wood along the grain. This, he explains, makes the wood less likely to break. Then, sitting at an old-fashioned shaving horse, he repeatedly draws his knife toward him, forming the damp wood into legs, rungs, and backs. He works so carefully that the finished pieces rarely need sanding; he has already carved away the rough edges with his knife.

After he gets the wood into the desired shape, he steam-bends the backs, giving the vertical supports a slight outward flair and curving the horizontal slats for style and comfort. He assembles the chairs through a process called wet-dry joinery. The legs are left to dry naturally until their moisture content is about 20 percent, while the rungs are kiln dried until they have only about 5 percent moisture. When the joints are assembled, the rungs naturally absorb some of the moisture from the legs, which tightens the fit.

PRICES
Footstools, $90;
side chairs, $300; rockers, $450;
seconds sometimes available

LOCATION
Home studio; 15 minutes
east of Brevard

PHONE
704/884-9207

HOURS
Call first

PAYMENT
Personal checks

"I go back to where the old folks left off," Michael says. "I use the strong points of the old ways and take off from there."

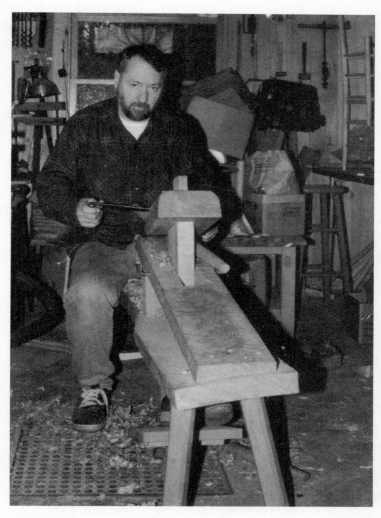

Michael Whitmore in his studio

DILLSBORO ··························

KITCHEN AND GARDEN POTTERY
Brant Barnes and Karen Barnes

O ne day in the early 1990s, Brant Barnes, a university-trained potter, was "banging nails" to supplement his income when he slipped and fell off a roof. He was lucky—he only broke his heel—but he knew he could just as easily have broken his back. "That was our cosmic nudge," says wife Karen. "It was time to do what we really wanted to do—pottery."

Today, the Barneses have a showroom and clay studio in downtown Dillsboro. Brant works on the wheel, throwing a wide

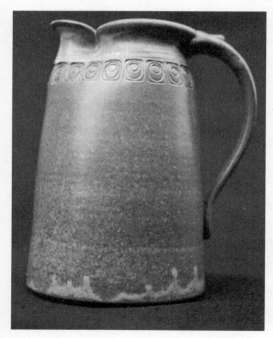

variety of kitchen and garden pieces such as mugs, plates, canister sets, vases, and hanging plant holders (which are nicely fitted with a cork to keep water from muddying the floor). When time permits, he amazes visitors by "blowing clay," a technique he learned from his glassblower friends. Karen primarily

Brant Barnes,
pottery pitcher

makes hand-built wall sconces and beads, both of which are proving to be best-sellers.

The duo has developed a design technique that involves making patterns from more than a hundred geometrically shaped stamps hand-carved by Brant. Their pieces come in a myriad of colors, ranging from blues and purples to standby earthtones.

• • • • • • • • • • • •

PRICES
Brant: mugs, $12; large platters, $78
Karen: beads, under $2;
wall sconces, $6–$24

LOCATION
Shop studio; downtown Dillsboro

ADDRESS & PHONE
Riverwood Pottery
60 Craft Cir., Dillsboro, NC 28725
704/586-3601

HOURS
Jan.–April: call first
May–Dec.: Mon.–Sat., 10 A.M.–5 P.M.;
Sun., call first;

PAYMENT
Visa, MasterCard, personal checks

• • • • • • • • • • • • • • • •

HAND-HAMMERED PEWTER

Ruth M. McConnell, Dee Shook, and Leo Franks

A rhythmic thump-thump, thump-thump, greets visitors to the shop and studio owned by Ruth McConnell. In the front room trays and bowls with elegantly simple lines are attractively displayed. In the back, Dee Shook and Leo Franks work steadily, hammering sheets of pewter into various shapes and forms, then trimming the edges and often adorning them

with pierced dogwood designs. Ruth does the finishing work, adding the fine lines that delineate the blossoms, signing and dating each piece, and polishing it to a fine luster.

Ruth has been a pewter person all her life, introduced to it by her father, Dr. Ralph Morgan. Ralph learned the craft while visiting his aunt, the legendary Lucy Morgan, founder of Penland School, during the summer of 1930. "Daddy'll tell you he worked his way through college and medical school beating pewter," says Ruth. Once Dr. Morgan finished his

PRICES
Key chains, $6;
small plain bowls, $15; cream
pitcher and sugar bowl sets, $50+;
candle sconces, $95;
punch bowls, $200

LOCATION
Shop studio; downtown Dillsboro

ADDRESS & PHONE
Riverwood Pewter Shop
17 Craft Cir., Dillsboro, NC 28725
704/586-6996

HOURS
Jan.–March: call first
April–Dec.: Mon.–Sat., 10 A.M.–5 P.M.;
Dee and Leo in studio:
Monday–Thursday 10 A.M.–3:30 P.M.

PAYMENT
Visa, MasterCard,
American Express, Discover,
personal checks

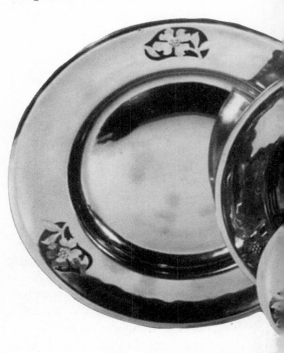

medical training, he taught Dee and Ray Shook how to form the pewter, opened a shop in the basement of his home, and did his doctoring while his wife tended the business. That was in 1949, and Dee's been hammering every since.

The shop moved to its present location, in a house-turned-shop complex that once belonged to mountain tycoon C. J. Harris, in 1957. Ray Shook died in 1988 and Leo Franks, a former carpenter, began using his hammer on pewter instead of nails.

Now Ruth, who has taken over the shop from her parents, has added some cast and spun pewter to her inventory, allowing customers to view a larger selection of items.

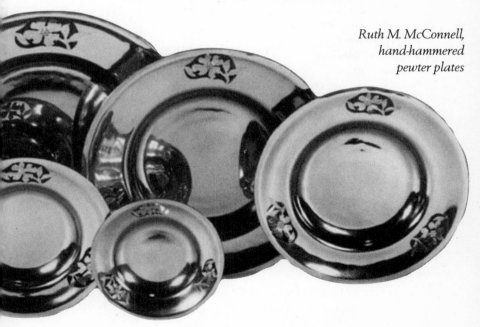

Ruth M. McConnell, hand-hammered pewter plates

FLETCHER..

Oscar Hubbert

*L*ook at the bronze eagle on one of Oscar Hubbert's wood-and-bronze banks and dream of the time when the U.S. mail was delivered by pony express. Look at the combination lock on another bank and remember when people kept in touch by mail rather than telephone. Oscar's banks—made from the bronze doors from old post-office lockboxes—are the American past encased in wood.

PRICES
Small banks, $45+;
midsize banks, $68+;
large banks, $85+

LOCATION
Home studio; 3 minutes
west of Fletcher

ADDRESS & PHONE
Woodcrafts
P.O. Box 1415, 16 Jeffery Ln.
Fletcher, NC 28732
704/687-0350

BROCHURE
Send a self-addressed business-size
envelope with $.32 postage

HOURS
Call first

PAYMENT
Visa, MasterCard, Discover,
personal checks

Between 1857 and 1955, when the last door was designed, the government had 257 different types of these doors—some with keys, others with combination locks or beveled glass. In the early 1970s the U.S. Postal Service gradually began converting the nation's post-office boxes from ornate bronze and glass to flat metal. Today about 80 percent of the country's post offices have the new boxes.

Oscar bids for the old boxes at government auctions. He cleans and polishes each door by hand, and attaches it to a box that he builds from oak, walnut, cherry, or wormy chestnut. The banks, like post-office boxes from both the past and the present, come in three sizes.

TRADITIONAL AND CONTEMPORARY QUILTS
Georgia Bonesteel

*T*he license plates on the white Chrysler van read "LAPQUILT," which is enough for thousands of fans to identify the woman at the wheel as Georgia Bonesteel. Georgia is quite possibly the nation's most well-known quilting guru—the author of five books and the star of nine PBS quilting series. While she didn't invent the idea of lap quilting—a method of block-by-block construction that frees people from the quilting frame— she did publicize it. By making quilting portable, Georgia made it infinitely more popular and, in the process, became its leading spokesperson.

Georgia learned to sew as a youngster, majored in home economics at Northwestern University, then used her skills in a variety of positions. When her husband was transferred to New Orleans, she got a job as an assistant on a television sewing show. She was the behind-the-scenes person, sewing off camera while the star delivered Georgia's sewing how-tos and used her examples on camera. It was around this time that she became interested in

PRICES
Wall hangings, $1,000–$3,000

LOCATION
Shop studio; 2 minutes
south of Hendersonville

ADDRESS & PHONE
Bonesteel Hardware
and Quilt Corner
150 White St.
Hendersonville, NC 28739
704/692-0293 Fax: 704/692-6053

BROCHURE
Send self-addressed business-size
envelope with $.32 postage

HOURS
Mon.–Fri., 8 A.M.–5:30 P.M.;
Sat., 8 A.M.–4 P.M.

PAYMENT
Visa, MasterCard,
American Express, Discover,
personal checks

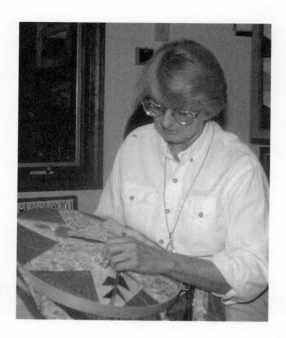

Georgia Bonesteel
in her studio

quilting. After moving to North Carolina, Georgia decided she
didn't need a front-person, so she contacted the public televi-
sion station and suggested a quilting show. The rest, as they say,
is history.

Now Georgia is so busy filming, teaching, and writing that she
has to squeeze her quilting into odd hours. Most of her current
quilts are machine-pieced and partially machine-quilted. Many
of her designs don't lend themselves to the block-by-block
construction she popularized, but she still does all of her hand-
quilting on her lap.

CONTEMPORARY POTTERY
Shari Eakes

*S*hari Eakes is pure North Carolina. Her home, which once belonged to her husband's grandfather, is at the end of a long gravel driveway bordered by wild rhododendron. The property is surrounded on two sides by a river, on a third by a mountain. From the upstairs window of her gallery she can see the homes of other members of her husband's clan: the old house where great-grandfather once lived, the current cabin of his father, and the home of his brother.

Somehow in these homey surroundings it comes as a surprise to see that Shari's pottery is sleek, smart, and sophisticated. Her palette is rich: forest greens juxtaposed with deep blues. "When I was in school my teachers wanted curlicues and handles, but I like smooth, straight lines. I use flare for handles," she says, pointing to a casserole that has a broad, flared rim. Shari specializes in dinnerware—plates, bowls, mugs, and goblets—but she also has a full range of other items including casseroles, candlesticks, pitchers, and a large lantern that can be lit either by electricity or candle flame.

PRICES
Candle dishes, $8; pitchers, $30; large bowls, $40; seconds sometimes available

LOCATION
Home studio; 15 minutes north of Hendersonville

PHONE
704/891-5642

HOURS
Call first

PAYMENT
Personal checks

WOOD CARVINGS
Werner Katzenberger

*W*erner Katzenberger has a dream: he wants to retire from his job as a furniture restorer at the Biltmore Estate and carve bears and other wildlife full time. "In restoring and reproducing furniture, I'm copying someone else's work. But in this," he points toward one of his bear carvings, "I'm doing my own expression."

Werner learned carving as a child in Germany. His father had a cabinet shop and, as the oldest son, Werner's job was to help out. All those years of training paid off. Werner's carvings capture the movement and personality of the animals that live in the nearby mountains.

Werner works mostly with hand tools and refuses to oversand his work. "The gouge marks let you see into the wood. If you sand too much," he shrugs thoughtfully, "you lose something important." Rather than placing his carvings on a separate base, Werner carves the mount right along with the animals, all out of the same block of wood. One of his multiple figure pieces—a bear and three hounds—won a blue ribbon at the Southeast Woodcarvers Showcase which included entries from seven states.

PRICES
Walking sticks, $25–$45; wildlife carvings, $175–$1,400

LOCATION
Home studio, 10 minutes northwest of Hendersonville

PHONE
704/891-8740

HOURS
Call first

PAYMENT
Personal checks

TURNED-WOOD VESSELS

Herb Quarles

*C*hips of wood fly as Herb Quarles puts a burl on his lathe which, he explains, is like "a potter's wheel turned sideways." Minutes later a vase begins to emerge. Herb stops, looks it over and makes adjustments to release the innate characteristics of this special piece of wood. Then he begins hollowing out the inside, leaving the walls only one-eighth inch thick at the top, three-sixteenths of an inch at the bottom. Sometimes his work is large, up to three feet high. Other times it's small, perhaps a miniature scaled for a collector's dollhouse. But most pieces are six to eighteen inches high, perfect for displaying on a coffee table.

Until recently, Herb finished his pieces with a light rubbing of mineral oil. Lately he's begun experimenting with color, and occasionally he uses strategically-placed feathers or pottery shards to further enhance his work.

Although decorative vessels like vases and bowls are his mainstay, he also makes functional items such as letter openers and ballpoint pens.

PRICES
Letter openers, pens, miniatures, under $20; vases, $45–$500

LOCATION
Home studio; 5 minutes south of Hendersonville

PHONE
704/692-6671

HOURS
Call first

PAYMENT
Visa, MasterCard, American Express, personal checks

PORCELAIN POTTERY AND PATTERNED STERLING JEWELRY
David Voorhees and Molly Sharp

*H*usband and wife David Voorhees and Molly Sharp work with very different materials to create their crafts. Molly works with silver to create patterned jewelry while David focuses his skills on porcelain pottery.

Like the North Carolina mountains in the spring, David's pottery is abloom with wildflowers. A garden of mixed delights surrounds a punch bowl, while wisteria climbs up a

Molly Sharp, patterned sterling earrings

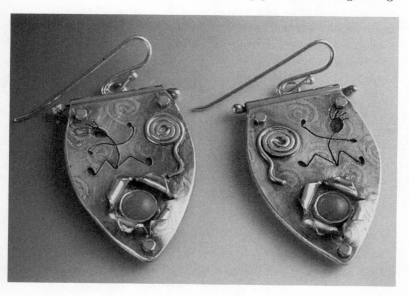

set of candlesticks. Done in shades of blues, pinks, and purples, his kitchenware is colorful but subtle.

David began his art career as a painter, a natural choice for the son of two professional painters. But after being introduced to ceramics, he realized the opportunities of three-dimensional art: he could play with clay and paint at the same time. He worked in stoneware for a while, but soon discovered that porcelain was the perfect canvas for his fine brushwork.

Molly begins the jewelry making process by patterning her silver. She places a small sheet of the metal over an acid-etched brass plate, then runs this through a rolling mill. The pattern transfers to the silver, imprinting spirals and zigzags. She uses a jeweler's saw to cut out the base shapes for each piece. Then she begins layering shapes. Sometimes she "draws" with fourteen-karat gold, other times she uses brass, semiprecious stones, or even small pieces of plastic window screen. As a final step, the pieces are oxidized, producing a patina surface that rarely needs polishing.

PRICES
David: cups, $18; serving bowls, $40; 4-piece canister sets, $200; seconds sometimes available; *Molly:* pins, $40+; earrings, $72+; pendants, $98+

LOCATION
Studio; 5 minutes south of Hendersonville

ADDRESS & PHONE
P.O. Box 735, Flat Rock, NC 28731
704/697-7719

CATALOG
Write for information

HOURS
Call first

PAYMENT
Personal checks

SALUDA......................................

Bill Crowell and Kathleen Carson

Kathleen Carson needed a table base for some of her hand-painted tiles. She asked her husband, Bill Crowell, for help. "Well, I think I could do that," said Bill, who was somewhat of a jack-of-all-trades. He borrowed a welding unit and, eventually, a table was born. So was a career.

Bill took a two-week blacksmithing course at Penland to perfect his recently acquired skills, gathered his tools, and opened a studio in Nostalgia Court that can accommodate a host of onlookers. There he produces a variety of table bases for Kathleen's decorative tiles, as well as several styles of plant stands, pot racks, chairs, lamps, bookcases, trellises, gates, and just about anything else that can be made out of iron.

Although his pieces are eminently practical, there's often a bit of whimsy about them, as with the tall chairs that feature an initial on the back. Many of Kathleen's tiles definitely bring a smile, especially her woman with a fruit-filled hat. Of course, Kathleen has (pardon the pun) an appetite for fruited headwear. As a longtime Carmen Miranda fan, she appeared for her wedding in Latin-style full skirts and a pile of fruit on her head.

PRICES
Wrought iron hooks, $3; plant stands, $15; gates, $800

LOCATION
Shop studio; downtown Saluda

ADDRESS & PHONE
Saluda Forge
Nostalgia Courtyard
Pearsons Falls Rd., Saluda, NC 28773
704/749-1370

HOURS
Mon.–Sat., 10 A.M.–5 P.M.

PAYMENT
Visa, MasterCard, personal checks

APPALACHIAN FURNITURE

Dominick Ferullo

*S*pring is a busy time for Dominick Ferullo. If he doesn't harvest maple saplings at just the right time, the bark won't come off cleanly to leave smooth wood for the legs of his Appalachian chairs and tables. It's not easy to get branches and small trunks that are sturdy, straight, and just the right dimensions.

He used peeled maple for his award-winning chair, a high-backed armchair of interlaced branches with a woven reed seat and matching footstool. Dom incorporated the natural forks of the branches into his design, carefully attaching one branch to another by means of small wooden dowels.

While maple, mountain laurel, and hickory work best for the legs of his stools and tables, the tops can be made from a variety of woods. Sometimes Dom uses trunk slabs still rimmed with bark as table or stool tops; other times he uses split logs; and on occasion he makes smooth-edged planked tops that contrast sharply with the rustic branch legs.

Dom's furniture is not only handmade; it's homegrown. Most of the wood comes from his own property, twenty-five acres of

PRICES
Stools, $150+;
coffee and end tables, $120+;
chairs, $500+; beds, $950+;
accepts commissions

LOCATION
Home studio; 10 minutes
south of Saluda

ADDRESS & PHONE
Rt. 1, Box 112A, Saluda, NC 28773
704/749-5276

HOURS
Call first

PAYMENT
Personal checks

forested land on the high ridge between Saluda and Tryon. And, while some of the barked wood is finished with a clear acrylic sealer to keep it from flaking, the smooth wood is rubbed with a natural beeswax contributed by Dom's own bees.

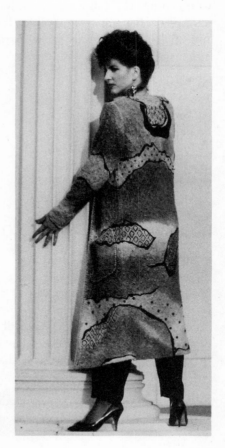

*Donna Maltony and
Lori Pickering,
dyed and painted theater coat*

DYED AND PAINTED CLOTHING

Donna Maltony and Lori Pickering

*D*onna Maltony and Lori Pickering create clothes that make a statement. The distinctive clothing—everything from casual jumpers to knockout evening wear—was Donna's idea. "Not having been taught all the rules and regulations, I had a higher degree of freedom," she says with a smile. "And somehow what I tried, what I did, worked." Each piece begins as a blank (all white) article of clothing made from a natural fiber such as cotton, silk, or wool. The blank article is then dipped into 185° to 190° dye baths and later decorated with fabric paint.

Donna and her partner Lori Pickering used to sell their Arta-Cloak creations nationwide. You could, for example, buy one of their hand-dyed, handpainted jackets in Boston for $600. But the mother-daughter team felt distanced from their customers. "We never met the people who wore our clothes," says Donna. "And only the wealthy could afford us," adds Lori. So a few years ago the duo decided to sell directly from their shop studio in downtown Saluda. Now you can buy an Arta-Cloak jacket for $150 and meet the creators at the same time. Matching glass jewelry (handmade by Lori) is available for just a bit more.

PRICES
Knit jumpers, $50;
raw silk shirts, $120;
theater coats, $350 +

LOCATION
Shop studio; downtown Saluda

ADDRESS & PHONE
Arta-Cloaks
Historic Pebbledash Bldg.
Church St., Saluda, NC 28773
704/749-1162

HOURS
Tues.–Sat., 10 A.M.–5 P.M.;
Sun., 1 P.M.–4 P.M.

PAYMENT
Visa, MasterCard, Discover,
personal checks

WOODCRAFTS, QUILTS, POTTERY
George McCreery, Lois McCreery, and Erin Jouvinea

*T*hree craftspeople work on the premises of Saluda Mountain Craft Gallery: a woodworker, quilter, and potter. The woodworker is co-owner George McCreery, whose inlaid wood items, including cheeseboards, clipboards, wine holders, and toy trucks, are some of the best bargains in the mountains. They're handsome and extremely well made, but George prefers to let his work speak for itself. "He's a bit reserved," says manager Beth Warshaw-Bailey.

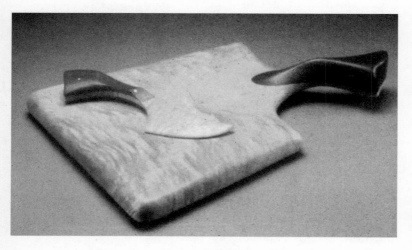

George McCreery, inlaid wood cheeseboard

Not so Lois McCreery, George's eighty-something-year-old mother. Lois, who works in the upstairs gallery, talks as fast as she quilts. "I did a quilt for Perry Como and his wife," she confides, a lilt in her voice and a twinkle in her eyes. "I used to be a secretary, but then I retired and taught myself how to do this. I've been at it almost twenty years now."

Potter Erin Jouvinea works in a downstairs shop, hand-throwing utilitarian patterned pottery, mostly in eggshell whites and soft blues. But her signature piece, a delicate angel oil lamp, is made from white porcelain.

The shop also carries a variety of other crafts, most made by folks from the nearby area.

Prices
George: toy cars, $7;
cheeseboards, $12–$20;
carving boards, $36–$48
Lois: quilts, $500+
Erin: mugs, $12;
angel oil lamps, $36;
three-piece canister sets, $100

Location
Shop studio; 2 minutes
east of Saluda

Address & Phone
Saluda Mountain Craft Gallery
Ozone Dr., Saluda, NC 28773
704/749-4341

Hours
Summer: Mon.–Sat., 10 A.M.–6 P.M.;
Sun., 11 A.M.–6 P.M.
Winter: close at 5 P.M.

Payment
Visa, MasterCard,
American Express, Discover,
personal checks

Tryon...............................

Wood Spoons and Bowls
Guy F. Taylor

*I*t's obvious that Guy Taylor loves wood. His eyes shine when he talks about the three-foot-wide piece of mahogany that a friend brought him from South America, the old wood that he rescued from his grandmother's house and transformed into a handsome cabinet, the chunk of tree that he's going to turn into spoons and bowls and boxes dovetailed by hand.

Guy's personal story seems to revolve around the wood he loves. "My mother's people were all woodworkers and builders, then I worked for the National Park Service and then I took this up after I retired in '89. I guess I've been working with wood 'most all my life," he says.

Guy can make just about anything out of wood: cabinets, boxes, candle holders, cutting boards—you name it. But he's best known for his spoons, which are hand-gouged and carved on a special spoon-making table he designed himself. In fact, each of Guy's tools has a story. His lathe, for example, dates back to the 1890s and was discarded from an old cotton mill. One of his drills dates back to the early 1900s. His trunk-sized tool box once carried lanterns for a railroad man.

Prices
Business card holders, $3; long-handled spoons, $25; salad bowls with servers, $70; furniture, $500+

Location
Home studio; 5 minutes east of Tryon

Phone
704/859-9923

Hours
Call first

Payment
Personal checks

DILLSBORO

Dogwood Crafters

This artist-owned co-op represents 130 local crafters who do mostly traditional work; some contemporary work is also represented.

- **Location:** Downtown Dillsboro
- **Address:** Webster St., Dillsboro, NC 28725
- **Phone:** 704/586-2248
- **Hours:** *Jan.–mid-March:* closed
 Mid-March–June, Aug.–Sept, and Nov.–Dec.: daily, 9:30 A.M.–5:30 P.M.
 July and Oct.: daily, 9 A.M.–9 P.M.

DILLSBORO

Oaks Gallery

A wide variety of traditional and contemporary work can be found at this gallery. One hundred and twenty full-time artists show their work here; approximately 100 of these craftspeople live in the southern mountains.

- **Location:** Downtown Dillsboro
- **Address:** 29 Craft Cir., Dillsboro, NC 28725
- **Phone:** 704/586-6542
- **Hours:** *Jan.–March:* Thurs.–Sat., 10 A.M.–5 P.M.
 April–Dec.: Mon.–Sat., 10 A.M.–5 P.M.

FLETCHER
Mountain Rug Mills

Braided and hooked rugs, both traditional and contemporary, are shown here. Commissions are accepted.
- **Location:** 2 minutes south of downtown Fletcher
- **Address:** 6385 Hendersonville Hwy., Fletcher, NC 28732
- **Phone:** 704/684-7131; 800/296-8036
- **Hours:** Mon.–Fri., 9 A.M.–5 P.M.

HENDERSONVILLE
Hendersonville Curb Market

Locals sell their mountain crafts in individual booths at this market.
- **Location:** Downtown Hendersonville
 Address: 221 N. Church St., Hendersonville, NC 28739
- **Phone:** 704/692-8012
- **Hours:** *Jan.–April:* Tues. and Sat., 8 A.M.–1 P.M.
- *May–Dec.:* Tues., Thurs., and Sat., 8 A.M.–2 P.M.

HENDERSONVILLE
Touchstone Gallery

Two hundred artisans, about half of whom are from the Southeast, show their contemporary crafts (many whimsical and bright) here.
- **Location:** Downtown Hendersonville
- **Address:** 318 N. Main St., Hendersonville, NC 28792
- **Phone:** 704/692-2191

- **Hours:** *Jan. – Feb.:* Mon.–Sat., 9:30 A.M.–6 P.M.
 March–Dec.: Mon.–Sat., 9:30 A.M.–6 P.M.; Sun., noon–5 P.M.

SALUDA

Heartwood Contemporary Crafts Gallery

Contemporary crafts of all kinds are featured, 40 percent made by folks who live in southern Appalachia.

- **Location:** Downtown Saluda
- **Address:** Main St., Saluda, NC 28773
- **Phone:** 704/749-9365
- **Hours:** *Jan.–March:* Mon.–Sat., 10 A.M.–5.P.M.
 April–Dec.: Mon.–Sat., 10 A.M.–5 P.M.; Sun., 1 P.M.–5 P.M.

Lodgings

Flat Rock Inn

*D*ennis and Sandi Page are dropouts—he from a large pharmaceutical company, she from banking. "We didn't like the rush, rush world of Dallas corporate life. We're more homebody types," says Dennis, relaxing in a large chair in the comfortable living room of the Flat Rock Inn.

"This is perfect for us," says Sandi. "We meet fascinating people... and I get to indulge in one of my hobbies: cooking." Her breakfasts often include such delights as eggs Benedict, cherry blintzes, and homemade buttermilk biscuits.

The Pages have restored and updated a 1888 house originally built by R. Withers Memminger, a minister from Charleston. Listed on the National Register of Historic Places, it has a wide veranda (complete with swing and rocking chairs), fireplaces in each of the four guest bedrooms, and huge trees shading a circular drive. Each room has its own personality. The Colonial room, for example, features a four-poster and attaches to a smaller room with two twin beds. The Sandburg room has a white wrought iron bed and a side private porch. And the Squire room (preferred by honeymooners, says Sandi) has a claw-foot bathtub peeking out from behind lace curtains. All rooms have queen beds and private baths.

RATES
May–Oct., $95, double occupancy; Nov.–April, $85, double occupancy; closed Jan.

LOCATION
5 minutes south of Hendersonville

ADDRESS & PHONE
2810 Greenville Hwy.
Flat Rock, NC 28731
704/696-3273;
reservations: 800/266-3996

PAYMENT
Visa, MasterCard, personal checks

TRYON
The Mimosa Inn

*T*he Mimosa Inn has a delightfully intriguing past: back in 1903, it was built as an entertainment annex to a larger inn next door. The ground floor, which is now a lovely living room and dining room, was a casino—complete with bowling alley and billiard tables. (Visitors with sharp eyes will notice the living room floor, which is made in part with boards from the old bowling alley.) The upstairs, now home of ten charmingly finished bedrooms, was a dance hall.

In 1916 the larger inn, which was built sometime in the 1700s, burned down, and the owners decided to turn the annex into sleeping quarters. People from New England and the Upper Midwest came down and settled in for the winter. On mild days they could sit on the columned veranda and enjoy the view of Tryon Peak and the Blue Ridge Mountains.

Six years ago former New Englanders Jay and Sandi Franks bought the place and refurbished. "We'd always planned to open a B-and-B someday," says Sandi, "but when we saw this place we decided 'someday' was now. We couldn't pass it up; we had to take a chance."

RATES
$65, double occupancy; includes breakfast; open year-round

LOCATION
5 minutes east of Tryon

ADDRESS & PHONE
1 Mimosa Inn Ln., Tryon, NC 28782
704/859-7688

PAYMENT
Personal checks

All rooms have private baths, but one of the nicest touches is a second floor sitting room, complete with wood-burning fireplace, television, and small kitchen for guests' use.

TRYON
Pine Crest Inn

"*S*taying at Pine Crest Inn is like staying at the home of very rich friends," said a recent guest. It was a comment that would have pleased F. Scott Fitzgerald, a past guest, every bit as much as it pleased Jeremy Wainwright, the present owner. "That's exactly how I want guests to feel," says Wainwright. "Comfortable and special."

RATES
$125–$165, double occupancy; suites and cottages: $140–$425; includes continental breakfast; dinner entrees start at $22; meals also available for non-guests; open year-round

LOCATION
3 minutes from Tryon

ADDRESS & PHONE
200 Pine Crest Ln. Tryon, NC 28782
704/859-9135; 800/633-3001

PAYMENT
Visa, MasterCard, American Express, Discover, personal checks

Listed in the National Register of Historic Places, the Main Lodge dates back to 1906, when it was built as a sanatorium for tuberculosis patients. Eleven years later it was purchased by Michigan equestrian Carter Brown, when it became a favorite retreat for the horsy set who made hunts, steeplechase races, and shows a prime part of the regional social scene. But by 1990, the inn had fallen into genteel shabbiness and was desperately in need of a major facelift. It was the perfect challenge for Wainwright, just retired from a bank in Buffalo. With his wife, Jennifer, and a host of consultants, he turned the Pine Crest into a delightful weekend getaway as well as a sought-after meeting spot.

There are thirty guest rooms in the Main Lodge and several adjoining cottages, each equipped with a private bath, telephone,

and television with VCR. Many of the rooms have fireplaces, whirlpool baths, and well-stocked bookcases.

Dinner at Pine Crest recalls the best of the Old South. Flames sparkle in the fireplace and candles flicker on the tables as the excellent wait staff serves artistically arranged plates of duck, salmon, or beef. This is a favorite eating spot for locals as well as visitors.

*T*rying to categorize craftspeople is a risky endeavor. A potter may be making dinnerware today and begin creating large sculptural vases tomorrow. A weaver who specializes in blankets (listed under household accessories) may be willing to make a shawl (listed under fashion accessories) if you ask.

Use this Shopping Guide as a beginning, but only that. Your best bet, if you're looking for a particular item, is to scan the table of contents, read about every craftsperson who might be able to make what you have in mind, and then ask, ask, ask. You're almost sure to find someone who will make it for you.

Happy hunting!

Note from the authors

This guidebook required the help of a great number of people—those who recommended craftspeople to us, the artisans themselves who shared their time and thoughts, and the folks at Peachtree Publishers who made it all come together. Our sincerest thanks...

In addition, special thanks go to Becky Anderson and Sassi McClellan of HandMade in America, Katherine Caldwell of the Southern Highland Craft Guild, and Marla Tambellini of the Asheville Chamber of Commerce. We couldn't have done it without you!

Are there any other craftspeople whom you feel should be included when we update this book? If so, please let us know. Please send us the name of the craftsperson(s), his or her address, phone number, and type of craft to: *Handcrafted* Updates, Irv Green and Andrea Gross, c/o Peachtree Publishers, Ltd., 494 Armour Circle, N.E., Atlanta, GA 30324. Thank you!

Photo credits

Rob Amberg: p. 230; Tim Barnwell: back cover, pp. 11, 22, 30, 82, 126, 147, 160, 248, 284; Woody Fender: pp. 1, 4; Martin Fox: pp. 19, 40; Irv Green: back cover, pp. 65, 71, 77, 80, 111, 122, 153, 223, 241, 226, 271; Mary Beth Hege: p. 101; Claude Lazzara: pp. 267, 288; John Littleton: p. 163; Tom Mills: p. 156; Jon Riley: p. *i;* Mike Rominger: p. 116; Michael Seide: p. 114; Tom Till: front and back cover; John Warner: p. 15; Westar: p. 208. With the exception of those taken by author-photographer Irv Green, all photographs were supplied by the artists with the artists' full understanding that they are to be used for publication.